A Gallery of Rogues: Cartoonists' Self-Caricatures

MILTON CANIFF

Mark Cohen: 15 May
 '76

 I greatly en-
joyed my look at the
self-portraits,

 All of us rogues
in one gallery!

 Cordially,

Box 2022
PalmSprings
Ca 92262

A Gallery of Rogues: Cartoonists' Self-Caricatures

Text by Robert C. Harvey

THE OHIO STATE UNIVERSITY
CARTOON RESEARCH LIBRARY

1998

We are grateful to Mark J. Cohen and Rose Marie McDaniel for making this book possible, and to William J. Studer and Gay N. Dannelly for their support. Special thanks go to the cartoonists who gave permission to publish their self-caricatures. In addition, we appreciate the selfless efforts of Robert C. Harvey and Frank Pauer, whose creative gifts have enriched the book immeasurably.

A Gallery of Rogues: Cartoonists' Self-Caricatures was published with the support of the Milton Caniff Endowment of The Ohio State University Cartoon Research Library.

Graphic design: Frank Pauer

C O N T E N T S

PREFACE

Collecting has assumed a different aura in the last half of the twentieth century. "Collectibles" are produced and marketed with the assumption that their value will increase simply because they are collected. The idea of collecting a cabinet of curiosities simply because they delight the mind, hand, and eye is out of style. It has been replaced with the idea of collecting as investment, a more decorative and enjoyable (though frequently riskier) way to earn money than stocks and bonds.

Mark J. Cohen and Rose Marie McDaniel are an exception to the trend of collectors as investors. They love cartoon art and collect for the fun of it — for the sport of hunting a prized item, the pleasure of finding it, and the joy of sharing their treasures with others. This book is one more example of a remarkable legacy that Mark and Rosie have provided for those of us who care about the history of cartooning. Their collection of cartoonists' self-caricatures is unique and remarkable. We are pleased to be able to celebrate their wonderful collection through the publication of this volume. The Ohio State University Cartoon Research Library is honored that some day the Mark J. Cohen and Rose Marie McDaniel Collection will be housed here.

Lucy Shelton Caswell
Professor and Curator
August 1998

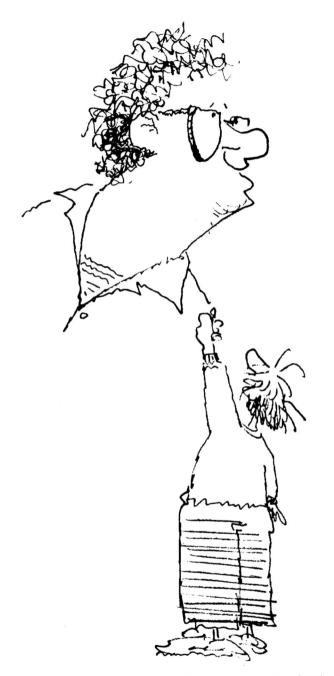

MEET THE FACE BEHIND THE LAUGH

Mark Cohen's is the face behind the laughs in this book: the cartoonists' self-caricatures that appear on the following pages are all from the Mark Cohen and Rose Marie McDaniel Collection of original cartoon art. Mark estimates that they have about 6,000 pieces of original art in the collection. I've been in his house, and I think he's right: cartoon artwork is lying around everywhere that it is not piled up, leaving not much room in the house for Mark and his wife, Rosie. Of the 6,000 pieces, around 600 are self-caricatures of cartoonists, a lot of which appear only in copies of books of the cartoonists' works that are inscribed to Mark and Rosie. So the 154 caricatures that appear in this slim volume are just a taste of the iceberger (as we say in these titanic times). But they are the pick of the litter (if I may mulch the metaphor a little).

They are also the outward and visible sign of Mark's love of cartooning.

At the beginning (which, for our purposes, is 1956 when Mark was about fourteen), he wanted to be a cartoonist. And one day, he took samples of his work to show them to a real cartoonist, hoping to get advice on how to proceed with his career. Bert Whitman, who was then editorial cartoonist for the *Stockton Record*, was Mark's mark.

"It took me weeks to get up the courage to call," Mark remembered, "and when I finally made the appointment, I was scared to death. When the day finally came, I went to the paper and was ushered into his office. Whitman was a big moose of a man. He seemed like a giant to me. I

remember that he was working on the day's cartoon, and he held a soft-lead pencil in one hand and an art gum eraser in the other. The hand holding the pencil would spiral down the sheet of coquille board and the other hand would work the eraser," Mark continued, demonstrating by moving both hands at once. "I was awestruck, watching him work with both hands, sketching and erasing at the same time, spiraling down the paper."

Whitman looked at Mark's cartoons and gave him some advice. He also gave the youth his first original cartoon.

Mark gave up his cartooning ambition because he didn't fancy the solitary life that cartoonists invariably lead. A highly gregarious sort, Mark needed to be with people. So he elected to become a magician, developing his act and an accompanying line of comedic patter. To make a living, he was eventually driven to sell real estate. But the comedian lived on: as he met cartoonists, he started writing material for them, beginning with Morrie Turner and *Wee Pals*. In the last analysis, though, it was Whitman who had persuaded him to give up being a cartoonist: "I couldn't spiral down the paper," Mark said with an impish grin.

But he still loved cartooning. Passionately. And there was something about the drawings in their original state that enthralled him. He had been dazzled by the original cartoons hanging on the wall in Whitman's office. A habitué of used-book stores and antique shops, Mark found some original cartoons in a Los Angeles shop, and he bought some of them. The passion was fueled. The collection was born.

Visiting a second-hand bookstore in 1971, he found a catalogue from a 1943 exhibit in San Francisco at the deYoung Museum called *Meet the Artist*. "It was a book of self-portraits," Mark said, "and it had Thomas Hart Benton in it and the better known artists of the day, but it also had a number of cartoonists who had done self-caricatures. It had Al Capp, Otto Soglow, Zack Mosley, and so on. And it just really hit me. I thought, how interesting. How fun it would be to collect self-caricatures. Where would you find self-caricatures to collect? I had no idea. So the logical thing to do was to make requests of the cartoonists for self-caricatures. And I believe the first one that I asked was Al Capp. I wrote to him. And one came back. And I became a self-caricature requesting maniac."

With every request to a cartoonist, Mark sent a money order. "I've always felt it was wrong to ask someone to give their product away," he said. "And while it may have been only a token payment, the cartoonists appreciated the ethic generally. I had a high degree of success."

Initially, he went after the self-caricatures of cartoonists he found in the deYoung catalogue. And then he began looking for self-caricatures of the cartoonists whose original art he had in his collection; pairing the cartoon with the cartoonist's self-caricature made an interesting display. And display them he did. As the collection grew, Mark offered it to museums around the country. When the exhibition consisted entirely of self-caricatures, Mark called the show "The Face Behind the Laugh."

Indulging his life-long love of *Mad* magazine, Mark began to acquire original art for the cartooning that had been published in *Mad*. This niche of the collection grew until it embraced nearly two hundred pieces, including cover paintings and such *objets d'art* as Alfred E. Neuman coffee mugs and wrist watches. When the *Mad* art goes on the road, it is displayed under the heading "Humor in a Jugular Vein." Among the self-caricatures herein are several of the "usual gang of idiots" (as the *Mad* men call themselves).

The careers of the cartoonists whose mocking self-images appear here span more than a century of American cartooning. From the earliest to the latest — from Thomas Nast and Fontaine Fox to Signe Wilkinson and Scott Adams; from the most famous to the lesser known — from Charles Schulz and Chester Gould and Walt Kelly to Peter Newell and Sol Hess and Nate Collier. Mark and I picked cartoonists whose life's works would be most familiar to the average citizen, but we also chose some whose pictures of themselves were particularly noteworthy examples of their artistry.

The book is organized by genre, with sections devoted to newspaper comic strip and panel cartoonists, followed by editorial cartoonists, then

Mad cartoonists, magazine cartoonists (those whose work appears mostly in *The New Yorker* and then those who are published in a variety of periodicals), then, bunched together, caricaturists, animators, and illustrators of greeting cards, books and advertising; finally, a section on comic book cartoonists. Those in the color section come from all genres.

The genres of cartooning trace the history of the medium. Among the earliest manifestations of cartooning in this country were those that appeared in magazines like *Harper's Weekly*, where Thomas Nast made powerful political statements with his drawings, and, later, in weekly humor magazines like *Judge, Puck*, and *Life* that cropped up in the 1870s and 1880s. These comic weeklies (or "comics" as they were often called) published humorous drawings and short funny stories and risible paragraphs. The humor in the humorous drawings usually resided in the captions underneath the pictures: these captions recorded the speeches of several of the persons depicted in the drawing, their exchange appearing like the script of a play, the last speech being the punchline.

By the 1890s, newspapers were publishing substantial Sunday editions, and at Joseph Pulitzer's *New York World*, the Sunday editor, Morrill Goddard, decided to fatten up his weekend offering by producing a humorous magazine patterned after the comic weeklies. His venture was so successful that when William Randolph Hearst invaded the New York newspaper territory in 1895 by buying the *New York Journal*, he saw immediately that he would have to launch his own Sunday comic supplement to compete with Pulitzer's *World*. The most popular feature of Pulitzer's Sunday comic supplement was Richard F. Outcault's *Hogan's Alley* cartoon, starring a jug-eared urchin in a nightshirt dubbed the Yellow Kid. Hearst hired Outcault away from Pulitzer, and Pulitzer found another artist to continue producing pictures of the bald-headed waif. Suddenly, the Yellow Kid was everywhere: the two papers trumpeted their Sunday editions with broadsides and posters advertising the Yellow Kid, who, some believe, lent his name to the sensational brand of journalism practiced by the warring newspapers in their battle for readers —"yellow journalism."

The humorous single-panel drawings eventually gave way to sequences of comic pictures that told a short story, "comic strips." And as the new century dawned, comic strips proliferated, spilling out of the Sunday papers into the weekday editions. Comic strip characters were extremely popular: very early, they were recruited for theatrical productions in New York and other large cities. The demand for the most popular of the comic strips resulted in the development of feature syndicates. These were marketing and distribution enterprises that made the comic strips of one newspaper available for a fee to any out-of-town paper that wanted to publish them. By this means, comic strips achieved national circulation: everyone read *Happy Hooligan* and *The Toonerville Trolley* and *Blondie* and *Dick Tracy* and scores more.

The Sunday funnies were so popular that the comic section was usually wrapped around a paper's Sunday edition to serve as a colorful cover. Through the 1930s, most comic strips had a full page to themselves in the Sunday sections. Some cartoonists produced two Sunday features, devoting about two-thirds of their page to their regular strip and at the top of the page, a "topper," another comic strip that was published on Sundays only.

Meanwhile, as magazine readers became more sophisticated, the comic weeklies with their vaudevillian style humor disappeared from the newsstand. By the late 1930s, only *Judge* remained of the vintage humor magazines, and it was soon coming out only once a month. But a newcomer, *The New Yorker*, emerged from the roaring twenties with a new approach and a new kind of cartoon. Its founder, Harold Ross, was a one-time hobo newspaper reporter, drifting from city to city, job to job. After helping to produce *The Stars and Stripes* during World War I, he hungered to publish a magazine of his own that would incorporate solid reporting and casual

comedy. And in February 1925, he began to realize his dream with the first issues of *The New Yorker.* The magazine cartoon with a single-speaker caption was not invented at *The New Yorker,* but it was surely established there: Ross published this kind of cartoon more and more often, and when his magazine outlasted all the other weekly humor magazines, his brand of cartoon emerged as the standard, setting the fashion for all other magazine cartooning. *The New Yorker* remains today a Mecca for magazine cartoonists.

On the funnies pages of the nation's newspapers during the third and fourth decades of this century, the humorous or "gag-a-day" comic strip was being elbowed off the page by strips that told stories, continuing them from day-to-day. Some of them were sob stories, heart-rending continuities about put-upon orphans and their faithful canine companions, for instance. Others aimed at adventure, as Roy Crane did in his *Wash Tubbs.* By the mid-1930s, most of the stories were adventure stories, fraught with danger and action — *Dick Tracy, Terry and the Pirates*, and so on. Joseph Patterson, publisher of the *New York Daily News*, was to this generation of newspaper comics what Hearst had been the previous generation: a mentor and promoter. And an avid fan.

After World War II, the continuity strip was displaced by another generation of gag-a-day strips. The box that had recently arrived in the living room was the culprit: newspaper editors supposed that readers wouldn't come to the comics section for a story that dragged on day after day when they could get an entire story on television in an hour. (Thirty years later, television was continuing its hour-long dramas from week to week, proving that continuity with its inherent cliff-hanger ending every episode was still alive and well in American popular culture.) But, the editors reasoned, readers would turn to the funnies to get a laugh. *Peanuts* and *Beetle Bailey* and *B.C.* set the pace.

Newspaper comic strip features had been reprinted in booklet form almost from the beginning. During the 1930s, the reprint business fostered another distinct genre of cartooning. It began with a couple of enterprising salesmen who produced a give-away magazine for stores selling products for kids. The magazine consisted of reprinted newspaper Sunday comic strips in full color. When the publication was enthusiastically received, they took the next step: they offered the same kind of booklet for sale on newsstands. The success of this enterprise was so great that it threatened to exhaust the supply of newspaper strips that could be reprinted, so entrepreneurial publishers started commissioning artists to produce original material for comic books. When Superman appeared in *Action Comics* in the summer of 1938, he started a new fashion for comic book stories. (The company that first published Superman stories was called Detective Comics, after one of its titles; it eventually became National Periodical Publications; then DC Comics. Names changed quite often in the comic book publishing game. Today's Marvel, for instance, had flown such flags as Timely and Atlas in its sixty-year history.) With Superman's success, the age of the superhero had arrived, and cartoonist Jack Kirby would soon set the pace for comic book artists in this genre.

But not all comic books were devoted to the adventures of well-muscled characters in long underwear. Will Eisner and his colleagues produced adventure stories of more-or-less ordinary beings — military men, detectives, and other kinds of crime fighters. Some of the comic books focused on funny animals, chiefly those whose antics on the movie screens had created a following — Donald Duck, Bugs Bunny, and the like. But it was the superhero and action-oriented comics that found favor among soldiers in World War II. G.I.s read them by the thousands: they were perfect reading matter for people who had to hurry up and then wait but remain prepared to hurry up again, discarding quickly whatever they had seized upon for temporary amusement.

After World War II, crime comic books took over the newsstands as superheroes fell out of favor. No longer "comic" (if, in fact, they ever were), comic books also began telling tales of supernatural horrors and science

fiction. At Entertaining Comics (EC), William Gaines and a group of skilled artists produced some of the finest examples in these genres. But by the mid-1950s, criticism of comic books, always a factor, had acquired a psychologist as leader. Under attack from Fredric Wertham, publishers were fearful that federal or state governments would take control of their industry, so they set up their own censoring agency to police the content of their comic books. Many publishers went out of business entirely. Gaines tried to compete under these new circumstances but couldn't. He discontinued all his titles except a satirical parody called *Mad*, which had been shepherded into irreverent existence by Harvey Kurtzman. Gaines had authorized Kurtzman to convert the comic book to a magazine in 1955, and so *Mad* escaped the industry censors and went on to become the most successful national humor magazine ever.

Another wartime enterprise resulted in the birth of the National Cartoonists Society. Cartoonists living in New York entertained soldiers recuperating in the military hospitals in the area, drawing funny pictures in chalk and making jokes as they did. Accustomed to laboring in solitude, the cartoonists discovered that they enjoyed each other's company and decided to perpetuate the conviviality by meeting regularly, once a month. To that purpose, they formed NCS in 1946. At the end of the first year of its existence, NCS conferred the first of its annual Outstanding Cartoonist of the Year awards. Officially named the Billy DeBeck Award to commemorate the creator of *Barney Google* (whose widow donated the trophy, a silver cigarette case), the award was briefly dubbed the Barney, and Milton Caniff received the first one. Some years later, the award was renamed in honor of one of the founders of NCS, Rube Goldberg. Starting in 1954, the Outstanding Cartoonist of the Year received the Reuben, which took the form of an antic pile of cartoon characters adapted from a statue Goldberg had molded himself, thinking he was making a lampstand.

Many of the events I've just outlined here are referred to in the brief biographies that accompany each of the caricatures on the following pages. So now you'll know what I'm talking about. For many of the facts rehearsed herein, I'm indebted to Ron Goulart's fine *Encyclopedia of American Comics* (Promised Land, 1990), but I also consulted other standard reference works in the field. As for the caricatures, they stand alone as a kind of monument to Mark Cohen's love for the art of the comics.

"The true collector," he said once, "is not an investor. The true collector collects because he loves the art. Every collection is special. Because it reflects the personality and the love of the collector. I hesitate to use the term, but Rosie and I have truly been blessed because the cartoonists have become our family, and it's really a love affair. The collection has been built because the cartoonists have been very generous with us. And we want to see it continue as a gift to the art that has been so wonderful to us. So we've arranged for this collection to go to the Ohio State University's Cartoon Research Library. There, it will be the body of a collector's life. It is a gift of life: it will be used; it will be useful. It can be lent to museums and libraries, publishers — whatever use is fitting and necessary. I think it's important to continue the good things that Ohio State has done for the art, and this way, the collection will always be available to benefit the art. The collection would not have grown and prospered without Rosie's active support, so it's no longer the Mark Cohen Collection: it's the Mark Cohen and Rose Marie McDaniel Collection. I'm proud of that."

Me, too.

Robert C. Harvey
July 1998

Robert C. Harvey is the author of two analytical histories about cartooning — The Art of the Funnies *(about newspaper comic strips; 1994) and* The Art of the Comic Book *(1996), both from the University Press of Mississippi.*

WALT KELLY
1913 | 1973

WALT
KELLY

Kelly's career included both animation (1936-1941) at Disney Studios and comic books (1942-1948) before embracing the newspaper comic strip form, and by the time he had finished, Kelly had elevated the form to high art in *Pogo,* winning the Reuben in 1951. The eponymous possum had first appeared as one of several spear-carriers in a comic book feature about a voracious alligator named Albert in the first issue of *Animal Comics* (December 1942-January 1943). And when Kelly became art director of the short-lived but much mourned *New York Star* in 1948, he reincarnated his comic book cast on October 8, this time

giving Pogo the title role. After the *Star's* demise, *Pogo* went into national syndication, May 16, 1949. Speaking a "southern fried" dialect that lent itself readily to the characters' propensity to take things literally and permitted an unblinking delight in puns, Kelly's "screechers" were perpetually

adrift in misunderstood figures of speech, mistaken identities, and double entendres that went off in all directions at once; thus occupied, they happily pursued various human endeavors without quite understanding their underlying purpose. The strip's ensemble soon transcended the "talking

animal" genre: Kelly added overt political commentary to his social satire when he ran Pogo for the Presidency in 1952, and the double meaning of the puns took on political as well as social implications, the vaudeville routines frequently looking suspiciously like animals imitating officials high in government. Kelly underscored his satirical intent with caricature: his animals had plastic features that seemed to change before the reader's very eyes until they resembled those at whom the satire was directed. The words and the pictures were thus perfectly wedded, the very emblem of excellence in the art of the comic strip: neither meant much when taken by itself, but when blended, the verbal and the visual achieved allegorical impact and a powerful satirical thrust. High art indeed.

HANK KETCHAM

BORN 1920

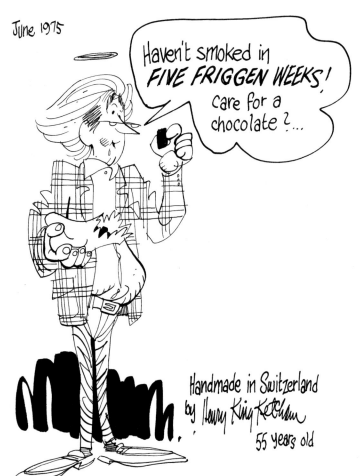

Like several others of the post-war generation of newspaper cartoonists, Ketcham graduated to newspaper syndication after matriculating in magazine cartooning. Before serving in the U.S. Navy during World War II, Ketcham learned his craft in the animation studios of Walter Lantz and Walt Disney. As a photographic specialist stationed in Washington, D.C., he produced for his base newspaper a comic strip called *Half Hitch* about a nautical Sad Sack. After the War, Ketcham joined the ranks of cartoonists making the rounds every Wednesday to show their week's work to magazine cartoon editors at the New York offices. Then in the fall of 1950, his wife, reporting to him in his bedroom studio, explained the commotion he'd just heard by saying, "Your son is a menace." To which Ketcham muttered, "Dennis? A menace?" The euphony proved irresistible: Ketcham rounded up a dozen little kid gags and sent them off to his agent and within a month, he had a syndicate contract to produce *Dennis the Menace*, which debuted March 12, 1951. Before the end of the year, over a hundred newspapers had signed up. The daily panel is distinguished by Ketcham's virtuoso performance in black and white — crisp line, dramatically spotted solid blacks, varying textures for shading and emphasis. He learned the telling effects of details from *New Yorker* cartoonist Perry Barlow, and Dennis is full of such graphic enhancements, every one — whether a bud vase on the piano or a cat arching its back or appliances in the kitchen — all are rendered in Ketcham's unique manner, each a stylistic triumph no matter how seemingly inconsequential in the context of the gag. Ketcham received the Reuben in 1952.

BOB THAVES
BORN 1924

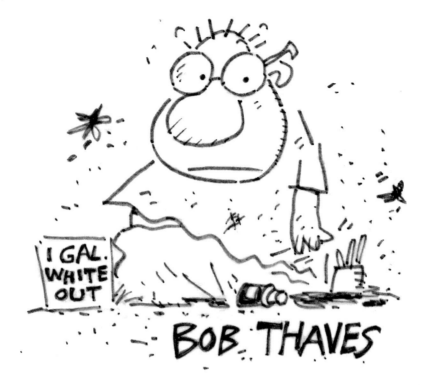

I GAL. WHITE OUT

BOB THAVES

Son of a midwest printer who produced several weekly newspapers every week, Thaves has printer's ink in his veins. Despite an academic preparation in psychology, he couldn't stay out of cartooning. Thaves became a consultant in industrial psychology to pay his way through a Ph.D. program at the University of Southern California, but he also freelanced cartoons to magazines. To escape the speculative nature of the latter, he sought syndication but with an unusual concept: he wanted to do a single-panel cartoon but the panel would be as wide as the usual comic strip and would run on the comics page. Originally, his plan did not include recurring characters, but eventually, he settled on *Frank and Ernest*, two squatty somewhat shabby-looking jacks-of-all-trades who gave their names to the strip. When the feature began in 1972, it broke three so-called rules: it was a single panel, strip-wide; the lettering was large and block-style; and its characters, although the same from day to day, held different jobs every day and even appeared in different historical periods. Envisioning the strip as a theater, Thaves explained, he sees Frank and Ernest as actors who perform different roles each day, sometimes in contemporary life, sometimes in the past, sometimes in the future. Thaves delights in puns, sometimes showering the reader with dozens at a time on Sundays, and in 1990, he was named Punster of the Year by the International Save the Pun Foundation; fittingly, the award was presented on April Fool's Day. Thaves continues to be amazed at his brethren in the inky-fingered fraternity: while they are perpetually in competition for space in newspapers, "we still seem to share a lot and attitudes are more friendly than bitterly competitive."

FELT TIP PEN ON PAPER | 12 X 10.6 CM. | 1987

DICK MOORES

1909 | 1986

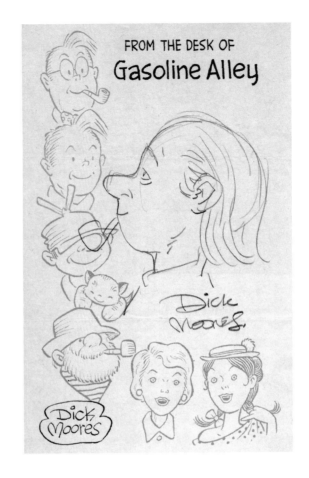

FROM THE DESK OF
Gasoline Alley

Until Moores took over and continued Frank King's comic strip *Gasoline Alley*, second acts were almost always but pale reflections of the first. Throughout the industry, it was widely accepted that the successor to the originator of a well-established comic strip would never be able to continue the feature successfully — that is, in the same spirit and quality. Moores not only continued the strip in all its usual ambiance, he improved upon it, winning the Reuben in 1974. Moores had begun his cartooning career as Chester Gould's first assistant on *Dick Tracy* (1932-1935). In 1935, he started his own strip, *Jim Hardy*, about a crime-fighter who was eventually elbowed out of the strip and its title by popular secondary figures, a simple-minded cowboy named Windy and his horse Paddles. *Windy and Paddles* was discontinued in 1942, and Moores went to the Disney Studios, where he worked on an assortment of newspaper comics (*Tales of Uncle Remus, Scamp,* and *Classic Tales*) and, in 1950, moonlighted to develop and sell a limited animation cartoon for television. The TV scheme failed (just two years ahead of its time), so Moores was happy to accept Frank King's 1956 summons to assist him. And when King retired in 1960, Moores took over the strip. He maintained it in small town America and continued aging the characters (a distinctive aspect of the strip). His way of drawing echoed King's style but was tidier (and therefore better suited to the smaller dimensions of the comics page) and at the same time more richly embellished. Attracted to two of the strip's minor characters, handymen Joel and Rufus (seen here third and fourth from the top on Moores' letterhead), Moores began devoting whole sequences to their bumbling Laurel and Hardy-like adventures. "There are probably many readers who look forward to Walt and Skeezix [the strip's long-time protagonists]," Moores once said, "but those characters are limited. You can go only so far with them. With Joel and Rufus, you can do anything, and it'll come out funny."

PENCIL ON PAPER | 14 X 21.6 CM. | 1976

JIM SCANCARELLI
BORN 1941

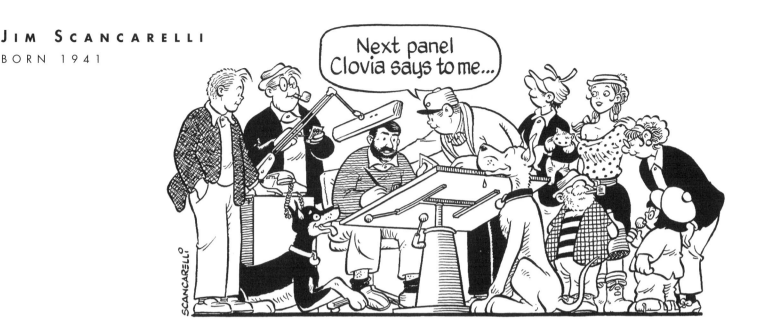

If second acts are almost never as good as first acts in syndicated comic strips, third acts are completely unheard of. And yet, *Gasoline Alley* has enjoyed both the impossible and the unheard of. Scancarelli took over the strip at Dick Moores' death in 1986 and sustained its characteristic homespun tone and crisp visuals, winning the NCS Best Story Strip Plaque in 1989. Before becoming Moores' assistant in 1979, Scancarelli worked as a commercial artist, first in television (he made the first color animated movie for a local TV station in his hometown, Charlotte, North Carolina), then, freelance, preparing slide art. When computers came along, capable of producing slide art faster and cheaper than an artist, Scancarelli was suddenly out of work. That's when he joined Moores, eventually inking everything on the strip except the characters' faces. For a time in 1982-1983 Scancarelli also inked *Mutt and Jeff;* launched in 1907, this venerable strip was produced in its final years by another Charlotte cartoonist, George Breisacher. (Thus, when *Gasoline Alley* turned seventy-five in 1993, Scancarelli became the only cartoonist to have worked on two strips in their seventy-fifth year.) Says Scancarelli about the writing of *Gasoline Alley:* "Frank King and Dick both left very indelible fingerprints on these characters. Their personalities are so set that they act out the stories themselves. I just throw them into a situation, and they go about doing whatever they're going to do." Scancarelli has done stories on such topical issues as deafness (Walt's) and naturalization, and he has sent members of the ensemble off on some fairly wild adventures, too. A passionate fan of his medium, he often devotes Sunday pages to nostalgic evocations of vintage comics, and he draws every installment, daily or Sunday, with painstaking thoroughness, seemingly in defiance of the hostility to cartoon art on any scale that prevails throughout the newspaper industry.

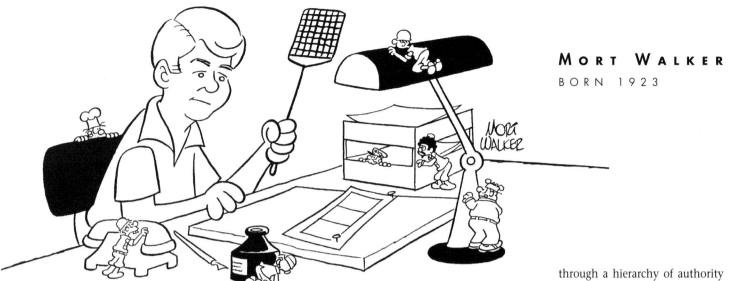

A successful magazine cartoonist, Walker imported to the funnies pages of American newspapers the simpler less fustian style of the magazine medium, helping (with Charles Schulz, q.v.) to set the pace for a generation of comic strip cartoonists. The title character in *Beetle Bailey* (seen here crouching on the lampshade) first appeared in *Saturday Evening Post* cartoons as a teenager named "Spider," but when the strip debuted September 4, 1950, Spider had acquired a different insect monicker and was in college. The machinations of a lazy collegian, however, did not attract much attention just then: most American males were more likely to be drafted into the Korean War than to matriculate on college campuses. Walker cannily fell into step with his countrymen and put a uniform on Beetle in March 1951. The strip immediately picked up a hundred new subscribers and grew steadily in circulation, eventually hitting 1,000, a mark that, until then, only *Blondie* had struck. (Ultimately, *Beetle Bailey* would pass 1,600, while *Blondie* and *Peanuts* passed 2,000.) Even when the Korean hostilities ceased, Walker kept the military locale: the Selective Service made certain that every American male would sympathize with Beetle's predicaments. And by the time the draft ended, the strip was not just about the Army. It had long before assumed a much more universal dimension: *Beetle Bailey* is a metaphor of all human society the essential order of which is sustained through a hierarchy of authority which those in the society tend to see as ridden with incompetence. And since the down-trodden Private Bailey is as incompetent as General Halftrack or Sergeant Snorkle, the strip is a great leveler: we are equal because we all have frailties. Walker's drawing style had also evolved, becoming increasingly abstract until the pictures, too, were metaphorical, geometrically surreal representations of the humans whose antics it recorded. Walker, a Reuben winner (1953), launched a half-dozen other successful strips with the aid of his cartoonist staff, and he founded the International Museum of Cartoon Art.

DIK BROWNE
1917 | 1989

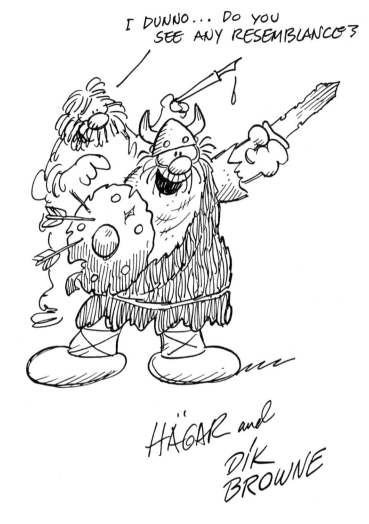

I DUNNO... DO YOU SEE ANY RESEMBLANCE?

HÄGAR and DIK BROWNE

The burly, bearded and somewhat disheveled Browne, as the above representations surely demonstrate, is more closely associated with *Hagar the Horrible* than with *Hi and Lois,* although his initiation into the world of syndicated cartooning was accomplished with the latter not the former. In the Army during World War II, Browne drew maps and charts and created his first comic strip, a feature about a WAC called *Ginny Jeep,* but after the War, he went into advertising, joining Johnstone and Cushing, a firm known for its use of cartoons in marketing strategies. He worked with the Birdseye bird, designed Chiquita Banana and revitalized the Campbell Soup kids. And for *Boys' Life,* he drew (1950-1960) *The Tracy Twins,* a monthly humor strip, which attracted the attention of Mort Walker, who, in 1954, had decided to launch a second strip — this one about Beetle Bailey's sister and her husband. Browne was tapped to draw *Hi and Lois,* beginning on October 18, and won the Reuben for it in 1962. But he wanted a strip of his own, and on February 4, 1973, he started *Hagar*

the Horrible about a burly, bearded and somewhat disheveled but childlike Viking who contends with all the vicissitudes of suburban fjord life while also mustering and leading a band of misfit marauders on raids against the English and other pillage-prone European cultures. For this enterprise, Browne developed an appealing variation on the Walker house style that prevailed in *Hi and Lois:* deploying the same bold outlining technique, Browne embellished the drawings with delicate cross-hatching and linear shading, giving the strip a rougher appearance, more appropriate to the robust activities of sacking and looting. He continued drawing *Hi and Lois* at the same time, both strips eventually ranking in the top ten in circulation, and he won his second Reuben for *Hagar* in 1973.

STEPHEN BENTLEY
BORN 1954

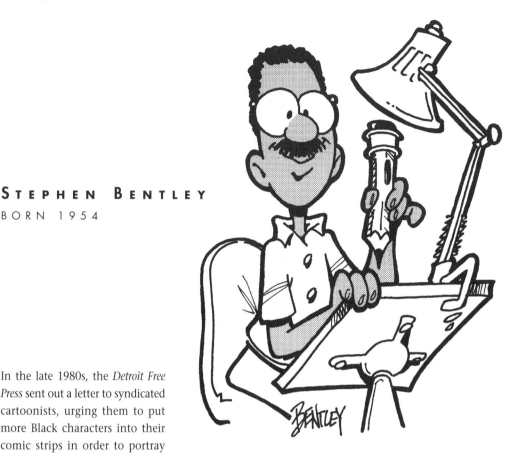

In the late 1980s, the *Detroit Free Press* sent out a letter to syndicated cartoonists, urging them to put more Black characters into their comic strips in order to portray accurately the racial diversity of American society. Ben Templeton (q.v.) and Tom Forman of *Motley's Crew* responded by trying to put together a comic strip about minorities, and just about then, Bentley, who'd heard what they were looking for, stepped forward. He'd been doing advertising cartoons for several years, and he started working with them, creating

Herb and Jamaal, which he was soon writing as well as drawing. As Bentley sees it, the strip (which started August 7, 1989) is about friendships and relationships. The title characters run into each other at a high school reunion fifteen years after graduating, and when they see that the ice cream parlor in their old neighborhood has closed, they resolve to open it

again as a way of reaffirming their friendship and the values they grew up with. Herb is married, and his wife and son and daughter, and his mother-in-law who lives with them, provide the context for family humor while he and his bachelor partner encounter the world of business and the neighborhood. "I want the characters to come across, first of all,

as identifiable people to any reader," Bentley said, "and, secondly, as personalities that ring true to the Black reader." Feeling an obligation to portray the Black experience in a positive manner, he has his characters get involved in street activities, like the neighborhood watch: "It gives a positive picture of how to combat theft and gang activity," Bentley explained, "— it's a round-about way to say that we have a problem, but this is how these characters are attacking it." But whatever his message, he keeps the strip entertaining, too. "You can teach something in the first two or three panels," he explained, "but in the last panel, you put in the comic twist, the humor."

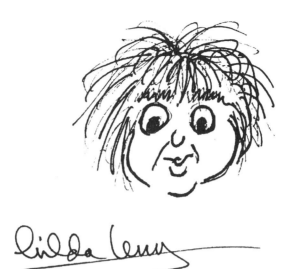

HILDA TERRY
BORN 1914

Coming to New York in 1931 in hopes of becoming a sports cartoonist, Terry found herself a waitress at Schraft's. Although she did some artwork during the decade, it wasn't until after marrying cartoonist Gregory d'Alessio in 1938 that Terry began to sell to magazines such as *The New Yorker* and *Saturday Evening Post.* "Success depends on who you know, but who to know is the fella who can teach you good," she once said, referring to her husband. In *American Magazine* she had a regular monthly panel called *Carrots O'Hara* about a teenager (printed with a second color, red, for the sake of the girl's tresses), which apparently attracted the attention of syndicate operatives. The result, *It's A Girl's Life,* a daily panel and Sunday strip, debuted December 7, 1941 — or, as Terry said, "on the back pages of Pearl Harbor." By 1945, it had changed its name to *Teena* and ran under that heading until it ceased in 1963. Terry was largely instrumental in integrating the all-male bastion of the National Cartoonists Society. In 1950, she wrote a letter to NCS (of which d'Alessio was then secretary) pointing out that a social club for the boys had been all right, but the more visible the club became as a professional association, the more damaging it was for women cartoonists to be excluded from membership. NCS soon changed its requirements, and Terry was among the first three women cartoonists admitted to membership. Following her career as a syndicated cartoonist, Terry returned to her first love, sports, and helped to design the first computerized scoreboards in sports arenas. In 1979, she received the NCS plaque for animated cartooning.

INK ON PAPER (DETAIL) | 12 X 34.5 CM. | 1989

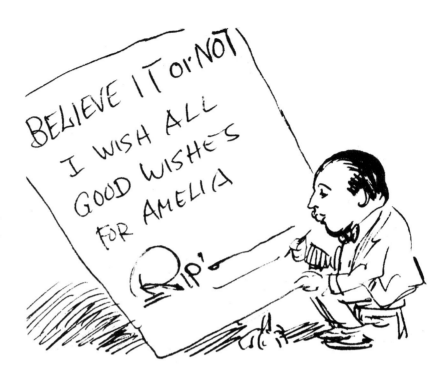

ROBERT L. RIPLEY
1893 | 1949

Ripley sold his first cartoon to the old *Life* humor magazine at the age of fourteen, but he hoped for a career in sports. When that didn't materialize, he turned to drawing pictures about sports in San Francisco at the *Bulletin* in 1910, moving soon to the *Chronicle*. He went to New York in 1913 and was hired by the *Globe*. One December day in 1918 he was at a loss for a topic for his panel, so he decided to illustrate several odd facts about sports and athletes that he'd accumulated. And from this tiny acorn, "believe it or not," grew the mighty oak with that clarion challenge as a title. Ripley soon began adding unusual non-sports facts to his pictorial report, and before long, he was doing a panel every day — a jumble of pictures about strange-looking pets and people, vegetables that resembled movie stars, compulsive accomplishments, and puzzles, palindromes, tongue-twisters, and brain-teasers. A collection of his *Believe It Or Not* panels was published in 1926, leading to syndication and a contract with Warner Brothers for a series of twenty-six short films. In the 1930s, Ripley took a much ballyhooed world tour to search for oddities, and in 1933 for Chicago's Century of Progress Exhibition, many of the artifacts he'd collected were exhibited in his "Odditorium."

Ripley, believe it or not, was born in Santa Rosa, California, home town of the curator and owner of the collection of caricatures being mined in this book, Mark J. Cohen. Finally — would you believe? — Ripley's first attempt at his subject that winter's day in 1918 he labeled "Champs and Chumps." His editor changed it, giving the feature the title that would ring through the ages.

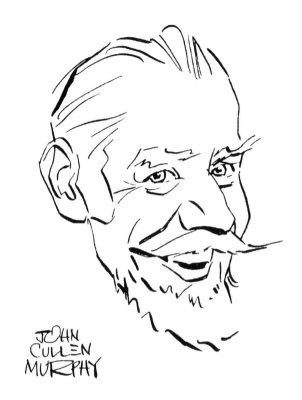

JOHN CULLEN MURPHY
BORN 1919

As a boy, Murphy modeled for a neighbor, Norman Rockwell, and as a young man, he studied at several prestigious art schools. Murphy was already a noted illustrator, specializing in sports, when he was approached in 1949 by Elliot Caplin (Al Capp's brother), who wanted Murphy to illustrate a comic strip about a prize fighter, *Big Ben Bolt*. At the time, Murphy was providing interior illustrations and cover art for such magazines as *Esquire, Holiday, Look, Collier's,* and *Sports*. Together the collaborators produced a literate strip about boxing, treating the milieu with respect and starring a fighter who was a college graduate, intelligent and articulate. Murphy's renderings were crisp and dramatic, sparkling examples of black-and-white art. Then in the late 1960s, Harold Foster, who had been producing his stunningly illustrated *Prince Valiant* page since 1937, began looking for someone to assist him who could carry on the feature after Foster retired. Several artists tried out for the job, but Murphy got the nod (reportedly because of his expressive way of drawing hands). Murphy began drawing *Prince Val* in 1970 and started signing the page May 23, 1971. Murphy turned most of the art chores on *Big Ben Bolt* over to other artists, including Gray Morrow, who signed it for the last eight months before it ceased April 13, 1978. Meanwhile, Foster continued writing *Prince Val* until he retired in 1979, three years before he died. Murphy's son Cullen then assumed the writing.

BUD GRACE
BORN CA. 1945

In the zany world of Grace's comic strip, *Ernie*, it doubtless makes sense for a Ph.D. in physics to lead to a career in cartooning. And that's what happened to Grace. He taught physics in college for a few years (even writing scholarly articles on such things as low energy neutral atomic scattering) before giving it up to freelance gag cartoons to magazines, selling to such periodicals as the British *Punch* as well as to the American *National Lampoon* and others. When he contemplated fatherhood in 1988, however, he decided he needed a regular paycheck and submitted *Ernie* for syndication. Unlike most American comic strips, *Ernie* is a flamboyantly outrageous enterprise, an unabashed assault on received wisdom and civilized sensibilities. The title character is somewhat bland, all the better to act as a foil for his grasping, venal, relentlessly self-serving Uncle Sid Fernwilter, who is the perpetual treasurer of what Grace describes as "a benevolent and protective or-ganization known as the Piranha Club," an unprecedented ensemble of skinflints, shysters, and "alu-minum siding salesmen" — all crooks, in other words, shallow water sharks (like piranhas) dedi-cated to collecting income without laboring for it. But Grace takes the entire human condition (with a particular emphasis on the American interpretation of it) as his province for satirizing. "Un-fortunately," he once said, "people take everything so seriously. I've had to moderate my satire and direct it at only licensed targets. Namely WASPS." Ernie is enor-mously popular in Scandinavian countries, and when Grace visits there, he goes on promotional tours like a rock star. Much of the mater-ial that he finds he can't use in his syndicated strip goes into a special comic book published in Scandinavia.

INK ON PAPER | 15.8 X 12.8.5 CM. | 1988

Thomas Aloysius "Tad" Dorgan

1877 | 1929

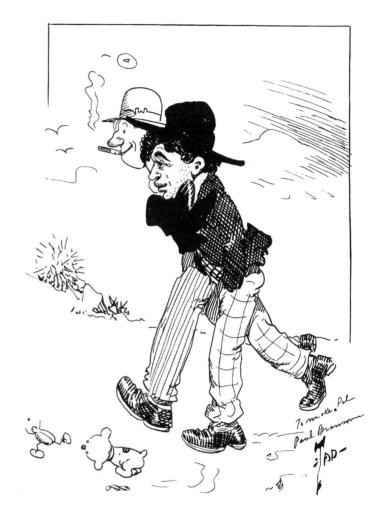

"Feet" were "dogs" to Tad. A game of dice he called "alley tennis;" a drunk was a barfly; eggs were cackle berries; eye glasses were cheaters. A restaurant was a beanery or a one-arm joint; and by the same token, waitressing was "dealing off the arm." A raconteur and picturesque talker of heroic reputation, Tad is credited with inventing these and dozens of other slang expressions during the first three decades of the century, but much of the attribution is apocryphal. Still, if he didn't conjure up "drugstore cowboy" to describe a "loafer," he gave the expression currency by using it often in his cartoons. Dorgan started out around the turn of the century in San Francisco on the sports pages of William Randolph Hearst's *Examiner*. He knew more about boxing than any noncombatant, and his fidelity to truth in reporting the sport was legendary. His drawing was not particularly distinguished (he called himself "a hick artist"), but his being able to draw at all was remarkable. As a boy, he'd lost the four fingers of his right hand because he'd put it into the working parts of a block-and-tackle just before a safe was hoisted out of a fourth floor window; nothing daunted, he learned to draw with his left hand. In 1905, Hearst summoned him to New York to work on the *Journal*. To get Tad to make the trip, he had to send for Tad's friend John Igoe, too. (Dubbed "Hype" by Tad — for reasons lost to antiquity — Igoe may be the personage on the far side of Tad in this picture.) Under the headings *Indoor Sports* and *Outdoor Sports*, Tad's raffish cartoons featured sporting types of every stripe from poker players to racetrack touts as well as actual athletes. Taking a gleeful delight in unmasking pretentiousness and stupidity, he eventually focused on human foibles rather than sporting life. Afflicted with heart trouble in his last years, he seldom left his home, listening to the radio as he drew his cartoons and muttering about the "phoney announcers faking their stories of the prize fights."

INK ON PAPER | 14 X 18.6 CM. | CA. 1920s

ROY CRANE
1901 | 1977

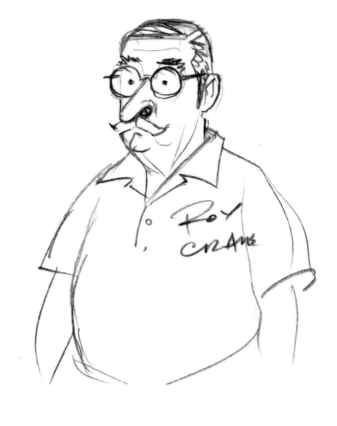

Crane did more to establish the adventure strip genre than any other candidate for the distinction, and he owed his initial success to the Landon mail-order cartooning course that he took at the age of fourteen. After high school, Crane wandered around a good deal, attending several colleges and art schools, working on art departments at different newspapers, and even going to sea on a freighter. He was working at the *New York World* when he tried to start a panel cartoon called *Music to the Ear*. It failed at one syndicate, so Crane took it to the Newspaper Enterprise Association, whose comics editor, Crane discovered, was none other than Charles N. Landon, his mail-order mentor. Landon still operated his correspondence course on the side, and when he realized Crane was a graduate, he exclaimed, "Crane, I like your stuff!" and accepted a comic strip about an ebullient pint-sized grocery clerk that Crane had showed him. *Washington Tubbs II* started April 21, 1924, and shortly thereafter, the Landon course publicity listed Crane as another graduate who had "made it to the Big Time" (presumably because of the course). Crane quickly wearied of the daily gag format he'd proposed, and by the end of the fifth month of syndication, his curly-haired hero was marooned on a South Sea island where he finds buried treasure. Beginning as a series of larks, Wash's subsequent adventures became more lifethreatening (albeit still full of rollicking last-minute dashes, fun-loving free-for-all fisticuffs, galloping horse chases, pretty girls, and sound effects — Bam, Pow, Boom, Sok, Lickety-whop). In 1929, Crane introduced his most celebrated creation, a hard-bitten hook-nosed soldier of fortune called Captain Easy, and by the early 1930s, his strip was the model for the generation of cartoonists who produced that decade's flood of adventure strips. Famed for his deployment of a chemical shading technique that gave his otherwise bigfoot cartoony style an almost photographic patina and therefore his stories a convincing aura of realism, Crane quit *Wash* in 1943 to produce another adventure strip, *Buz Sawyer*, which he would own, but by this time, he was imitating one of those who had studied him so closely, Milton Caniff. In 1950, Crane won the Reuben.

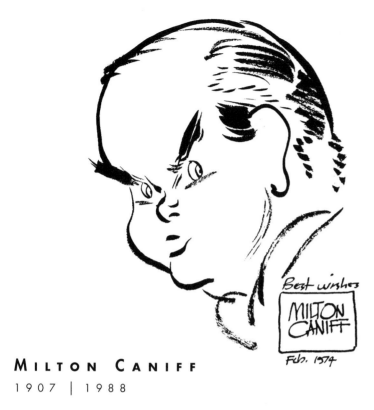

Best wishes
MILTON CANIFF
Feb. 1974

MILTON CANIFF
1907 | 1988

Talented both as a graphic artist and as an actor, Caniff chose cartooning and virtually redefined the adventure strip so thoroughly did he improve upon the genre's basic ingredients. His first syndicated strip was *Dickie Dare* (July 31, 1933) about a boy who dreamed himself into adventures. Then October 22, 1934, he began his most remembered work, *Terry and the Pirates,* about a youth and his mentor, Pat Ryan, wandering around China. *Terry* was among the first comic strips to take its characters into World War II, and to boost morale in the armed services, Caniff created another strip, the slightly risqué *Male Call,* for exclusive publication in base newspapers. After the War, he gave up *Terry* and on January 13, 1947, started *Steve Canyon* in order to own and control his creation. Inspired in 1934-1935 by the work of his studio-mate, Noel Sickles, Caniff developed in *Terry* the most imitated of his refinements, an impressionistic style of drawing that suggested reality with shadow rather than with linear particulars. And he added realism of detail, striving for absolute authenticity in depicting every aspect of the strip's locale, whether Oriental or, later, military. But Caniff's signal achievement was to enrich the simple adventure story formula by making character development integral to the action of his stories: readers wanted to know not just what would happen but how the characters would fare. To weave into his stories such an intriguing character as an alluring but ruthless pirate queen called the Dragon Lady (doubtless the most famous of Caniff's creations and one Roy Crane aped in *Buz Sawyer* with a femme fatale called the Cobra) was to add to the strip's exotic locale a powerful enhancement: her characterization complemented the mysteriousness of the Orient with the inscrutability of her personality, which nonetheless seemed so true-to-life that it lent the authority of its authenticity to the strip's stories, making the most improbable adventures seem real. Within a few years of its debut, *Terry* was setting the pace for cartoonists who did adventure strips. Caniff's career and life enacted the American dream — establishing its efficacy in his mind and creating thereby his hubris. Caniff proved that hard work and talent can yield success, and during World War II, the trenchant patriotism he infused into *Terry* inspired both soldiers at the front and their families at home and brought Caniff unprecedented fame. But when he sought to invoke the same spirit during the Vietnam War in *Steve Canyon,* he inspired only virulent protest, and newspapers canceled the strip by the score. Enjoying the highest regard of his peers, he won the first Cartoonist of the Year trophy awarded by the NCS in 1946 and received the Reuben again in 1971.

INK ON PAPER (DETAIL) | 11.8 X 13.4 CM. | 1974

ELMER WOGGON

1898 | 1978

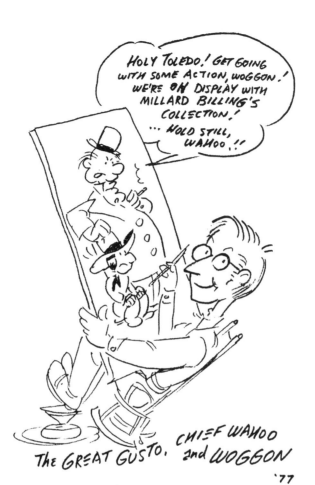

THE GREAT GUSTO, CHIEF WAHOO and WOGGON '77

A native of Toledo, Ohio, Woggon set records. His first comic strip, *Skylark* in 1929, is reputedly the first aviation strip. It soon disappeared, but with his second venture in 1936, Woggon launched a strip that went through more permutations than any other in newspaper syndication. Called *The Great Gusto,* the strip starred a con man named J. Mortimer Gusto, an itinerant snake oil salesman modeled after W. C. Fields, who was assisted in his medicine show by a English-mangling Indian companion and drum-beater dubbed Chief Wahoo. When the pint-sized Indian in his huge ten-gallon cowboy hat proved more appealing than the wind-bag Gusto, the strip was rechristened *Big Chief Wahoo.* Although initially a comedy continuity, the strip acquired a more serious, adventuresome tilt towards the end of the decade; Woggon's writer and co-creator of the strip, fellow Toledan Allen Saunders, a writer of detective stories for pulp magazines, wanted to join the adventure strip trend taking over the funnies pages. (In 1939, he would take over the scripting chores at *Apple Mary,* converting that strip to the medium's most influential soap opera strip, *Mary Worth.*) As the stories got serious, Woggon's bigfoot cartoon style of rendering was hopelessly out of place, and he surrendered the drawing to his brother, Bill, who was followed by Don Dean and a succession of ghosts. By this time, Gusto was long gone, Wahoo's life had been invaded by a stalwart fellow of heroic mein named Steve Roper, and the strip was now called *Chief Wahoo.* Wahoo played sidekick to Roper, and by 1946, the strip had been re-named accordingly, *Steve Roper and Wahoo.* Wahoo disappeared from the title (and the strip) by 1948, and when Roper acquired another side-kick, a hardcase named Mike Nomad, the name of the strip changed again in 1984 to include the names of the new duo.

GEORGE HERRIMAN

1880 | 1944

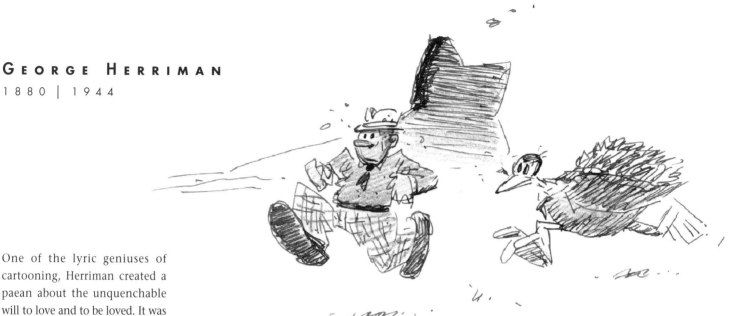

One of the lyric geniuses of cartooning, Herriman created a paean about the unquenchable will to love and to be loved. It was Gilbert Seldes, an art critic, who, writing in *The Seven Lively Arts* (1924), called Herriman's *Krazy Kat* "the most amusing and fantastic and satisfying work of art produced in America today." With that kind of accolade being cited these days at every reference to the allegedly lunatic cat of Herriman's masterwork, we might expect to find that Herriman was a household name, but his genius was not widely recognized in his lifetime, and his immortal kat and mouse strip ran in very few papers, kept in circulation solely because William Randolph Hearst, the boss, loved the strip. Like most of his car-

tooning contemporaries, Herriman produced an array of comic features, both before and during *Krazy's* run, among them — *Major Ozone, Baron Mooch, Gooseberry Sprig, Baron Bean,* and *Stumble Inn.* The kat first appeared in a 1910 strip called *The Family Upstairs*: Krazy was the household pet of the Dingbats, the family that suffered the behavior of their upstairs neighbors, and Herriman filled vacant space at the bottom of the panels with depictions of the antics of a mouse and a cat (not yet kat). On July 26, the mouse (Ignatz) hurls what might be a piece

of brick at the feline, and the saga was underway. Krazy took the brick as a symbol of Ignatz's affection and, blind with love, pined for its every reappearance. To turn this duet into a plot, Herriman introduced a regulator of law and order, Offissa Pup, who loves Krazy and sets out to prevent Ignatz from "kreasing the kat's bean." The canine constable occasionally succeeds, but then Krazy is disappointed; when the dog fails, Krazy is ecstatic. None of the members of this eternal triangle ever gives up. The title *Krazy Kat* first appeared over the strip on

October 28, 1913, and remained there until Herriman's death brought an end to the poem. Herriman is revered also for his imaginative Sunday page layouts and the shifting, dreamlike topography of his landscapes. Inspired by the Arizona-Utah desert in Monument Valley, the scenery of the strip acted as a thematic elaboration on the fanciful drama being enacted. Herriman drew himself in this holiday missive addressed to the third wife of Jimmy Swinnerton (q.v.), the man who had introduced him to the beauties of the desert.

BILL HOLMAN

1903 | 1987

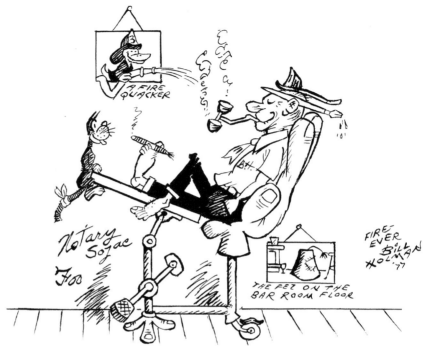

THIS IS A HAND CROCHED SELF PORKTRAIT OF Wm EXLAX HOLMAN BETTER KNOWN AS BUNG HOLMAN OR SKAT OR PREPERATION H. IN HIS STUDIO AT SCRIBBLE CREEP INDIANA WHERE BUNG PEDDLES HIS SMOKEY STOVER ART— THAT'S STOVERS CAT SPOOKY YOU SEE HANGING AROUND — MR H. OFTEN SIGNS HIS CARTOONS ALK.TRAZ WHICH IS HIS PEN NAME.

As anyone looking at this self-portrait can tell, Holman delighted in wacky word play. And the zany puns suggest the kind of the antic slapstick humor that infested his comic strip, *Smokey Stover.* Holman went through the old style apprenticeship, starting as a copy boy for the *Chicago Tribune,* but his first syndicated work was for Newspaper Enterprise Association (NEA) out of Cleveland — *Billville Birds,* a daily strip (c. 1922). He went to New York in 1923 and did *G. Whizz Jr.* for the *Herald-Tribune* (c. 1924-1928) and freelanced gag cartoons to every magazine on the market in this country and England. When he heard that Joseph Patterson was looking for a Sunday comic strip

about fireman, he submitted *Smokey Stover,* which debuted March 10, 1935. Later, he did a short-lived daily version of the strip and then a panel, *Nuts and Jolts* (c. 1939), which, with the Sunday *Smokey,* he continued until he retired in 1973. Spooky, the cat with the perpetually bandaged appendage, appeared in a bottom-of-the-page tier for a time; the cat had been a feature of Holman's

work even in his magazine cartoons and could be found peeping out from behind chairs or in passenger seats of cars. Among the goofy verbiage sprinkled so liberally in his cartoons, several words became catch phrases for Holman's work: "Foo," which Holman once explained meant "good luck" in Chinese (he attached it to an improbable two-wheeled car that became known thereafter as the

Foomobile in the strip); "Notary Sojack," his phonetic spelling of the Gaelic "Nodlaig Soghach," meaning "Merry Christmas;" and "Nix Nix 1506," by which encryption he was warning young ladies to beware the invitations of a bachelor cartoonist friend, Al Posen, who lived in Room 1506 of a hotel.

INK ON PAPER | 17.5 X 15.8 CM. | 1977

November 18 is very possibly the date of Sadie Hawkins Day, an annual footrace in which the unmarried maidens of the hillbilly town of Dogpatch pursue unattached males pell-mell across the landscape like so many hounds baying after a hare, marrying those whom they catch. This wholly bogus national holiday (the date of which changes in every source) is the invention of one of cartooning's most protean talents, who is seated here on the knee of the title character of his strip *Li'l Abner* (1934-1977), which is populated by a cast of thousands, mostly Dickensian eccentrics like Senator Jack S. Phogbound; the voluptuous Moonbeam McSwine, who liked pigs better than people; Joe Btfsplk, a jinx whose influence was symbolized by a small raincloud that hovered always over his head; Evil-eye Fleegle, whose glance could fell an ox; Lena the Hyena, a woman so ugly that Capp wouldn't

draw her; Appassionata van Climax, a sex symbol; Fearless Fosdick, a razor-jawed parody of another comic strip character, Dick Tracy, who threatened to take over the strip; and the Shmoos, cuddly, pliant pear-shaped creatures who cheerfully die in order to supply

everyone's needs. All this provided the societal stew bubbling up adventures for Abner, a red-blooded nineteen-year-old with the physique of a body-builder but the mind of an infant, his diminutive Mammy, the pipe-smoking matri-

AL CAPP
1909 | 1979

arch of the Yokum family, his simpleton Pappy, and Daisy Mae Scragg, a skimpily clad blonde mountain houri of impossible beauty who desperately wants to "marry up wif" Li'l Abner, who shuns this opportunity as somehow unmanly. Capp's Candide, Abner is fated to wander off into the outside world, where he encounters civilization — politicians and plutocrats, mountebanks, bunglers, and love-starved maidens. By this device, Reuben-winner (1947) Capp contrasts Abner's country simplicity against society's sophistication — or, more precisely, his innocence against its decadence, purity against corruption — the contrast creating both the uproarious comedy and the biting satire of the strip.

Chic Young
1901 | 1973

With a pronounced knack for drawing pretty girls, Young created *Blondie* in 1930 (September 8) as the fourth in a succession of flapper strips he'd launched (*The Affairs of Jane* in 1922, *Beautiful Bab* later the same year, and *Dumb Dora* in 1924), but it wasn't until he put an apron on his heroine that the strip began to climb to its eventual pinnacle as one of the top four or five most widely circulated strips in the world (a position it enjoyed for at least the rest of the century). At first, Blondie was just another dizzy sheba with a flock of beaux left over from the recently departed Jazz Age, but when circulation began to slip, Young and syndicate officials decided to let her

marry one of her admirers, the scion of a wealthy railroad mogul, who disapproves of Blondie. Before the wedding on February 17, 1933, Dagwood Bumstead goes on a twenty-eight-day hunger strike to secure his parents' consent to marry. The ploy worked: the strike revived readership and stimulated sales of the strip — and Dagwood's parents grant him permission to marry Blondie but disinherit him.

Dagwood and Blondie were now an ordinary, middle-class married couple, and the husband went off to work like husbands all across the land. Their concerns were the concerns of millions of readers, and Reuben-winner (1949) Young built his daily gags around four of those preoccupations — eating, sleeping, raising a family, and making money — every week offering at least one

strip on each topic. In 1934, the Bumsteads had a baby; christened Alex (after *Flash Gordon* cartoonist Alex Raymond, who had once assisted on *Blondie*), the boy was called Baby Dumpling, and his arrival sparked another leap in circulation. When Young died, his son Dean (born 1938) assumed the writing of the strip, with artwork by long-time assistant Jim Raymond (brother of Alex). The child depicted in the Christmas card caricature of Chic and his wife Athel above is Dean's older brother Wayne, who tragically died of jaundice in 1937, in the midst of Baby Dumpling's popularity; a sorrowing Chic and his wife took a year's sabbatical in Europe to recover while Jim Raymond continued the strip.

RUBE GOLDBERG
1883 | 1970

Goldberg started in the sewer and wound up in the dictionary, creating en route one of the longest and most productive cartooning careers in American history. With a degree in engineering from the California School of Mining, he spent a few months in 1904 helping design the sewer system in San Francisco but soon gave it up to pursue his first love, cartooning. During the next few years, he did sports cartoons for San Francisco newspapers, replacing Tad Dorgan (q.v.) at the *Bulletin* when Tad went to New York in 1905. Encouraged by his sale of a Sunday color feature, *The Look-Alike-Boys,* to the World Color Printing Company in 1907, Goldberg went to the Big Apple, finding a position at the *New York Evening Mail.* Like most

newspaper staff cartoonists of the time, he produced a variety of individual features, most employing a catch phrase as punchline and title. If such a feature caught on with readers, it lasted until the cartoonist ran out of ideas; if it didn't catch on, it sunk from view in a day or so. Among those of Goldberg's that lasted were *Foolish Questions; I'm the Guy;* and *Mike and Ike, They Look Alike.* Later he created *Phoney Films, Boobs Abroad, Life's Little Jokes, Bobo Baxter* (a humorous continuity strip, 1927-

1928); and in the thirties, *Doc Wright* (a sentimental continuity strip, 1934-1936) and *Lala Palooza* (a humor strip, 1936-1939) — to name a few. For all this variety, Goldberg is most remembered for two features: *Boob McNutt,* a comic strip about the perennial fall guy (1915-1934), and a panel cartoon that he produced weekly (1909-1935), depicting the outlandish inventions of Professor Lucifer G. Butts. With the latter, Goldberg indulged his suspicion that maybe modern technology wasn't all it

purported to be, earning his place in the dictionary as the creator "of extremely intricate diagrams of contraptions designed to effect relatively simple results" (*American Heritage Dictionary*). In the 1940s, he was editorial cartoonist for the *New York Sun,* winning a Pulitzer in 1948. He was largely the reason the National Cartoonists Society started in 1946 (he agreed to convene the group even though he disliked formal organizations), and in 1967, he received the Reuben, the NCS trophy for Best Cartoonist of the Year (which was named for him and designed from one of his sculptures).

INK ON PAPER | 31.2 X 23.1 CM. | CA. 1958

WALTER BERNDT
1899 | 1986

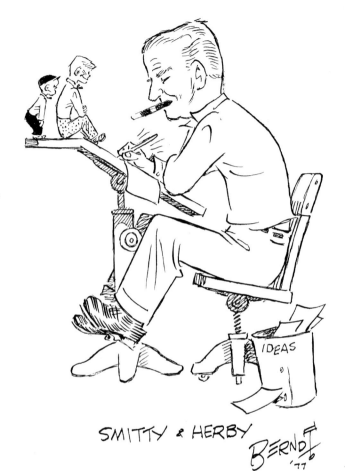

SMITTY & HERBY

Berndt's long-running strip *Smitty* (1922-1973) was one of the famed line-up that publisher Joseph Patterson mustered to appeal to the big city readers of his *New York Daily News,* the nation's first successful tabloid newspaper. Like many of those readers, Berndt's title character worked in an office; an errand boy and sweeper of floors, Smitty re-enacted the cartoonist's own first working experience — as a sixteen-year-old office boy at the *New York Journal,* where he swept up after such cartooning luminaries as Harry Hershfield, Milt Gross (q.v.), Winsor McCay, and Thomas A. "Tad" Dorgan (q.v.). Aspiring to join their ranks, young Wally was soon assisting some of them,

lettering their work, erasing pencil lines, and so forth. Tad, impressed by the youth's energy and eagerness, took him under his wing. Berndt would later say that everything he learned about cartooning, he learned from Tad (and in homage to his mentor, he imitated in the last letter of his signature the way Tad signed the first letter of

his). After leaving the *Journal,* Berndt produced a couple of short-lived strips, including *Bill the Office Boy,* which he drew for the *New York World.* Fired after only two weeks ("because," he said, "of the way I addressed my boss"), Berndt took *Bill* to Patterson, who liked the idea but wanted a different name. Berndt stabbed his finger

blindly in a open phone book, and when he opened his eyes, found himself pointing to a page of Smiths. Smitty's lisping little brother Herbie (perched here next to his seated sibling) starred in the strip's Sunday topper and often occupied the spotlight in *Smitty.* Patterson came to rely upon Berndt's judgement in matters cartooning, and Berndt was consequently responsible for the contracting of Bill Holman, Zack Mosley, Gus Edson, and Al Posen as *Daily News* cartoonists. Although Reuben-winner (1969) Berndt, like many syndicated cartoonists, employed an assistant for much of the strip's run, he did it single-handedly for the last twenty years, after his assistant became eligible for Social Security and retired in 1952.

INK ON PAPER | 12.5 X 18.4 CM. | 1977

22

The hungry diner who only wanted something to eat.

My best wishes to Patsy from Clifford McBride Oct. 10, 1933

Personal Sketches

CLIFFORD McBRIDE
1901 | 1951

McBride drew his dog strip, *Napoleon,* with an exuberant pen, producing such a ferociously kinetic line that even when depicted in repose, his subjects seemed vitally energetic. And the style suited the subject (in fact, given the low-key humor of the strip, the style may have been the subject). The strip focused on a portly bachelor and his giant pet — Uncle Elby and Napoleon — achieving, as art critic Dennis Wepman once wrote, a "beautifully balanced team — the fat man, all stasis and order, and the lean dog, all motion and chaos." It is Elby's fate (and the flywheel of the strip's daily punchline) to be forever

dogged (pun intended) by misfortune of a minor dimension: if his own bumbling doesn't frustrate his plans that day, then the clumsy albeit goodhearted meddling of his affectionate, over-sized hound does. Elby was patterned visually after McBride's uncle, Henry Elba Eastman, a Wisconsin lumberman; and after awhile, as the self-portrait above suggests,

McBride himself resembled his creation. Napoleon was inspired by the cartoonist's St. Bernard, but in rendering the creature, McBride slimmed him down until he looked more like an Irish wolfhound. McBride had been producing pantomime Sunday strips for McNaught Syndicate for several years before settling on a fat man

and his dog as popular enough to sustain a strip themselves. Launched June 6, 1932, *Napoleon* appeared before cartoonists had made an accepted convention of talking animals in strips that also featured humans, but Napoleon needed no words: McBride made the dog's face talk, giving it a range of expression that spoke volumes.

INK ON PAPER | 25.5 X 16.3 CM. | 1933

JAMES SWINNERTON

1 8 7 5 | 1 9 7 4

Usually dubbed one of the three founding fathers of the American comic strip form, Swinnerton had one of the longest careers in cartooning even after his doctor told him he had only months to live. It was Coulton Waugh, the venerable comics historian, who, in his 1947 book, *The Comics*, asserted that a comic strip consisted of three elements: (1) picture narrative in which (2) words were included in the pictures, usually in speech balloons, and (3) the same cast of characters re-appeared in subsequent installments of the feature. Rudolph Dirks (q.v. John) was first to use speech balloons regularly. Swinnerton and Richard F. Outcault share the honors for introducing continuing characters: Outcault with the Yellow Kid (beginning February 17, 1895) and Swinnerton with "little bears" in late 1893. At the time, Swinnerton was a staff artist on William Randolph Hearst's *San Francisco Examiner*, and a little bear, kindred of the state's grizzly mascot, was invented to promote interest in the Midwinter Exposition that opened in January 1894. Swinnerton's little bears were scattered throughout the paper, and after the Exposition closed, they continued to appear as the weather ears on the paper's front page. Subsequently, the bears showed up on other pages, often accompanied by small urchins that Swinnerton called "tykes," and people on the staff referred to these embellishments as Swinnerton's "little bears and tykes." The cartoonist journeyed to Hearst's *New York Journal* at the turn of the century, and on February 14, 1904, he began the strip most often associated with him: *Little Jimmy* ran, with some interruptions and a hiatus or two, until 1958, featuring the misfortunes that befall others because of a diminutive, well-meaning kid who can't seem to get anything right. In 1906, Swinnerton, diagnosed with tuberculosis and given only a few months to live, went to a dry climate to drink. But he didn't die; instead, he fell in love with the desert of Arizona and began a painting career, which he pursued avidly while still producing cartoons for Hearst, including *Canyon Kiddies*, a color feature about Navajo children for *Good Housekeeping* (1922-1926, 1933-1941).

M I L T G R O S S
1 8 9 5 | 1 9 5 3

With his characters' customary goggle-eyed bulb-nosed physiognomy, sausage-fingered hands and flat feet, Gross may be said in his drawing style to epitomize "cartooning." Like many of his peers, he began as an office boy at a newspaper, the *New York American,* where he soaked up techniques from such notables as Harry Hershfield, Cliff Sterrett, Winsor McCay, and Thomas A. ("Tad") Dorgan (q.v.). Most of Gross's earliest strips (like most enterprises of

that time) were short-lived, lasting only a few installments before yielding their place to his next comedic catch-phrase concoction. Starting in 1915, some of these included *Henry Peck — A Married Man, Phool Phan Phables, Izzy Human, Kinney B. Alive,* and *Then the Fun Began.* Gross worked briefly in animation (c. 1917-1921), his tenure interrupted by service during World War I. By 1922, he was at the *New York World,* where he produced his most celebrated works. *Gross Exaggerations,* a column that

he wrote and illustrated, gave rise to several books written in comic Yiddish dialect (*Nize Baby, Hiawatta Witt No Odder Poems, Dunt Esk,* and *De Night In De Front From Chreesmas*), the first of which inspired a strip (1926-1929). In 1929, Gross began producing the Sunday page, *Count Screwloose from Toulouse,* a morality play in which the dapper pint-sized Count escapes from a mental institution every week, only to return to the relative sanity within its walls after witnessing the inexplicable antics of

the world outside. Gross's masterpiece, *He Done Her Wrong,* a pictorial novel without words ("No Music, Too"), appeared in 1930, mocking the conventions of Hollywood adventure films and stage melodramas. When the *World* merged with the *New York Telegram* in 1931, Gross started a new strip, *Dave's Delicatessen,* which often ended with an extraneous panel in which a small boy observes his father at some nefarious activity and proclaims joyfully, "That's my Pop!" — a phrase that subsequently inspired a radio program.

W. A. CARLSON
1894 | 1969

SOL HESS
1872 | 1941

The Nebbs, a strip about a married couple that Carlson drew and Hess wrote, was created, according to report, because Hess was piqued at how cheap Sidney Smith was. Hess had started out as a traveling jewelry salesman, and he had the raconteur wit of the breed. When he later settled in a store in Chicago, he took to frequenting a nearby libation establishment called Stillson's, where he rubbed shoulders with other habitues, mostly newspapermen. Among their number was Smith, who in 1917 had launched a new comic strip for the *Chicago Tribune* called *The Gumps.* Hess's hilarious accounts of his home life found their way into Smith's work, and before long, Hess was supplying much of the strip's material. *The Gumps* became an enormously popular feature, and in recognition

of the strip's great appeal, Smith was signed to a million dollar contract in 1922 — $100,000 a year for the next ten years. And then Smith made his mistake: he offered Hess $200 a week to continue ghost-writing the strip, and Hess, who had been scripting the strip for the fun of it without any remuneration whatsoever, felt insulted (and intrigued, no doubt, by the sudden realization that big money could be made in comics). Hess

broke with Smith and looked up Carlson with whom he had worked on a short-running series of Gumps animated cartoons. Together, they concocted *The Nebbs* (the name is derived from a Yiddish term for a sap or loser, *nebich* or *nebbish),* which, like *The Gumps,* revolved around the get-rich-quick schemes of the *pater familas,* Rudy, and whatever other domestic crises he encountered with his wife Fanny.

Starting in 1923, the strip outlived Hess but not Carlson. When *The Nebbs* ceased in 1947 (having been absorbed into another strip called *The Toodles,* which was created by Hess's daughter and her husband, who had been writing *The Nebbs* after Hess died), Carlson produced a panel cartoon in his nicely rounded style; called *Mostly Malarky,* it lasted until about 1966.

ALEX GRAHAM
1917 | 1991

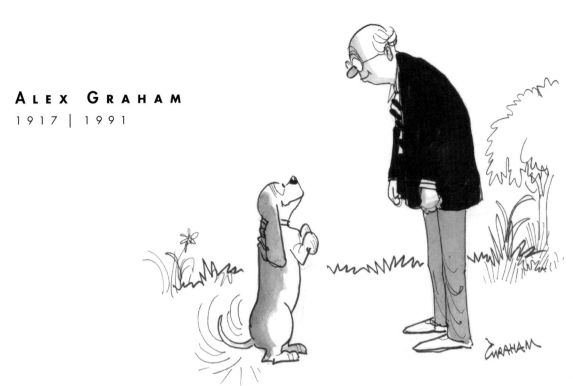

Born in Glasgow, Scotland, Graham began selling cartoons to magazines in England during World War II while on duty with the Argyll & Sutherland Highlanders. He created a comic strip, *Wee Hughie,* in 1945 for the *Dundee Weekly News* and continued the feature until about 1970. British comic strips are not syndicated in that country but are produced exclusively for individual periodicals, and Graham originated two other strips, *Our Bill,* for *Tidbits* in 1946, and *Briggs the Butler,* a feature that ran in the monthly

Tatler & Bystander magazine, 1946-1963. He also contributed cartoons to many magazines, including *Punch* and *The New Yorker,* for which he did a cartoon that may have launched the expression "Take me to your leader": it showed a space ship which has just landed on earth and a couple Martians, one of whom is addressing a horse. On July 9, 1963, Graham began the comic strip with which he is most closely associated — *Fred Basset,* "the hound that's almost human."

Created for the *London Daily Mail,* the strip was later syndicated worldwide. Its gimmick was that the protagonist *thinks* like a person, balloons of verbiage hovering over Fred's head; but, unlike Snoopy in *Peanuts* (which Graham had never seen until *Peanuts* showed up in the *Mail* sometime after *Fred* started), Fred always behaves like a dog. Said Graham: "I think the unusual thing is that he's the character in the strip who is commenting on the behavior of other characters [the humans

mostly] in the strip." Although he might be assumed to know a great deal about bassets, Graham denied it. Bassets are very strong-willed, he maintained, and recalled a story about a dog trainer who advised a basset-owner how to train his dog: "The only way you get a basset hound to be obedient is that you work out what the basset hound is going to do and then you tell it to do it." Graham contributed to *Punch* throughout *Fred's* run; the strip continued for awhile after the cartoonist's death because, "being a canny Scotsman," as Graham once said, "I'm a year ahead on producing strips."

INK AND WASH ON PAPER | 16.5 X 13.8 CM. | 1986

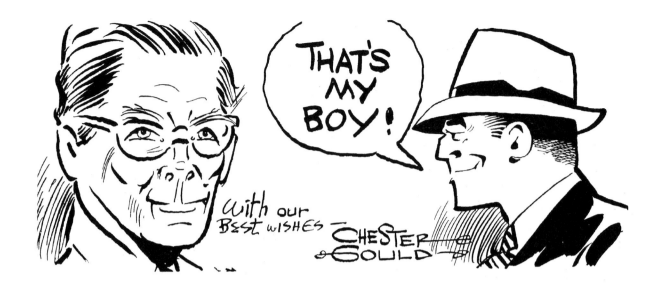

CHESTER GOULD

1900 | 1985

Until the debut of *Dick Tracy* on October 4, 1931, the continuity (or story-telling) strip had focused on one of two extremes, exotic adventure or domestic intrigue. *Tracy* brought the excitement of adventure to readers' front doors when Gould's plainclothes cop started fighting contemporary crime in everyone's home town. Gould came to Chicago in 1921 to attend Northwestern University, and he also began inventing comic strips. He kept it up for the next ten years, submitting nearly sixty ideas, he later said, and selling one every now and then, but nothing ran for long. Finally, simmering with anger at the lawlessness of the Prohibition era, Gould bethought himself of the kind of hero who would rescue America — "a symbol," as Gould said, "of law and order who could dish it out to the underworld exactly as they dished it out, only better." Gould appropriated the hardboiled detective persona from the day's pulp fiction and, in visualizing him, gave him the chiseled profile he associated with Sherlock Holmes. It was the beginning of raw violence on the comics page. No comic strip had previously shown gunplay and bloodshed; within a couple years, a half-dozen imitators were trading hot lead in the funnies. But Tracy was more than a shoot-'em artist. Gould began working closely with Chicago police, incorporating authentic procedural techniques into his strip. But in creating villains for his hero, he departed dramatically from reality to create a gallery of ghoulish crooks, caricatures of evil that underscored the moral of his strip: crime doesn't pay, and a life of crime will put you in daily communion with such creatures as these — Pruneface, Flattop, the Mole, Shoulders, B.B. Eyes, the Brow, Shakey, Mumbles. Gould's creation would come to share a place in the history of detective fiction hitherto occupied in solitude by Conan Doyle's Sherlock Holmes. Gould was twice recognized with a Reuben in 1959 and 1977.

DICK LOCHER
BORN 1929

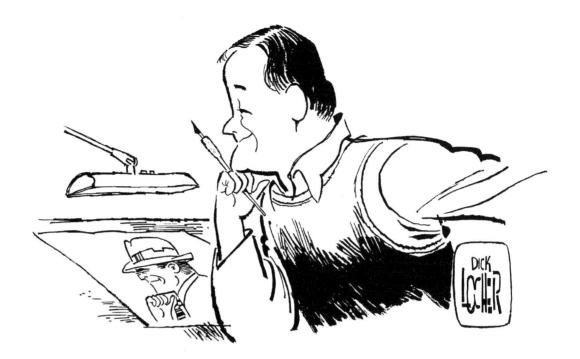

Times change, and Dick Tracy can no longer shoot it out with the bad guys on the funnies page. "We can't show somebody being shot, directly," Locher said. "On the front pages of our newspapers, we can show robbery, rapes, arson — but only on the front pages, not in the comic strips. And that's a handicap to work under in a detective strip. Even in Sherlock Holmes on television, they can show somebody being killed. But we can't do that. Action like that happens off-screen. Sam Catchem can say to Tracy, 'Oh — nice shot, Tracy,'" he finished with a laugh. Locher's life with Gould's jut-jawed cop began in 1957, when he worked as Chester Gould's assistant for four-and-a-half years. He was running his own sales-promotion agency in 1972 when Gould told him that the *Chicago Tribune* needed an editorial cartoonist to take over for the retiring Joseph Parrish. Locher submitted samples and was selected. Gould retired in 1977, leaving *Dick Tracy* to his assistant Rick Fletcher and writer Max Allan Collins; when Fletcher died in 1983, Locher was tapped in March to continue drawing the strip. It was a busy year: a month before, he'd launched a hip strip called *Clout St.* with editorial cartoonist Jeff MacNelly (q.v.); and in April, he received the Pulitzer Prize for editorial cartooning. In 1993, Locher acquired a new writer on the strip, author Mike Kilian. Locher feels the weight of the responsibility in his stewardship of this American icon: "Say Dick Tracy to anybody in the United States," he said, "and they know what you're talking about. They may not have read the strip, but they know who Dick Tracy is. It's as if someone took Grant Woods' *American Gothic* and made a comic strip out of it. You've got to protect it."

JOHN LINEY
1912 | 1979

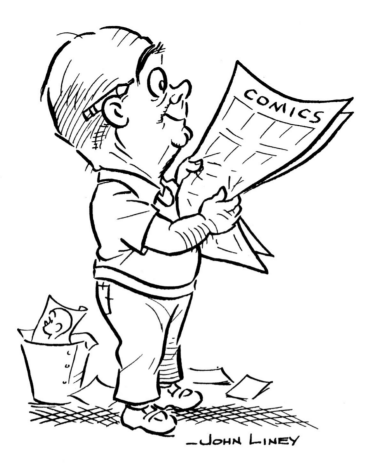

—John Liney

Looking over a stack of mail he'd received from handicapped children, Liney remarked that it was very rewarding and made him happy that he chose "the toy department of journalism, the field of pantomime comic art." He'd been at it most of his adult life. Liney started writing gags for Carl Anderson's *Henry* comic strip in 1936, shortly after the character began appearing in newspapers. (Henry — whose muteness was emphasized visually by the absence of a mouth in renderings of his visage — had debuted as a panel cartoon character in the *Saturday Evening Post* on March 19, 1932, and when William Randolph Hearst saw the feature, he invited Anderson to bring Henry into syndication, which he did, starting December 17, 1934.) Anderson was assisted by Don Trachte virtually from the beginning of syndication, but when Japan bombed Pearl Harbor, Trachte promptly enlisted, and Anderson, then in his 70s and ill, asked Liney to help him produce the strip. (Anderson would die in 1947 after a long illness.) Liney did both dailies and the Sunday page until after the War, when Trachte returned to resume doing the Sundays. In addition to doing the daily strips, which he did until his death, Liney also did the comic book version of Henry, 1946-1961. "They sold over fourteen million copies in fifteen years," Liney reported; but he was proudest of his involvement with the education of the deaf and others with learning disabilities. Approached by an instructor in a school for deaf youngsters, Liney provided instructional materials adapted from the strip. The grateful instructor wrote back: "Through the [pantomime] language of Henry, the deaf child can relate Henry's thoughts to his own and, in the process, learn to use that language to express his own original ideas."

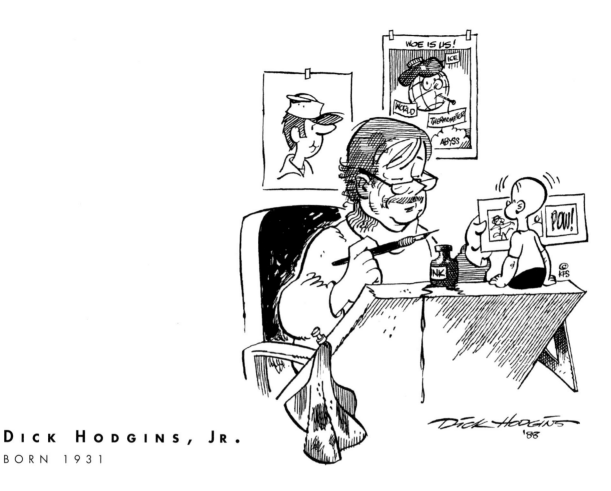

DICK HODGINS, JR.

BORN 1931

Wielding one of the crispest pen techniques in the business, Hodgins is a second-generation cartoonist, following in the footsteps of his father (Dick Hodgins, Sr., editorial cartoonist for the *Orlando Sentinel*). Hodgins' career has been as varied as the drawing styles he's emu-lated in producing a great variety of cartoon features, some of whose characters can be seen near him at the drawing board. After a stint in the art department of the Associate Press, Hodgins did *Half Hitch* (1969-1974) for Hank Ketcham (q.v.) in the patented Ketcham manner while at the same time producing editorial cartoons for the *New York Daily News* in his own style for twelve years. When Dik Browne (q.v.) started *Hagar the Horrible* in 1973, Hodgins assisted. He then took over the *Henry* dailies (1983-1995), and when his turn was up there, he assumed the inking chores for *Hagar*. During all this time, he also freelanced pro-lifically in advertising. A stalwart worker for NCS, he won the Silver T-Square in 1979 for outstanding service to the Society and the profession.

BILLY DeBECK
1890 | 1942

DeBeck's cartooning genius was such that he seemed capable of renewing his creation again and again, each time with a more inventively hilarious novelty than before. He had been cartooning around on midwestern papers for almost a decade before launching a strip with the unlikely title of *Take Barney Google, For Instance* in 1919. Like the panel cartoon he'd started in 1916, *Married Life,* the new strip was about a husband and wife and their domestic travail, but in 1922, that changed: Barney acquired a race horse named Spark Plug, and the sad-faced nag, most of whose anatomy was hidden underneath a moth-eaten shroud-like horse blanket, became the Snoopy of the roaring twenties.

Barney entered the horse in a race, and DeBeck quickly discovered the potency of a continuing story for captivating readers: for most of the decade, he kept his audience on tenterhooks by entering Spark Plug in a succession of suspenseful contests, the outcomes of which were never certain (some of them, surprisingly, Spark Plug won), drawing with a loose but confident line and intricately wispy shading.

The character was relentlessly merchandised, and Billy Rose even wrote a song about the horse and his master, "Barney Google with the Goo-goo Googly Eyes," which even the characters in the strip sang. The continuities were always comic as well as cliff-clinging, but by the early thirties, DeBeck was wearying of the horse flesh formula, and in 1934, he sent Barney off into

the hills of North Carolina, where he encountered a bristly pint-sized hillbilly named Snuffy Smith, who was instantly so popular with readers that DeBeck stayed in the hills for the rest of the thirties, and by the time World War II broke out, the strip was called *Barney Google and Snuffy Smith.* DeBeck was an early advocate of American military readiness: in 1940, Snuffy joined the Army where he popularized "yard birds" as a catch phrase for malingering enlisted personnel. A year later, Barney enlisted in the Navy and almost disappeared from the strip forever.

PENCIL AND GREASE PENCIL ON PAPER | 16.8 X 18.2 CM. | 1930s

FRED LASSWELL

BORN 1916

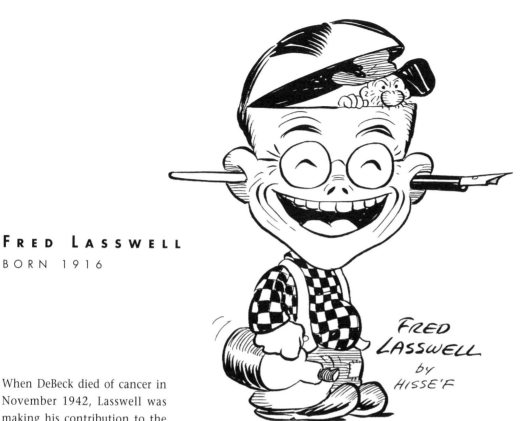

FRED
LASSWELL
by
HISSE'F

When DeBeck died of cancer in November 1942, Lasswell was making his contribution to the war effort in Africa, working as a radio operator for Pan American Airways. He had been DeBeck's assistant on the strip since 1934, shortly after Barney met Snuffy, so it was natural that the syndicate asked him to return to the U.S. to continue the feature. Lasswell promptly quit Pan Am, returned stateside, joined the Marines to work on *Leatherneck* magazine in Washington, D.C. (for which he

created a special strip, *Hashmark),* and began cranking out *Barney Google and Snuffy Smith* during evenings in his apartment. In New York in the syndicate bullpen, staff artist Joe Musial produced the Sunday strips and, sometimes, dailies until the end of the War, when Lasswell took over entirely. Acting upon the advice of syndicate officials, Lasswell gradually eased

Barney out of the strip to concentrate on the more picturesque Snuffy. Growing up in rural Florida, Lasswell felt at home with the hillbilly folk of Snuffy Smith's Hootin' Holler mountain country and was therefore able to make his own distinctive contribution to the saga of the strip, thereby making it entirely his own creation. He drew

in DeBeck's style but slowly adopted a bolder line, better suited to the minuscule reproduction comic strips faced after the War. He introduced a host of intriguing characters for his post-war stories (most memorably, Tiger Li'l, a sexy nightclub dancer; Tieless Ty Tyler, the necktie tycoon; and Riddles Barlow, who married the winsome Cricket Smif), but in the mid-fifties, he converted the strip to gag-a-day to keep step with the trend in the industry. Awarded the Reuben in 1963, Lasswell occasionally still slipped Barney and Spark Plug back into the strip for brief appearances — "for the old folks," he said.

INK ON PAPER | 12.1 X 13.7 CM. | CA. 1942

FRANK GODWIN

1889 | 1959

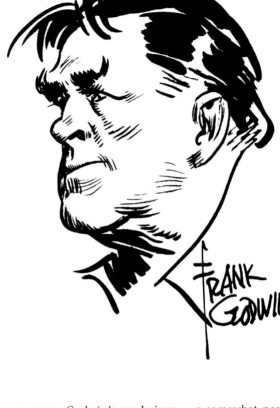

A superb illustrator in the romantic style of Charles Dana Gibson and James Montgomery Flagg (a close friend with whom he shared a studio for a time), Godwin was one of the few first-rank commercial artists to divide his time between newspaper comic strips and book and magazine illustration. While still a teenager, he went to New York and the Art Students League and met Flagg; they soon formed a friendship, and the youth began selling illustrations to magazines and art to advertising agencies shortly thereafter. In the early 1920s, Godwin became a staff artist with the *Philadelphia Public Ledger*, producing covers for Sunday magazine editions and illustrations for fiction as well as an extremely popular humorous domestic series called "Vignettes of Life." In 1927, he began producing a comic strip called *Connie,* one of the earliest continuity strips. (The Sunday page began November 13; the dailies, not until May 13, 1929). The heroine (whose last name was, appropriately, Kurridge) was plunged almost immediately into crime-fighting adventures, which continued until 1944, concluding with a long science fiction sequence. Godwin's renderings for the comic strip were much less embellished with pen technique than his advertising and illustration work. For his strip, he made loosely sketched drawings, deploying a languid vibrant line to depict svelte blonde Connie and her fashion-plate companions. On January 26, 1948, Godwin returned to the comics pages with *Rusty Riley,* a somewhat nostalgic adventure tale about a youth's life growing up in an America that had ceased to exist long ago. This effort was more tightly rendered and thoroughly embellished than Connie; wholly dependent upon Godwin's masterful work for its success, it did not survive the death of the artist.

SCOTT ADAMS
BORN 1957

This is me.

Scott Adams
7/17/91

Shortly after *Dilbert* began in 1989, Adams wrote an article in *Cartoonist PROfiles* which contained the following sentences: "My mother always told me I could do anything I wanted when I grew up. Cartooning would be great fun, I thought, but how many people actually make money at it?" So he decided to major in economics, "get a thankless job with some soulless corporation and live out my days in anonymity and quiet despair." The soulless corporation turned out to be Pacific Bell Telephone, but "cartoons kept oozing out of my fingers," Adams said. To amuse himself and his fellow workers,

he drew cartoons about a dumpy-looking character with glasses and a striped tie that stood out from his chest at right angles. This was Dilbert, a techno-nerd "shaped vaguely like a shaving brush" (as one wag put it) with a dog named Dogbert. By the summer of 1996, Dilbert was well on his way to being the most visible comic strip character in the country: his mouthless, expressionless face appeared on the covers of most popular magazines by the end of the year, and Adams had two best-selling books on the market (with extensive prose text, not just drawings) not to mention calendars and other consumables. Adams explained his popularity by saying

that he had been the third or fourth most favorite cartoonist — after Gary Larson *(Far Side),* Berke Breathed *(Bloom County, Outland),* and Bill Watterson *(Calvin and Hobbes);* and when all three of them stopped producing their strips within a year or so of one another, *Dilbert* rose to fill the vacuum. But there's more to it than that. Adams'

stark rendering of cubicle life in American offices is relentless in delivering a daily jibe at corporate America, its one-motive managers and its profit-driven objectives. For every American who works in an office — that is, for millions of us — *Dilbert* is an act of revenge, and we relish it.

RICK DETORIE

BORN 1954

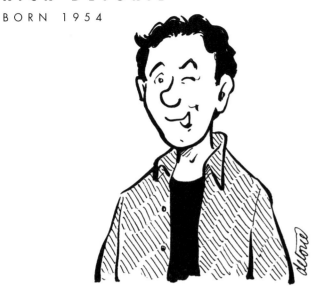

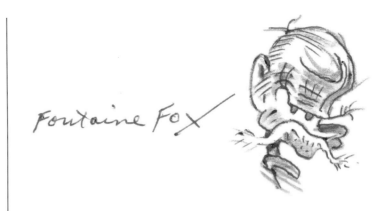

Fontaine Fox

FONTAINE FOX

1884 | 1964

Author of over twenty humor books, fourteen of them published before becoming a syndicated cartoonist, Detorie worked for an advertising agency after college, and he began successfully submitting cartoons to magazines shortly thereafter. His first big break in cartooning was designing products for the revival of the Chipmunks in the early 1980s. Then when cat books flooded the bookstores, he was inspired to crank out a host of similar enterprises, including *No Good Lawyers, How To Balance the Federal Budget, How To Survive An Italian*

Family, and two best-sellers — *No Good Men* and *Catholics (An Illustrated Guide).* The *Italian Family* book taught him that he did his best work when writing about something he knows, so that's what he decided to do when approaching the comic strip medium. Since Detorie's grandparents lived next door to his family while he was growing up, he conceived of a comic strip about just such an extended family experience, and *One Big Happy* was launched in 1988. In the midst of the family, Ruthie, an irrepressible six-and-a-half-year-old has stolen the show from everyone else.

In the forty-year run of the panel cartoon *Toonerville Folks,* Fox created about seventy characters, each with a distinctive, not to say eccentric, personality — among them, Powerful Katrinka, Mickey "Himself" McGuire, Aunt Eppie Hogg (the fattest woman in three counties), the Terrible Tempered Mr. Bang, Tomboy Taylor, Two Cane Tille, and the ever-pragmatic Skipper, who guided an antique open-platform trolley car from outlying residential areas through countless vacant lots to the city's center. "The Toonerville Trolley That Meets All the Trains" was the over-line Fox scrawled above his panel cartoon the first time he did one about the Trolley in about 1915. Born in Louisville, Kentucky, Fox had worked on local papers as both reporter and sketch artist, and by 1908 he was in Chicago at the *Evening Post,* where he did a weekly cartoon about kids in the suburbs.

When his work attracted the attention of a syndicate, Fox moved to the New York vicinity in 1913. It was while traveling around the area on a rickety rural trolley that Fox remembered the unreliable service he'd endured as a youth and re-enacted it for Toonerville. The Trolley and those along the line soon shared the spotlight with the kids. One of the first cartoonists to be syndicated nationally, Fox recognized at once a new requirement for his effort: "In drawing for many papers instead of one, I had to make each cartoon's appeal as sure in San Francisco as in New York." The Trolley rattled its last mile on February 9, 1955.

ROGER BOLLEN

Bollen is one of those cartoonists who never seem to have enough to do. At one time, he produced three syndicated features — two daily and Sunday comic strips and a daily panel cartoon. While doing all three, he also did humorous illustrations for magazines. "It gets me around to meet other people," Bollen explained; "doing this kind of work is sort of a hermit-like existence, and you tend to lose touch. This enables me to work with people." But Bollen's first creation, a comic strip called *Ripple Falls,* was short lived. Then his syndicate asked him in 1965 to revive the panel cartoon, *Funny Business,* another cartoonist's creation. Shortly thereafter, seeking a middle ground between *Pogo* and *Bugs Bunny,* he invented a lion and liked it. The lion was Lyle, and Bollen gave him a mouse for a companion. When he submitted the strip, syndicate officials told him to get rid of the mouse because there were already too many mice in the funnies. "So what do you do when a mouse is rejected? Why, create a dodo, of course." Bollen laughed. The result, *Animal Crackers,* began in 1968. The characters in Bollen's menagerie engage in some social commentary occasionally, but mostly, they encounter each other and their foibles. Bollen's second strip, *Catfish,* whose title character is a mangy sort of "B" western movie character, began in 1971 for a fifteen-year run.

INK ON PAPER | 7.6 X 6.9 CM. | 1989

THIS IS **EXACTLY** HOW I LOOK IN REAL LIFE, TOO !!

HE CANNOT TELL A **LIE !!**

BILL GRIFFITH
10·25·87

BILL GRIFFITH
BORN 1944

Actually, Griffith has adopted a more conventional haircut since 1987 when he drew this, but that may be the only conventional thing about him. Growing up in what he calls "the quintessential American suburb, Levittown, Long Island — a great place to escape from," Griffith devoured *Mad* as a youth, went to Paris to study art for a year, and subsequently escaped his origins and training by drawing cartoons ("comix") for underground newspapers in the East Village on the Lower East Side of Manhattan. He sold his first cartoon to *Screw* because it was just the right size to fit an existing page layout. In 1970, he went to the

"comix Mecca," San Francisco, where he invented an anthropomorphic amphibian, Mr. Toad, who was anger incarnate, and, for a mock romance underground comic book, a bizarre pointy-headed personage called Zippy. Meanwhile, Griffith and Art Spiegelman (q.v.) founded *Arcade Comics* in 1975 and continued it

for seven issues; when it folded in 1976, Griffith started doing a weekly half-page *Zippy* strip for a syndicate that Rip Off Press operated to service alernative independent newspapers. Rip Off discontinued the service in 1980, but Griffith continued to syndicate his strip himself. In 1985, William R. Hearst III, who wanted to "shake

up his readers" as well as attract a younger audience, asked him to do *Zippy* for the *San Francisco Examiner* as a daily strip. Shortly thereafter, an official at King Features invited Griffith to consider syndication, and when he unaccountably met all Griffith's demands (he wanted editorial freedom, the copyright, odd proportions for the strip, and no censorship), *Zippy* went into national distribution. Later when the official had left King, Griffith learned he'd wanted to leave the syndicate with the weirdest strip in America, "a ticking time bomb on their doorstep." And *Zippy* is surely unusual: its so-called non-sequitur humor stems from Zippy's total submersion in popular culture and television commercials, which he assumes constitute the real world (an assumption that gives the strip its satiric bite). Griffith caricatures himself in the strip as Zippy's foil, Griffy.

INK ON PAPER | 13.5 X 16.6 CM. | 1987

BURNE HOGARTH

1911 | 1996

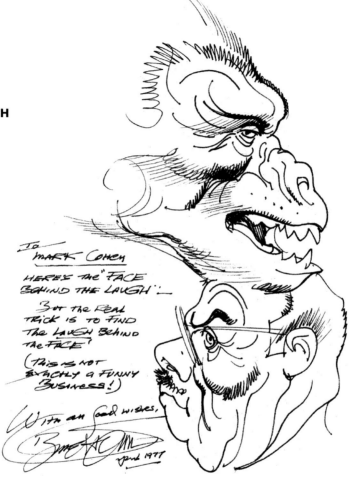

Not without ample justification is Hogarth sometimes called "the Michelangelo of the comics": Tarzan's physique as rendered by Hogarth may have set the fashion for the way superheroes in comic books are drawn — with the musculature so meticulously delineated as to suggest that the first few layers of skin had been flayed for the purpose of anatomical display. Although noted for his work on the *Tarzan* Sunday comic strip, Hogarth made at least as great an impression on the profession as an educator and theorist. He worked briefly in the King Features bullpen in 1934, which may be where he attracted the attention of syndicate officials, who asked him to continue *Tarzan* after Hal Foster left it (in 1937 to create *Prince Valiant*). Hogarth produced the adventures of the Burroughs ape-man from May 9, 1937 until mid-August 1950, leaving for short periods to create two other strips: *Drago*, about a gaucho's adventures on the pampas (November 4, 1945-November 10, 1946); and Miracle Jones, a rendition of the Walter Mitty persona (c. 1946-1948). In 1944, Hogarth founded the Academy of Newspaper Art in New York City, and from this modest beginning evolved the Cartoonists and Illustrators School, which, in 1956, took its present name, the School of Visual Arts, the largest accredited private art school in the world. Hogarth devised curricula, wrote courses, and taught a full schedule until he retired in 1970. He wrote two art instruction books, *Dynamic Anatomy* and *Dynamic Light and Shade*, and, in the seventies, produced two book-length "graphic novels" revisiting the jungle lord, *Tarzan of the Apes* and *Jungle Tales of Tarzan*. An articulate and forceful conversationalist, Hogarth was never bashful about voicing his opinions about the state of the art of cartooning — how it was and how it ought to be.

FELT TIP PEN ON PAPER | 17.9 X 24.6 CM. | 1977

DAN PIRARO
BORN 1958

Since January 1985, Piraro has been producing a syndicated panel cartoon called *Bizarro* in which he foists off onto unsuspecting readers the by-products of a truly peculiar sense of humor. In one of his favorite cartoons, an angel is talking to a newly arrived soul, dressed in a sky-diver's togs, who, in apparent bewilderment, is holding what appears to be a string in his hand. The angel says, "No, see, this is your rip cord. That's just a loose thread." It's nearly impossible to know anything for sure about Piraro because of his habit of making crypto-humorous statements about his life that are designed to veil the truth. For instance, this is what he wrote about himself for the membership directory of the National Cartoonists Society: "Dan Piraro was born in the latter half of the 20th century to a pair of small-town game show hosts in the American Midwest. When not being forced to attend church or Catholic school, he was left alone in the family trailer home with his eleven siblings, five dogs, and a mysterious man named 'Betty.' At the age of eighteen, he fled to Dallas with little formal education and no job skills. Shortly after his parole in 1985, he got into cartooning and has been unable to escape since. He has been married to a woman well out of his league since 1980 and they have two children of similar gender." We suspect that his Dallas sojourn was in some sort of institution (perhaps one for higher learning), and that by "parole" he means "graduation." But who can say?

ALEX KOTZKY
1923 | 1996

APARTMENT 3-G

ALEX KOTZKY

One of the few newspaper cartoonists to graduate from comic books, Kotzky had achieved an enviable body of work in the four-color format before starting to draw *Apartment 3-G*, May 8, 1961. He began his comic book career as a teenager before World War II, assisting Will Eisner, among others, and drawing a variety of features (such as *Blackhawk*) for the Quality line of comic books. After the War, he resumed working for Quality until the comic book industry began to collapse in the early 1950s, when he joined Johnstone and Cushing, an advertising agency that specialized in comic strip advertising. There Kotzky produced such endeavors as *Duke Handy*, a strip about a hard-charging action hero who smoked Phillip Morris cigarettes, and he helped out on some newspaper comic strips, ghosting for Milton Caniff on *Steve Canyon,* for instance. When writer Nick Dallis launched his third soap opera strip (adding *Apartment 3-G* to his *Rex Morgan* and *Judge Parker* scripting chores), Kotzky was invited to draw the feature. He was an inspired choice. The strip rotates adventures among a repertory company of the three young career women who share an apartment in New York — a nurse, a secretary, and a school teacher — and Kotzky could draw the faces of beautiful women with consummate skill. Not only did they look beautiful, but they looked different from one another — and Kotzky could even draw them with different expressions but still recognizable as Tommie, Margo, or LuAnn, and still beautiful. As comic strip sizes continued to shrink and continuity strip artists resorted more and more to talking heads to tell their stories, Kotzky's skill in rendering faces and facial expressions gave the strip a handsome distinction.

ROBB ARMSTRONG

BORN 1962

Armstrong has had good luck listening to the women in his life. He and his brother and his mother were abandoned by his father soon after he was born, but his mother, a seamstress, insisted that he develop his talent, paying for private art classes and getting him into a prestigious private school. She died during his freshman year at Syracuse University, but her friends kept young Armstrong at his studies when, angry and grieving, he threatened to drop out. Still angry, he drew a comic strip for the campus paper about a grouchy character named Hector. And he met Sherry West, a chemistry major. "I was saved from a hollow existence by a wonderful woman," he said; they married in 1986 and have a daughter. After college, Armstrong became art director of an ad agency and submitted *Hector* for syndication; when that didn't sell, he tried a strip about a policeman called *Cherry Top*. After receiving a string of rejection slips, Armstrong put the strip aside — until his wife urged him to show it to his friend Mark Cohen, and Cohen took the strip to United Media. An editor there saw promise in the strip but felt Armstrong would do better if he wrote more out of his own experience. So he did, creating *Jump Start* (which started October 2, 1989), a strip about Joe Cobb, a policeman, and his wife Marcy, a nurse, and their daughter Sunny. At first, they spoke street slang, but when Armstrong realized he was perpetuating stereotypes, he stopped. "I don't talk like that," he said. He realized that "the closer the strip is to your own life, the easier it is to write." Now, he says, the strip "flies in the face of racial stereotypes. Joe and Marcy are just normal, everyday people, committed to doing the jobs they are paid to do." And his fan mail tells him his readers identify with the Cobbs. "I'm thrilled when people say that," he said, "because I'm drawing about my life — about a Black couple because I'm Black. It's wonderful to know that people respond to these characters."

LYNN JOHNSTON

BORN 1947

The characters in Johnston's comic strip about a family are all based upon her own family, her husband and her daughter and her son. And herself. Although Elly, the mother in the fictional Patterson family, is named in memory of a childhood friend who died, the leading player in *For Better or For Worse* is, as Johnston says, "so very obviously, me." And Elly's trials and tribulations and triumphs are derived, one way or another, from Johnston's own experiences as a mother and wife. When Johnston left the Vancouver (Canada) School of Art, she thought she was entering a career in animation. But she wound up producing slides for medical lectures at McMaster

University Medical Center in Hamilton, Ontario. Later, pregnant with her first child and forced to await her obstetrician's attention in a prone position on his examining table, Johnston nagged him to put pictures on the ceiling so his patients would have something to occupy themselves with while waiting, and he responded by asking her to furnish him with cartoons for the purpose. She did eighty, and at his urging, they were published in 1974 as a booklet, *David, We're Pregnant!* Johnston produced two similar books, attracting the attention of an American syndicate, which invited her to submit a comic strip "about family life from a woman's point of view — something contemporary, a little controversial perhaps." The

result (starting September 9, 1979) is a reality-based, warmly human strip that also generates the requisite controversy. In 1993, one of the son's teenage friends comes out of the closet, announcing his homosexuality; two years later, the beloved family dog dies, and three years after that, Elly's mother dies. Such events are inevitable in a strip in which the characters grow up. But Johnston's strip is scarcely all controversy: to millions

of readers, her characters are genuine people, humorously experiencing ups as well as downs in the ordinary business of daily living. Her peers recognized her achievement with a Reuben in 1985, making Johnston the first woman to be so honored. She was also the first woman cartoonist to be president of the National Cartoonists Society (in 1988-1989).

INK ON PAPER (DETAIL) | 12.5 X 23.4 CM. | 1986

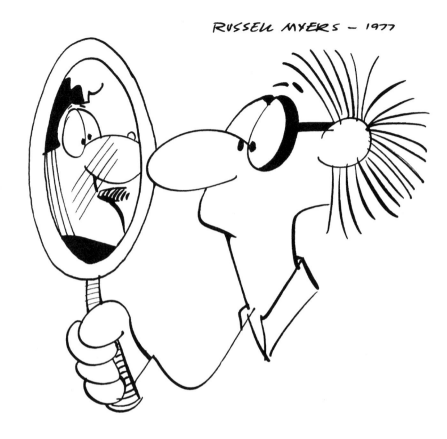

RUSSELL MYERS — 1977

RUSSELL MYERS
BORN 1938

After ten years turning out greeting cards for Hallmark in his hometown of Kansas City, Myers finally sold one of his many submitted comic strip ideas, and on April 19, 1970, *Broom-Hilda* began. The title character is a 1,500-year-old witch with green skin, a wart on her nose, and a chip on her shoulder. Love-starved but surpassingly ugly, she is forever experiencing rejection by prospective boyfriends, but, undaunted by failure, she never gives up and continues to assault every eligible male who wanders into view. In sharp contrast to her vulgarian spirit are her genteel, vegetarian buzzard associate, Gaylord, and a sweet-tempered troll named Irwin. This trio encounters life as they find it — sometimes in the twentieth century, sometimes in the eleventh. Myers accompanies this whimsical treatment of time with an equally frivolous attitude about the landscape that surrounds his cast: trees twine like vines or soar like skyscrapers, and the hills turn into buttes that, in turn, change shape in the same manner as the scenery did in *Krazy Kat*. To an extent that many highly verbal contemporary strips do not, Broom-Hilda relies on pictures for its jokes as well as verbiage. Myers also created *Perky and Beans*, a short-lived strip (1985-1987) about a little girl and her grandfather.

INK ON PAPER (DETAIL) | 15.7 X 15.7 CM. | 1977

HEY! OUDT FUM
DER SCULPTURE SHOP
UND BACK TO DER
DRAWING BOARD!

John Dirks 8-77

JOHN DIRKS
BORN 1917

The bearded fellow and the two urchins at the window are three of the longest-lived characters in American comic strip history. The Captain and Hans and Fritz first appeared under the heading "Katzenjammer Kids," a Sunday strip invented in 1897 (debuting December 12) by Rudolph Dirks (John's father) at the behest of Rudolph Block, the comics editor of William Randolph Hearst's *New York Journal;* Block wanted something akin to the juvenile German pranksters, *Max und Moritz,* created by Wilhelm Busch in 1865. Dirks' concoction is probably the first American newspaper comic "strip": while the Yellow Kid had surfaced earlier in

Richard F. Outcault's *Hogan's Alley,* that feature did not appear regularly as a succession of individual panels but most often as a single huge half-page drawing. *The Katzenjammer Kids,* on the other hand, started as a "strip" of pictures and soon incorporated speech balloons within them, constituting thereby the first genuine "comic strip" to be regularly published in the U.S. In 1913, Dirks went on a vacation, and while he was gone, he agreed to produce the Katzies for Joseph Pulitzer's *New York World,*

Hearst's chief rival. Dirks couldn't use the same title, though, so when he resumed the strip in 1914, it was called *Hans und Fritz* — until anti-German sentiment during World War I prompted a revision to *The Captain and the Kids.* Dirks left the strip for awhile in the 1920s and again in the mid-1930s. His son John began assisting him after World War II, and upon his father's retirement in 1955, John took over, continuing the feature until it ceased in 1979.

Inclined more towards sculpture and painting than comics, John could at last pursue a career that, above, seems but a distraction. He has created more than five hundred sculpted fountains, and in 1987, he became director of the Ogunquit Museum of American Art in Maine. The original *Katzenjammer Kids,* meanwhile, was continued by Harold Knerr and others through the rest of the century, becoming the longest running comic strip in history.

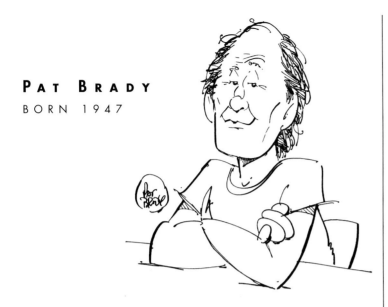

PAT BRADY
BORN 1947

BERKELEY BREATHED
BORN 1957

Rose Is Rose, which started April 16, 1984, is Brady's second syndicated effort: from 1979 to 1982, he produced *Graves, Inc.,* which was set in the business world. *Rose* is all homefront. It's about a mother and housewife, Rose, her husband Jimbo, and their son, Pasquale, who is a preschooler. But it is much more than a "family strip." It is also a continuous experiment in cartooning. Brady varies perspective and angle and every other aspect of graphic art to provide every day a fresh look at his creation. Sometimes, he concocts visual puzzles: the first panels of a strip create a kind of mystery — What does this picture mean?

Then the next couple panels explain the mystery, solving the puzzle, and when we suddenly comprehend the explanation, we smile at the surprise. That's the joke. Brady explores the visual potential of the medium as a way of keeping himself interested and creatively engaged: "Doing the pictures straight on is, for me, monotonous," he once said. "The more I experiment, the more I challenge myself; and the more I challenge myself, the more my art, I think, improves." But *Rose* is more than clever visuals: it's also about domestic love and respect, and Brady creates this ambiance with a sure but never cloying hand.

Breathed shocked the cartoonist fraternity by quitting not one but two popular comic strips before he was forty years old. Attending the University of Texas, Breathed created for the campus newspaper a comic strip called *Academia Waltz,* the popularity of which (1978-1979) attracted syndicate attention. Renamed *Bloom County,* the strip, which looked and laughed a lot like Garry Trudeau's *Doonesbury,* may have benefitted shortly after its launch on December 8, 1980, from the sab-

batical that Trudeau took two years later (discontinuing *Doonesbury,* January 1983-September 1984), many newspapers substituting Breathed's strip for Trudeau's. Breathed's pen didn't drip with as much vitriol as Trudeau's, and he aimed more often at social mores or popular culture than politics, but his strip appealed to many of the same readers as Trudeau's had; by the time he voluntarily stopped producing the strip August 6, 1989, it was appearing in more college newspapers than any other. The

BRADY: INK ON PAPER | 14.1 X 14.6 CM. | 1986 BREATHED: FELT TIP PEN ON PAPER | 4 X 5.9 CM. | 1983

denizens of Bloom County included not college liberals but several precocious children, a male chauvinist, and a cool paraplegic, but the character who readers took to their hearts was Opus, a wistful penguin with gentle opinions on most aspects of the human condition. Breathed created a second, Sundays-only strip called *Outland* (September 3, 1989-1995), into which, eventually, Opus wandered. Breathed explained his early retirement by saying, "A good comic strip is no more eternal than a ripe melon." He was also critical of the steadily shrinking space allowed to comic strips by newspapers. Like Trudeau, Breathed won a Pulitzer Prize (in 1987) for editorial cartooning in his strip.

GUS ARRIOLA
BORN 1917

A pioneer in producing "ethnic" comics, Arriola drew upon his own Mexican heritage in concocting *Gordo,* a strip about a portly south-of-the-border bean farmer, his nephew Pepito, their menagerie (rooster, dog, pig, and more as the years went by), and the farmer's friends (Juan Pablo, the Poet, and Pelon, who ran the local cantina). When the strip started November 24, 1941, it was rendered in the big-foot style of MGM animated cartoons, upon which Arriola had been working until then. But over the years, Arriola dramatically changed his way of drawing, producing eventually the decorative masterpiece of the comics page, the envy of his colleagues. He frequently made the strip educational, informing his readers about the culture of Mexico, but he was continually criticized for the stereotypical lingo his characters spoke; gradually, Arriola softened the dialect until it disappeared altogether. "I realized," he said, "that I was depicting a people — my people. And *Gordo* was the only strip here that's actually located outside this country. So I started to use jokes other than ethnic." Gordo became a tour bus driver and rather sophisticated. When the strip ended March 2, 1985, Arriola gave his forty-three-year saga an ending, marrying Gordo to his long-time housekeeper, Tehuana Mama.

MELL LAZARUS
BORN 1927

One of the first evidences of the growing influence of *Peanuts*, Lazarus' popular *Miss Peach* comic strip (starting February 4, 1957) featured children making precocious comments on life in the schoolyard and the classroom and beyond and was drawn simply, even grotesquely, the children having heads and noses several times the size of their microscopic bodies. Lazarus, like many of his vintage, had started doing cartoons for magazines (in 1945) and transferred that style of cartooning to his syndicated work. He also worked in comic books, serving as art director for Toby Press, 1949-1954, an experience reflected somewhat in his first novel, *The Boss Is Crazy, Too* (1964). Lazarus collaborated with cartoonist Jack Rickard, writing a continuity strip, *Pauline McPeril*, a spoof of cliff-hanging adventure stories, 1966-1969, but he achieved a second crowd-pleaser on October 26, 1970, when he began producing *Momma*, an comedic examination of the relationship between a possessive and self-absorbed mother and her children, rendered in the same abbreviated manner as his kid strip. While producing two strips, Lazarus also wrote plays, books of humorous pieces, and novels. He received the Reuben in 1981 for *Miss Peach*.

INK ON PAPER (DETAIL) | 9.8 X 14.9 CM. | 1991

BUD BLAKE
BORN 1918

Blake launched his comic strip *Tiger* in 1965, having spent the previous decade doing a syndicated panel cartoon, *Ever Happen to You?*, which he had begun in 1954. Before that, he had been executive art director for an advertising agency, and his work shows an exquisite sense of design. Noted in the cartooning fraternity for his dramatic spotting of solid blacks, composition values, and clean weighted lines, Blake is among a rare few whose artwork his colleagues universally admire and speak of reverently. Alex Toth (q.v), no slouch himself at stunning compositions in black and white, once wrote of Blake's "technical/ artistic wizardry": "Bud Blake draws a strip of truly fine artistic merit. There's a solid, chunky quality to his figures and stage props. He draws any facial expression or body attitude with a few crisp pen lines and exemplary economy throughout all other picture elements in his little panels." Art critic Dennis Wepman described *Tiger* as "a gracefully drawn strip, neither sentimental nor arch, about a gang of believable kids." Typically, Blake labors hardest over the pencil drawings of his pleasantly squatty figures of children. For Sunday pages, he begins drawing with the last panel (trying for "a good picture ending," he says) and often revises the entire strip more than once before arriving at a rendering that pleases him. In devising gags, Blake keeps a close eye on his characters: "How would they react?" he asks; "What would they say?"

RAY GOTTO
BORN 1916

Gotto drew sports cartoons for most of his career but is likely to be most readily recalled as the creator of *Ozark Ike,* a comic strip about a not-too-bright hick star baseball player named Ike McBatt. Inaugurated in late 1945, the strip seemed to incorporate aspects of both *Li'l Abner* and *Joe Palooka* — the hillbilly slow-wittedness of the former and the sports realism of the latter. Always sparked with a gentle humor, the stories alternated between realistically suspenseful contests on the diamond and fantastical feuds in the hills of the title character's origins. Gotto drew in a mannered style that combined a simple bold but undulating line with an astonishing array of meticulously applied shading and feathering techniques. The other noteworthy visual element in the strip was Ike's girlfriend Dinah, a blonde with a Veronica Lake hair-do and an extraordinarily statuesque torso the contours of which were fastidiously defined by the curving of the stripes on her tank top. Gotto abandoned the strip in 1954 to create another sports epic, *Cotton Woods,* whose title character was a little brighter than Ike. But this enterprise lasted less than four years, and Gotto then returned to straight sports cartooning. He had started cartooning in this genre for the *Nashville Banner* in his home state; now he continued in the same vein for the nationally-distributed *Sporting News.* In 1961, Gotto designed the emblem for the New York Mets.

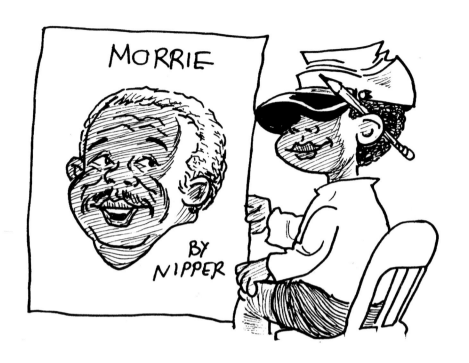

MORRIE TURNER
BORN 1923

The first Black cartoonist to produce a nationally distributed comic strip raising racial consciousness, Turner began freelancing cartoons to magazines after his stint in the Army Air Corps during World War II. Inspired by *Peanuts,* he developed in 1963 a strip about black moppets called *Dinky Fellas,* selling it to the *Berkeley Post* in his native California and to the *Chicago Defender.* In 1964, acting on the advice and encouragement of Charles Schulz and comedian Dick Gregory, Turner integrated the strip and sold it as *Wee Pals,* which debuted February 15, 1965. Every minority (including the handicapped) is represented in the strip, and Turner promulgates a benevolent message of harmony as well as humor. When Nipper (the Black kid) and his racially diverse friends are picking a name for their club, they consider "Black Power," then "Yellow Power," then "Red Power," finally settling on "Rainbow Power"— all colors working harmoniously. Turner also produces a Sunday panel about African American history called *Soul Corner,* and he created an animated biography of Martin Luther King, Jr. Turner has received many awards for his work in cartooning and in education, including the Brotherhood Award of the National Council of Christians and Jews in 1968 and the B'nai B'rith Anti-Defamation League Humanitarian Award in 1969. Mark Cohen has a number of Turner's self-caricatures in his collection (and a number of Turner's caricatures of Cohen) because he's contributed gags to *Wee Pals* for years.

BEN TEMPLETON

BORN 1936

With his writing partner Tom Forman, Templeton has filled more demographic market holes on the comics page than just about anyone. He was running his own graphic design and consulting firm and producing two cartoon features (*Yankee Doodles*, c. 1974-1977; and *200 Years Ago Today*, c. 1976) when Forman approached him to draw a strip called *Super Fan*, aimed at filling a niche on the sports page. Syndicate officials suggested balancing sports with social commentary, and *Motley's Crew* was born, September 6, 1976. Mike Motley is a middle-class blue-collar worker who loves sports, and his

creators have taken Mike (and the strip) to such major sporting events as Superbowls and the Olympics. They had President Jimmy Carter spend a night with the Motleys in 1977, and when the Carters asked for the original strips, Templeton and Forman were invited to the White House to present them. Reviving their sports page notion, they produced a panel cartoon, *The Sporting Life*, July 9, 1978-1985; and then, seeking to fill a gap where there ought to be something on the universe of television, they created *Prime Time*, a strip-wide panel cartoon (with no continuing characters), February 5, 1979, which ran until 1982. Then they created a strip aimed at young readers, *Elwood* — a teenager who has his own garage rock band (c. 1983-1990).

All these efforts were rendered in Templeton's graceful relaxed manner, employing a thin languid line with stunningly spotted solid blacks. Although Forman died in 1996, the work of the partners was marked by their compatibility. Said Templeton: "Find somebody like Tom to do the hard part, the writing." "That will cost you an extra 10%," Forman said. "Settle for another beer?" asked Templeton. "Same thing," said Forman.

INK ON PAPER (DETAIL) | 5.6 X 11.6 CM. | 1987

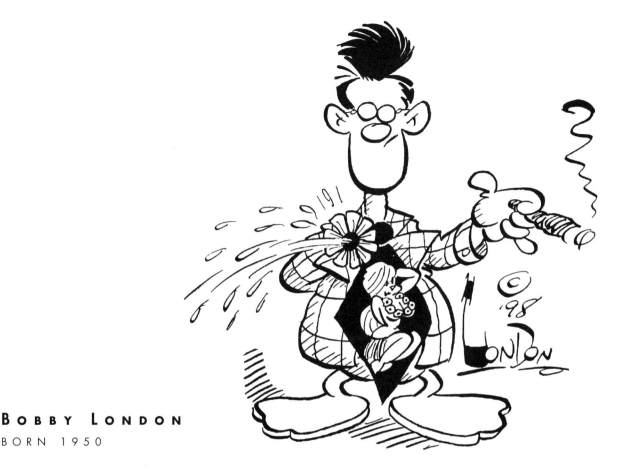

BOBBY LONDON

BORN 1950

A fugitive from the comix underground, London started selling cartoons to counterculture publications in the late 1960s in New York's East Village. His first published strip was *Merton of the Movement* in 1969. London moved to the West Coast and in 1971 sold a comic strip feature to the *Los Angeles Free Press*. This was *Dirty Duck*, an evocation in appearance of cartooning styles in the 1920s (especially George Herriman, q.v.). The irascible Duck and his insect side-kick, Weevil, graduated to the *National Lampoon* the next year, and by 1977, they were appearing in the pages of *Playboy*, where they continued until 1987. London worked briefly at Disney Studios and freelanced illustrations for *Rolling Stone, Esquire*, and various newspapers, contributing all the while to comix. In 1986, he was tapped to produce the daily version of the mainstream syndicated strip, *Popeye*, after Bud Sagendorf retired. He revived the strip's continuity and brought back many of the characters that the strip's originator, E.C. Segar, had introduced a half-century or more before; and he gave the stories a contemporary edge. But in 1992, London was summarily fired; the igniting incident was a sequence that made allusions to abortion.

INK ON PAPER | 15.6 X 15.5 CM. | 1998

WILEY MILLER

BORN 1951

One of the wiliest marketing strategists among contemporary syndicated cartoonists, Wiley (his pen-name) began his cartooning career doing educational films in Los Angeles, but by 1976, he was on the other side of the continent, doing editorial cartoons and general artwork at the *Greensboro Daily News* in North Carolina. Two years later, he was doing the same thing back in California at the *Santa Rosa Press Democrat*. In a financial cutback during the recession of 1981, Wiley lost that position and, while still producing editorial cartoons for syndication, concocted his first comic strip, *Fenton*, which focused on the trials and tribulations of a retired man. It debuted March 7, 1983, running until early 1986, when Wiley resumed editorial cartooning, this time for the *San Francisco Examiner*. Subsequently, at a local pub, he began amusing himself and the patrons by sketching cartoons on napkins — "Bartoons,"

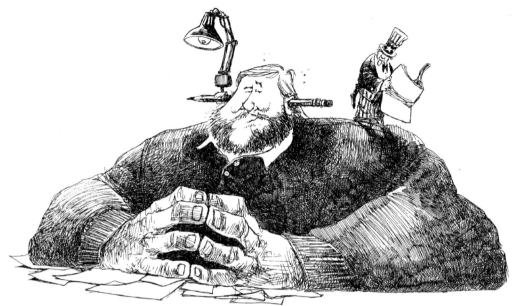

SELF PORTRAIT IN CARICATURE....AND VICE VERSA

he called them. He sold some to *Playboy*, and when the *Examiner* cut him back to three cartoons a week, he started exploring syndication options for "Bartoons." But syndicates were not interested in panel cartoons without a continuing cast of characters. Wiley promptly revised his plan, adopting a strip format and, to indicate the absence of a regular cast, named the feature *Non Sequitur*. It began February 16, 1992, as a strip-wide single panel

cartoon — a format that permitted editors to run it on their regular comics page. Later, Wiley realized that he could make the feature available in the standard panel cartoon format as well, giving editors a choice about how to publish *Non Sequitur*. He also experimented with the Sunday format, again to give editors choices. In 1995, he began collaborating with Canadian cartoonist Susan Dewar on another strip, *Us and Them*, an adventur-

ous treatment of the battle of the sexes which alternates day-by-day from a male protagonist (done by Wiley) to a female protagonist (by Dewar). In 1997, Wiley relinquished his *Us and Them* spot to Milt Priggee (q.v.), and in 1998, he started a Sunday-only strip, *Homer*, in vertical format, an innovation that enabled editors to add the feature to their line-ups without dropping another strip.

INK ON PAPER | 23.2 X 18 CM. | 1986

MIKE PETERS

BORN 1943

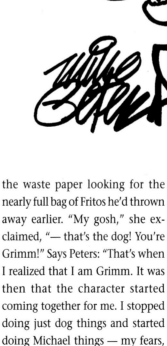

One of a steadily increasing list of those who follow Jeff MacNelly's lead (q.v.) in producing a daily comic strip as well as an editorial cartoon, Peters as a teenager fell under the spell of Bill Mauldin (q.v.), who was then cartooning at the *Post-Dispatch* in St. Louis, Peters' hometown. Peters credits Mauldin with opening the door for him at the *Chicago Daily News* where he began his first newspaper staff artist position in 1965 and at the *Dayton Daily News*, where he has been editorial cartoonist since 1968. In 1984, Peters launched the ultimate dog strip, *Mother Goose and Grimm*. At first, the strip's humor sprung from anachronistic fairy-tale allusions, but then Peters found his inner self and began concentrating on Grimm, Mother Goose's pet dog. Here's the story of this discovery: seeking to control his insatiable appetite for Fritos, Peters buys them in small bags and throws the bags away after taking out only a single handful. One day, his wife Mirian comes upon her husband, bent over the trash can, sorting through the waste paper looking for the nearly full bag of Fritos he'd thrown away earlier. "My gosh," she exclaimed, "— that's the dog! You're Grimm!" Says Peters: "That's when I realized that I am Grimm. It was then that the character started coming together for me. I stopped doing just dog things and started doing Michael things — my fears, my desires, whatever. I then projected these onto the dog. And that has made it a lot easier for me to draw him because now I understand him." Grimm, like many dogs, drinks out of the toilet; we won't go into that any further. Peters received the Pulitzer in 1981 and the Reuben in 1991.

JOHNNY HART
BORN 1931

Another of the new breed of comic strip cartoonists who apprenticed in magazine cartooning, Hart started *B.C.* February 17, 1958. Inspired by what he saw in *Peanuts,* he drew in a simple, magazine cartoon style, and his strip, like Schulz's, depended for its humorous impact upon a dichotomy between what the reader saw and what the characters said. The setting for *B.C.* is prehistoric; but the concerns and preoccupations of its characters are entirely contemporary. Many gags are anachronistic, and the comedy arises from the naivete of the characters: Thor, the inventor, invents the wheel, but because he hasn't quite grasped the principle, he "rides" only one wheel, straddling it as if it were a unicycle. The strip began to attract attention when Hart introduced an anteater, whose tongue, when it lashed out at the ants, snapped "Zot!" The University of California at Irvine designated the anteater as its mascot, and the monosyllable became forthwith the school cheer. On November 9, 1964, Hart introduced another strip, *The Wizard of Id,* drawn by an old friend, Brant Parker. Focusing mostly on the diminutive king in a medieval monarchy, the strip provides an outlet for social satire that can't find expression in *B.C.* — "There's no society to deal with in *B.C.,"* Hart explained. When he won the Reuben in 1968, both strips were cited.

RAY BILLINGSLEY

BORN 1957

The title character in *Curtis* is a feisty eleven-year-old African American who lives with his parents and his eight-year-old brother in an inner city and who always wears a cap turned backwards. He is, in other words, a typical sort of kid having typical kid adventures in school with his classmates and teacher, in the city streets, and at home. While the strip occasionally takes up racial issues, Billingsley stresses relationships not race. "I like to delve into the aspects of what makes a person who he or she is," he said, "— family, friends. I want to show that we Blacks like to laugh at ourselves, just like everyone else." Curtis' father is critical of his son's passion for loud rock music; Curtis pesters his father to give up smoking (even squirting him with a water pistol). "But the father is a heavy smoker, and these methods aren't enough to discourage the hardcore smoker," Billingsley said, "so it's a continuing battle." One of Curtis' friends is Gunk, a refugee from Flyspeck Island (which is located at the northeast tip of the Burmuda Triangle), who adds a fantasy element to the proceedings. Billingsley began cartooning professionally at the age of twelve when he was hired by *Kids* magazine as a staff artist; he worked after school and weekends. Growing up in New York City, he went to the famed High School of Music and Art, after which he received a four-year scholarship to the School of Visual Arts (1975-79). *Curtis*, which began October 8, 1988, is Billingsley's second comic strip; he produced *Lookin' Fine* from 1980 to 1982. Between and before strips, he worked as a commercial artist.

JULES FEIFFER
BORN 1929

A sort of Renaissance Man of cartooning, Feiffer's achievements include not only a weekly syndicated cartoon but plays, screenplays, novels, children's books, and countless magazine articles. His earliest professional cartooning was assisting Will Eisner (q.v.); starting in the spring of 1946 by erasing pencil lines, he eventually moved up to help write *The Spirit*. His first published creation was *Clifford*, a back page feature of Eisner's weekly comic book newspaper supplement. After a stint in the Army, 1951-1953 (which inspired the book-length strip about military ineptitude, *Munro*), Feiffer concocted several unsold comic strips while working in art agencies, then, hearing about an avant garde newspaper in Greenwich Village, he successfully launched a weekly feature in the *Village Voice*, October 24, 1956. He set out to satirize "my own kind," meaning Greenwich Village intellectuals and the self-acclaimed creative elite, who "explained themselves in an endless babble of self-interest, self-loathing, self-searching and evasion," he said. The essential Feiffer cartoon is about communication, the failure of most people to achieve it even within themselves. And the demonstration of that failure is the constant talk of his characters. Feiffer deflates not only the pretensions of the Villagers but the duplicity of politicians and the fashionable aspirations of the middle class. In 1958, *Playboy* contracted for a monthly cartoon, and Feiffer began writing magazine articles, novels, and plays. His book *The Great Comic Book Heroes* (1965) legitimatized interest in old comic books; his screenplay for *Carnal Knowledge* (1970) gained notoriety for the alleged obscenity of its language. He won an Oscar for the animated cartoon version of *Munro* in 1960 and a Pulitzer Prize for cartooning in 1986. Feiffer's attitude and graphic style influenced other cartoonists, notably Garry Trudeau in *Doonesbury*. About his craft, Feiffer once said: "Surviving our leaders is not just a struggle, it is a joy; that is the irony of the work I do. The more outraged I am as a citizen, the more fun I find as a cartoonist."

JIM BORGMAN
BORN 1954

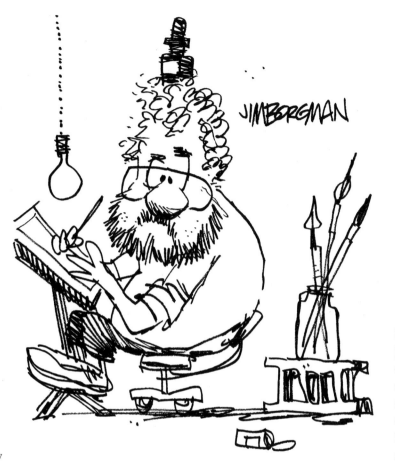

In June 1976, Borgman, freshly graduated from Kenyon College in Ohio, walked into the offices of his hometown paper, the *Cincinnati Enquirer,* and was promptly hired as its editorial cartoonist. It was nearly unprecedented good fortune. The paper expected him to hue to its editorial line, and Borgman, not knowing any better, did. For a time. Slowly, however, he eased in-to his own political stance, which, he says, is neither liberal nor conservative. Calling himself "a progressive iconoclast with a dirt-under-the-fingernails conservative streak," he is inspired more by a contrary nature than any ideology. "If the crowd starts leaning one way," he once said, "I instinctively lean the other way. These cartoons are not final pronouncements. They are works in progress, all of them, done in the spirit of firing up the American debate." He won the "best editorial cartoonist" plaque from NCS four times (in 1986, 1987, 1988 and 1994), the Pulitzer in 1991, and NCS's Reuben in 1993.

In 1995, with *Wonk City* Borgman joined the ranks of those editorial cartoonists who also produce a syndicated comic strip. Then in the summer of 1997, teaming with cartoonist/gag writer Jerry Scott, Borgman started drawing *Zits,* a comic strip about a teenager. The strip was virtually an overnight success, picking up more than four hundred subscribing papers by Christmas. Although doing the strip increases his work week by hours, he believes his editorial cartoons have improved as a result: "The strip lets me get away from political thoughts, which refreshes my brain."

FELT TIP PEN ON PAPER | 17 X 19.8 CM. | 1986

MIKE LUCKOVICH
BORN 1960

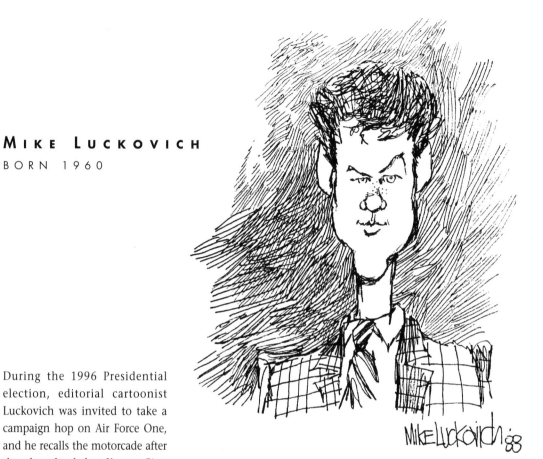

Mike Luckovich '88

During the 1996 Presidential election, editorial cartoonist Luckovich was invited to take a campaign hop on Air Force One, and he recalls the motorcade after the plane landed at Kansas City: "As we snake along in the motorcade, people are standing outside of homes and businesses, waving and cheering. Young and old, rich and poor — all just to see a cartoonist." But Luckovich wasn't always a celebrity. In fact, he wasn't always a cartoonist. He graduated from the University of Washington in 1982, sent out resumes all over the country, but didn't get a single positive response. It was a recession year. So he took a job selling life insurance, which he did for two years before being hired by the *Greenville News* in South Carolina. He'd heard of the opening through an ad in *Editor & Publisher*, to which, in desperation, he had subscribed. "I kept a copy of *Editor & Publisher* open beside me on the seat of my Pinto as I drove around selling people life insurance," he remembered. "It gave me hope. I hated selling life insurance." He stayed in South Carolina only nine months before leaving for a larger venue, the *Times-Picayune* in New Orleans; and he stayed there until 1989, when the *Atlanta Constitution* hired him. Luckovich loves his work: "The greatest thing for me is still coming in every day and drawing a cartoon." His hope every day is to make a cartoon that is both humorous and pointed; he dislikes editorial cartoons that just tell jokes. "I want to get my point across and show the flaws in the other side's arguments or show this individual to be wrong somehow, through ridicule in my cartoon," he once said. "The fun part of the job is knowing that I'm going to make somebody squirm." He received a Pulitzer in 1995 and a Presidential self-caricature from Clinton on that campaign flight: "Mr. President," Luckovich argued, "remember that Ronald Reagan did a caricature of himself and look what happened to him — he got a second term." It was a persuasive argument.

INK ON PAPER | 13.3 X 17 CM. | 1988

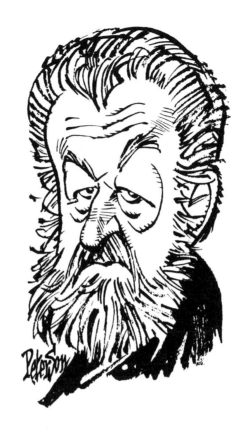

ROY PETERSON
BORN 1936

Like many other cartoonists, Canadian Peterson "always wanted to be a cartoonist." After graduating from high school, he started working in advertising and display at Vancouver department stores while freelancing to magazines the gag cartoons he drew on weekends. Eventually, he was selling to magazines in the U.S., Canada, and the United Kingdom but not enough to make a living. Still, he maintained his weekend cartooning regimen for eight years. Towards the end of that period, he did some editorial cartooning for the *Vancouver Province* but quit when the editors asked him to draw the ideas they supplied. Then in 1962, he joined the *Vancouver Sun,* doing one editorial cartoon a week (the paper already had another editorial cartoonist on staff, Len Norris) and several cartoon illustrations each week for the op ed page. "Nobody at the *Sun* has ever told me to draw any ideas except my own," Peterson once said. "A lot of newspapers argue that since the editorial cartoon appears on the editorial page, it should reflect the editorial policy of the paper. I've never particularly bothered with that. The public is smart enough to know that the cartoon is just a personal comment. A cartoonist signs his cartoon, so it is the same as a signed newspaper column." Peterson also freelances, producing full-color caricatures for the covers of numerous magazines and illustrating children's books that are part political fable. He is a six-time winner of the National Newspaper Award, the Canadian equivalent of the American Pulitzer.

INK ON PAPER | 6.2 X 10.7 CM. | 1987

JOHN (GIOVANNI) FISCHETTI
1916 | 1980

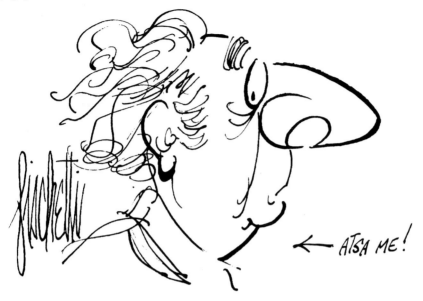

← ATSA ME!

Fischetti's first cartooning job after leaving Pratt Institute in 1939 was at the Disney Studio — an assembly line for artists, he called it, where one worked at the "oars of the galley ship" — which he left, he once said, "incoherent." He then freelanced in Los Angeles and San Francisco before arriving in the summer of 1941 in Chicago, where he continued freelancing, doing illustrations and spot drawings for *Coronet* and *Esquire* until landing a job as associate editorial cartoonist for the *Chicago Sun,* then in its pre-publication stage. Soon after Pearl Harbor, Fischetti enlisted in the Army, spending World War II in the European Theater, almost two years on the staff of *Stars and Stripes,* where he met cartoonist Dick Wingert. Upon discharge, he continued freelancing and also assisted Wingert on the panel cartoon, *Hubert.* In 1951, he joined the Newspaper Enterprise Association (NEA) in New York as the political cartoonist in the syndicate's national package. It was a precarious situation for an opinion monger: "When you're doing political cartoons for a service and you happen to irritate an editor in Curmudgeon, Georgia, he can threaten to cut off the *whole* package if that so-and-so Fischetti keeps on disagreeing with him," Fischetti wrote in his autobiography, *Zinga Zinga Za!* In 1961, he resigned and went to work for the *New York Herald-Tribune,* insisting upon complete editorial freedom as a condition of his employment. He also revamped his format and drawing style, adopting a horizontal panel rather than the traditional vertical panel and abandoning the editorial cartoonist's customary grease crayon in favor of linework and gray tone (Ben Day or Zip-a-tone). He had been contributing regularly to England's *Punch* magazine, and his new editorial cartoon style was distinctly European in appearance. Fischetti's innovation paved the way to the subsequent acceptance of Australian Pat Oliphant's similarly composed editorial cartoons later in the decade, an acceptance that virtually revolutionized the American editorial cartoon. When the *Herald-Tribune* folded in 1966, Fischetti moved to the *Chicago Daily News,* winning the Pulitzer in 1969.

MILT PRIGGEE

BORN 1953

"The cartoon's power is in the picture, not in the punchline," says Priggee, editorial cartoonist for the Spokane, Washington, papers *(Spokesman-Review* and *Spokane Chronicle)* and master of the splashiest, most energetic and vital brush stroke in print. "My favorite cartoon is the kind that when you put your hand over the caption or balloon, you can still receive the impact of the message. If you can put your hand over the art and just read the balloon or caption and get the message, what's the purpose of the visual image?" After graduating from Adams State College in Alamosa, Colorado, in 1976 with a degree in fine art, Priggee went to Chicago and with the help of John Fischetti (q.v.) freelanced editorial cartoons to the city's papers, selling

his first in 1976 to the *Chicago Daily News.* In 1978, he became the regular cartoonist at the weekly *Crain's Chicago Business,* where he stayed until he found an editorial cartooning berth in 1982 at *The Journal Herald* in Dayton, Ohio. When that paper folded in 1986, Priggee took his editorial cartooning to Spokane. "I can't imagine doing anything else," he said. "I'm very fortunate to have a daily platform to visually speak to a number of people about whatever is on my mind, to be able to spend the best hours of the day visually expressing myself. The other side of the coin is that a lot of people do not even know what an editorial cartoon is. They mistake it for a comic strip, an advertisement, a photograph, the newspaper's endorsement, or a non-offensive illustration. Unfortunately, too

many editors/publishers think a cartoon is all of the above." In addition to advocating absolute freedom of expression for editorial cartoonists, Priggee became the co-producer of a unique syndicated daily comic strip in 1997. Called *Us and Them,* it was created in 1995 by Wiley Miller (q.v.) and features a female protagonist one day, a male the next. The strip is drawn

by Priggee on the male day; by Susan Dewar on the female day. Counting cartoonist Fischetti as his mentor, Priggee recalled Fischetti's "sure-fire way" to tell if a cartoon is good or not: "When you look at it, do you ask yourself, Damn — why didn't I think of that? If you do, it's a good cartoon."

WATCH OUT— I'M TOLD HE BITES

D R A P E R H I L L
BORN 1935

A historian and scholar of the arts of editorial cartooning as well as an adroit practitioner in the arena, Hill here depicts himself framed by Mark Cohen. Hill often appears in his own cartoons, playing the role of Everyman: "Mine is the most readily available mug on which I can suggest all the emotions I need," Hill explained, " —stupidity, incompetence, complete bewilderment." While an undergraduate at Harvard University, Hill sharpened his cartooning skills by working on the *Harvard Lampoon* (whose editor, or "president," in Hill's freshman year was John Updike) and whetted his scholarly appetite by producing a lengthy paper entitled *Image of America in English (viz. Punch) Cartoons* and his undergraduate thesis on Joseph Keppler, the artist-founder of *Puck*. After a post-graduate 1957 summer tour of Europe during which he initiated a life-long friendship with England's famed editorial cartoonist David Low, Hill was hired by the *Patriot Ledger* in Quincy, Massachusetts, as reporter and odd-job illustrator (which included the occasional editorial cartoon). In 1960, he left on a Fullbright scholarship to continue his artistic and scholarly pursuits in London, where he began research that resulted in his first book, *Mr. Gillray the Caricaturist* (1965). When he returned to the U.S. in 1964, he became editorial cartoonist for the *Worcester* (Massachusetts) *Telegram* until 1971 when he went to Memphis and the *Commercial Appeal*, where he stayed until joining the *Detroit News* in 1976. He continues researching and writing in his spare time (most recently, on a biography of Thomas Nast, q.v., for which purpose he received a Guggenheim Fellowship in 1983-1984), often reflecting his scholarly passion in his cartoons by including verbal or visual allusions to literature or history. While the sense of the cartoon requires no special knowledge from the reader, Hill says, "I just can't function without thinking of the cartoonist as a possible delivery system for grace notes that reward the reader who wants to stick around a bit longer than it takes to get the central point."

SIGNE WILKINSON
BORN 1950

"Newspapers are among the worst offenders when it comes to backing down on issues," Wilkinson once said. "It takes only two complaining readers for editors to dive under their desks." The first woman editorial cartoonist to win a Pulitzer (1992), she scoffs at advocates of political correctness and opponents of stereotyping. "Every organized group wants to have control over their own stereotypes," she said. "I'm sorry, they can't. We have joint custody." After graduating from Denver University with a degree in English, Wilkinson worked as a freelance reporter in West Chester, Pennsylvania, for several years, then freelanced editorial cartoons until securing her first post as an editorial cartoonist at the *San Jose Mercury News* in 1982. Three years later, she moved her drawing board to the *Philadelphia Daily News*. Possessed of a tart and ready wit as well as a daring pen, Wilkinson advocates taking strong stands, saying that "fear of offending creates a mushy middle that is not very firm footing; you don't get any wildness, there's no craziness and no strong stands." As president of the Association of American Editorial Cartoonists (1994-1995), she took a strong stand on cartoons: "Cartoons are a reason people read newspapers. Thus, newspapers should have more rather than fewer, run them bigger rather than smaller, and should feature them prominently rather than hide them. That's my platform," she said, "— that and condom distribution. The boys refer to me as Signe Rodham Wilkinson. They're scared. They think I have a health plan to foist on them."

GEOFFREY MOSS
BORN 1938

BERT WHITMAN
1908 | 1990

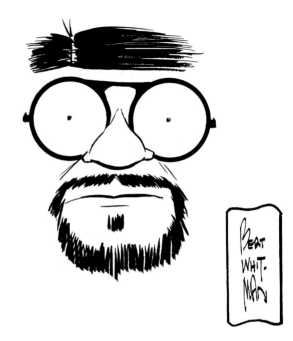

Beginning his artistic career in the art restoration department of New York's Metropolitan Museum of Art in 1963, Brooklyn-born Moss spent only about ten years there before becoming a freelance illustrator and cartoonist. Syndicated since 1974, he says his political cartoons are the first captionless cartoons to be nationally distributed. Moss has been a guest lecturer at both the Pratt Institute and Parsons School of Design, and he has illustrated several books in addition to those he authored — *Arthur's Artichoke* and *The Art and Politics of Geoffrey Moss*.

A jack of many cartooning trades, Whitman started his career in the art department of the *Los Angeles Times* in the mid-1920s. Ten years later, however, he was back in his native New York, freelancing with newspapers and also producing comic book material for one of the industry's pioneers, Major Malcolm Wheeler-Nicholson, who laid the foundation upon which DC Comics is built. In 1940, Whitman set up his own comic art "shop," which produced original stories for a variety of comic book publishers. His bullpen included, at one time or another, such cartooning luminaries as Jack Kirby (q.v.), George Storm, Mort Drucker (q.v.), and Frank Robbins. His operation shut down after a relatively short period, and

MOSS: INK ON PAPER | 20 X 16.6 CM. | 1989 WHITMAN: INK ON PAPER | 12.4 X 14.2 CM. | 1976

Whitman went to work for Fawcett and turned out numerous comic book features about second-banana characters, some serious, some humorous. Whitman also had a hand in several comic strips. He did *Mr. Ex,* a short-lived Sunday adventure strip for the *Chicago Tribune's* weekly *Comic Book Magazine* in the early 1940s, and he ghosted *Scorchy Smith* for Robbins for a few weeks in 1943. In 1942, he started his own strip, *Debbie Dean,* about a girl reporter, drawn in a Caniffesque manner. When the strip was discontinued at the end of the decade, Whitman took up editorial cartooning, first at the *Stockton Record* in California and then at the *Phoenix Gazette* in Arizona. He remained an editorial cartoonist for the rest of his career.

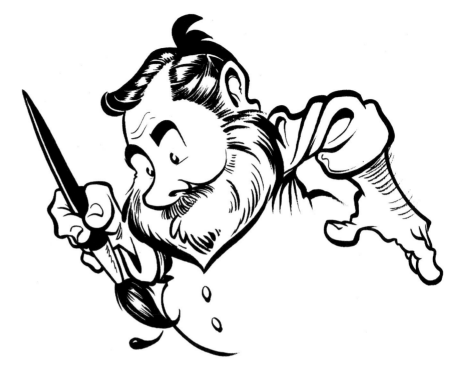

JIM LARRICK
BORN 1946

The wielder of a brush that makes one of the juiciest lines in cartooning, Larrick joined the *Columbus* (Ohio) *Dispatch* in 1982 after working a gaggle of journalistic assignments for the *Clarion-Ledger* in Jackson, Mississippi — general assignment reporter, business editor, sports cartoonist, and editorial cartoonist.

His experience as a reporter gave him an appreciation of noisy newsrooms, and when he found himself in a private office at the *Dispatch,* he couldn't work. "It was too quiet," he said. "I couldn't get the juices going. I kept walking into the newsroom." Eventually, he found himself more at home in a cubicle near the rest of the staff.

Larrick sees himself as a journalist rather than an artist. "I always say an editorial cartoon is an editorial that is drawn rather than written. This is different than the gag approach of some editorial cartoonists." His reporting experience was invaluable: it gave him an understanding of "what the news is" (and what might be libelous in his cartoons). "It also gives me a greater appreciation of deadlines," he said.

JACK OHMAN
BORN 1960

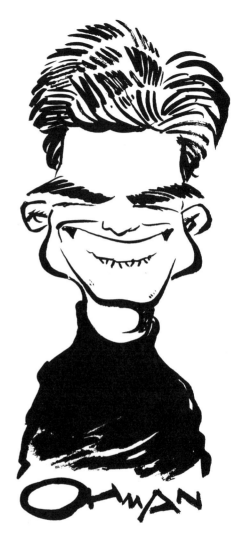

In 1982 at the age of twenty-two, Ohman was the youngest editorial cartoonist in the country working full-time at a major daily newspaper, the *Detroit Free Press*. By the time he reached that tender age, Ohman had already held the editorial cartoonist chair at another major daily, had been published in *Newsweek,* and had run his own newspaper syndicate. He didn't set out to be a cartoonist: he wanted to go into politics. He'd worked on a state-wide campaign while in high school, and when he entered the University of Minnesota at seventeen, he majored in political science. He fell into the editorial cartoonist slot at the campus newspaper not so much because he could draw well but because of his first-hand experience of real-life politics. After a year, Ohman started his own syndication operation in Minnesota to distribute the cartoons he produced for the *Minnesota Daily.* In 1980, Tribune Media Services took over syndicating his cartoon;

his work attracted the attention of editors at the *Columbus Dispatch*, and he started cartooning there in the spring of 1981. About that time, Jeff MacNelly (q.v.) stopped editorial cartooning (briefly) to concentrate on his comic strip, *Shoe,* and TMS announced that Ohman would be MacNelly's replacement. He lost only about ten percent of MacNelly's client papers; by the time MacNelly returned, Ohman was working at the *Detroit Free Press*, where he remained until 1983, when he heard of an opening at the *Oregonian* in Portland, his new wife's hometown. They moved to the Northwest, and there, as one of only a few editorial cartoonists in the region, Ohman soon felt an obligation to cartoon about the environment as well as politics. In 1994, Ohman started doing a daily syndicated comic strip in addition to his editorial cartoon. Called *Mixed Media,* it has no cast; instead, Ohman offers his view of American life awash in popular culture. Although he sees a place for such

social commentary in editorial cartoons, he's glad to have the strip as an outlet for this kind of humor so that he can concentrate on current events in his editorial work. He finds that doing a comic strip has changed his life: "With the

political cartoons, you just go home at the end of the day: it's done and you don't think about it again until tomorrow. But you can always work on a comic strip; it's like having a novel that's never finished."

JEFF MacNelly

BORN 1947

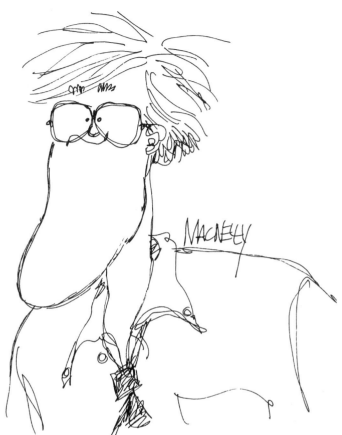

Winner of both the Pulitzer (thrice, 1972, 1978, 1985) and the Reuben (twice, 1978, 1979, the latter for his comic strip, *Shoe),* MacNelly, who left college before getting a degree, could have inspired a generation of college drop-outs; instead, he inspired a generation of editorial cartoonists (a notion he pooh-poohs, saying that if there are MacNelly clones out there, then he is a clone of Pat Oliphant or Paul Conrad). He joined the staff of the *Richmond News-Leader* in 1970, having discovered that he could not live on the salary he was paid by a twice-weekly community newspaper he'd left college to draw for the previous year. In 1977, he launched *Shoe,* a comic strip about a flock of birds who produce a newspaper called *The Treetops Tatler* and wisecrack about newspapering, politics, and other social phenomena, thereby raising the bar for those who saw him as an example. Although he was not the first editorial cartoonist to simultaneously produce a syndicated daily comic strip, he was the first whose strip was a roaring success, reaching over one thousand client papers. In the next decade, several of his editorial colleagues also started comic strips. MacNelly retired from the *News-Leader* in the summer of 1981 but, missing the excitement of the political arena, took up the lance again the following winter, producing three cartoons a week for the *Chicago Tribune.* About his profession, MacNelly has said: "Political cartoonists violate every rule of ethical journalism — they misquote, trifle with the truth, make science fiction out of politics and sometimes should be held for personal libel. But when the smoke clears, the political cartoonist has been getting closer to the truth than the guys who write political opinions." He also said that he knows many "great editorial cartoonists who, if they couldn't draw, would be hired assassins."

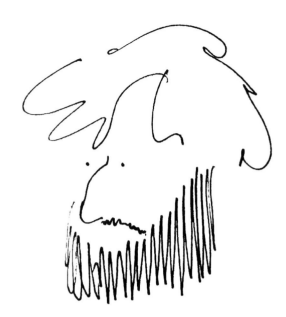

TONY AUTH
BORN 1942

At the University of California at Los Angeles, Auth majored in "biological illustration." Said he: "It was really a double-major in art and zoology. I knew there were a lot of starving artists in the world, and I didn't intend to become one of them." After graduation, he worked as a medical illustrator at Rancho-Los Amigos Hospital, a large teaching facility, and he was pleasantly surprised at the ready acceptance he encountered when lacing his illustrations with humor. By 1965, the Vietnam War debate had aroused his political instincts, and he began doing an editorial cartoon for the *Open City,* a weekly underground paper in Los Angeles. He showed his work to Paul Conrad at the *Los Angeles Times,* who urged him to produce more cartoons, so Auth volunteered at the UCLA campus newspaper. For the next four years while working at the hospital, he did three cartoons a week for the *Daily Bruin* and, at the same time, sent his work out to the underground circuit with the Sawyer Press Syndicate — and looked for a regular berth. In 1971, he finally landed at the *Philadelphia Inquirer,* where he sees his role as "confronting people with things they really don't want to see." A Pulitzer winner (1976), Auth is always angered by the abuse of power, particularly "institutional abuse of power because that's something that we, as a society, are really much better equipped to deal with — and it's also something that we're more tolerant of." The most important elements of an editorial cartoonist's work, he believes, are conviction and passion.

Says he: "I enjoy the gag-type editorial cartoons that have been appearing on our editorial pages, and I wish I were better equipped to do that kind of work because on a day when you're not mad about something, you've still got to fill your space. But there is nothing as good in our field as a good, strong passionate editorial cartoon."

THOMAS NAST
1840 | 1902

"THE TREE OF KNOWLEDGE."

"PLEASE" NOTICE. STANDING ROOM ONLY.

BOX-OFFICE. LYCEUM THEATRE.

"SOUR" FRUIT FOR FOXEY — (NOT AN ÆSOP FABLE)

If editorial cartooning in the United States has a patron saint, it's Nast (who made himself a character in his cartoons often — here, expressing in a privately-circulated drawing his displeasure at not obtaining a free ticket to a play). Born in Bavaria, he came to this country with his family in 1846, and at the age of fifteen, he was hired to do news sketches for *Frank Leslie's Illustrated Newspaper*. In 1859, working for the *New York Illustrated News,* he went abroad to report on the campaigns of the Italian patriot Garibaldi. Investing his drawings with his approval of the Italian's activity, Nast turned political rather than reportorial.

When he returned to the U.S. in 1861, he joined *Harper's Weekly,* where he found fame. He was so effective a spokesman for the North in the Civil War, that Lincoln called him "our best recruiting sergeant." And in the 1868 Presidential election, he worked so well for U.S. Grant that Grant later declared he owed his victory to "the sword of Sheridan and the pencil of Thomas Nast." But it was Nast's assault on corrupt New York City politics that

brought him cartooning sainthood. Almost all big city government at the time was ridden with grafters and influence peddlers; but when Nast's cartoons attacking the so-called "Tweed Ring" of Tammany Hall resulted in William Tweed and his minions being voted out of power, Nast demonstrated in the most convincing way possible the power of the pen — and, therefore, of the editorial cartoon. After Nast, no cartoonist could be safely

relegated to the realm of "harmless entertainment." In 1886, he left *Harper's* and began a sad series of short engagements on a succession of papers, never again attaining the power and influence he had once enjoyed. Theodore Roosevelt, hearing of Nast's financial plight, appointed him consul to Ecuador, where he died of fever within six months. Nast is credited with establishing the elephant as a symbol for the Republican Party, and he also created the popular image of Santa Claus as a jovial white-bearded fat man. Fittingly perhaps, the other figure for which Nast is remembered is also a fat man. Boss Tweed, corpulent with graft, is, according to critic Adam Gopnik, "Santa's evil twin, the embodiment of Bad Greed whereas Santa is the embodiment of Good Greed."

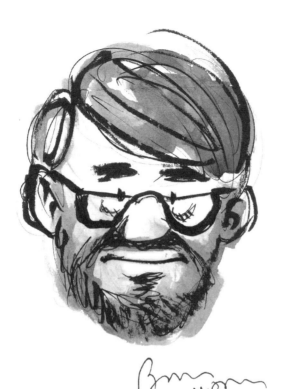

1977

BILL MAULDIN
BORN 1921

Mauldin was famous as an anti-authoritarian critic by the time he was twenty-four years old. He acquired his notoriety in the most authoritarian of societies, the U.S. Army during World War II: in the cartoons he drew for military newspapers, he depicted the life of the "dogface" (foot soldier) the way it was. Rained on and shot at and kept awake in trenches day and night, the combat soldier was wet, scared, dirty, and tired all the time; and Mauldin's spokesmen — the scruffy, bristle-chinned, stoop-shouldered Willie and Joe in their wrinkled and torn uniforms — were taciturn but eloquent witnesses on behalf of the prosecuted. Through simple combat-weary inertia, they defied pointless army regulations and rituals: they would fight the war, but they wouldn't keep their shoes polished. Their popularity was an affront to generally accepted notions of military propriety, but Mauldin never wavered even after General George S. Patton leaned on him. "I knew these guys best," Mauldin said, "and [the cartoons] gave the typical soldier an outlet for his frustrations, a chance to blow off steam." Published in *Stars and Stripes* and syndicated stateside as *Up Front,* the cartoons revealed just what sort of hell everyday war was and won Mauldin his first Pulitzer Prize in 1945. Returning to civilian life a celebrity with the circulation of his syndicated cartoon doubled, Mauldin soon found that his approach to car-tooning wasn't working: cartoons that were critical of post-war America, while taking essentially the same satirical stance as he'd taken in the service, were seen as "political" rather than "enter-taining," and newspapers dropped his feature quickly, saying they had their own political cartoonist. Mauldin dropped out, too, for about a decade, writing books, acting in movies, and running (once — unsuccessfully) for Congress. Then in 1958, he was invited to replace Daniel Fitzpatrick, the retiring political cartoonist at the *St. Louis Post-Dispatch*, and suddenly, Mauldin's liberal voice had a home again. Winning his second Pulitzer in 1959 and the Reuben in 1961, Mauldin continued the battle he had begun in the Army. "I'm against oppression," he said, "— by whomever."

INK AND WATERCOLOR ON PAPER (DETAIL) | 12.2 X 19.2 CM. | 1977

KARL HUBENTHAL

1917 | 1998

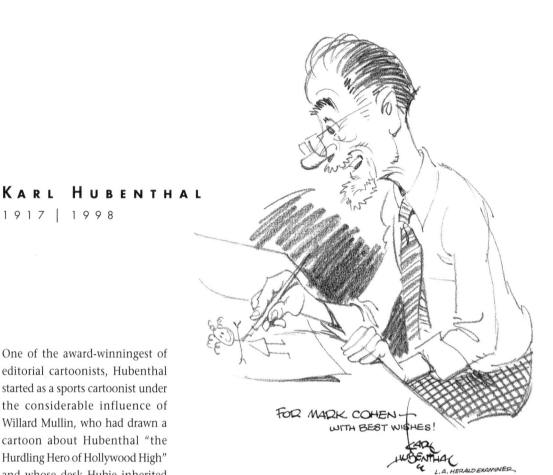

FOR MARK COHEN—
WITH BEST WISHES!

KARL
HUBENTHAL
L.A. HERALD EXAMINER

One of the award-winningest of editorial cartoonists, Hubenthal started as a sports cartoonist under the considerable influence of Willard Mullin, who had drawn a cartoon about Hubenthal "the Hurdling Hero of Hollywood High" and whose desk Hubie inherited when he joined the art department of the *Los Angeles Herald-Express* in 1935. "I shall never forget that desk," Hubenthal wrote. "It was covered with a mosaic of J.C. Leyendecker *Saturday Evening Post* covers. Willard had carefully cut out around the figures, pasted them down in overlapping fashion and varnished the whole thing."

Hubenthal's other cartooning idols were George Herriman (q.v.) and Will Gould, whom Hubenthal assisted for a time on the comic strip *Red Barry* ("he taught me how to letter, flow a pen line and spot blacks"). After his 1942-1945 stint in the Marine Corps, Hubenthal did semi-humorous magazine and advertising illustration until 1949

when William Randolph Hearst summoned him back to the sports pages, and, a few years later, convinced him to take up editorial cartooning. "I went kicking and screaming every step of the way," Hubenthal recalled. "I wanted to stay in the toy department with sports, but, as usual, Hearst got his way." Not quite. Hubenthal nego-

tiated a contract that gave him complete editorial freedom. "That was quite a departure," he noted: "In those days, the editorial page cartoon was considered a mouthpiece of the publisher just as the adjoining editorial column reflected his policy." Although he claimed no interest in politics, Hubie cartooned about it for the next thirty years, retiring in 1982, and along the way won twenty-five Freedoms Foundation Medals, the National Headliner's Club Award, the NCS Plaque for Editorial Cartooning, and numerous others. A founder of the Association of American Editorial Cartoonists (he also designed the AAEC logo), he rejoiced in the disappearance of the old-fashioned "moralistic" editorial cartoon a-flutter with labels but believed that humor in editorial cartooning should be thought-provoking not just hilarious.

PENCIL AND INK ON PAPER | 17 X 21.5 CM. | 1988

BEN SARGENT
BORN 1948

Born to newspapering parents in Amarillo, Texas, Sargent always thought of himself as a newspaperman. He majored in journalism at the University of Texas, and when he graduated in 1970, he went to work as a reporter for the *Corpus Christi Caller-Times,* moving on shortly to cover the state capital in Austin for United Press International and Long News Service (an independent Texas op-

eration) and, eventually, covering state politics for the *Austin American Statesman*. But he was always drawing. As he sat listening to the drone of the legislature, he doodled. And his doodles came to the attention of his editor, who asked him to do illustrations part-time. Starting with three cartoons a week in August 1974, Sargent was

drawing one every day before the end of the decade, and in 1982, he won a Pulitzer. The first full-time editorial cartoonist at the paper, Sargent delights in the job: "Now I'm getting paid for what I used to get in trouble for when I was in school — drawing in class." Saying that he is "an editorialist with a mindset of absolute irreverence for

everything," Sargent is actually a dedicated liberal in a state that needs liberals as antidote. Austin is a liberal town, Sargent notes, but in the rest of the state, people seem to have a "fundamental ignorance about civil liberties." Eschewing the chemically treated drawing papers used by many of his colleagues, Sargent draws the old-fashioned way, achieving gray tone with painstakingly applied crosshatching. He produces at least two cartoons a week on Texas politics because they're "so incredible." Texas politicians, he maintains, "go to all sorts of strange excesses of fatuousness and stupidity. It has sort of a special quality all its own."

INK ON PAPER | 9.2 X 13.6 CM. | 1986

AL JAFFEE
BORN 1921

No matter which way you look at it (try upside-down), Jaffee is an inventive picture-maker. His most notorious invention is doubtless a feature of *Mad* magazine called the "fold-in," a picture that, when folded into vertical fourths to obscure the central half of the drawing, presents a completely different image (and also a wry comment on the initial image). Born in Savannah, Georgia, he grew up in a small town in Lithuania, his family returning to the U.S. and New York City in time for him to attend the famed High School of Music and Art, where other *Mad* men (Harvey Kurtzman,

q.v.; Will Elder, q.v.) would also tread shortly thereafter. His first cartooning was for comic books in 1941 — a two-page filler for *Military Comics* called "Inferior Man;" then similar features for other companies. After serving in the Army Air Corps during World War II, Jaffee continued supplying comedy material for comic books *(Super Rabbit, Patsy Walker)* until a fated day in 1955 when he joined the storied gang of mental defectives to help Kurtzman convert his antic comic book to a manic magazine. It was, Jaffee later claimed, the positive turning point in his career. His regular appearances in the magazine attracted the attention of advertising agencies, and he soon had a substantial income from the commercial work he did in addition to his *Mad* machinations. In 1958, he launched a syndicated newspaper feature called *Tall Tales*, a long, thin pantomime panel, which ran until 1965. When the National Cartoonists Society asked him to state his life's goal, Jaffee replied: "To become a vital force reshaping the social, intellectual, and political destiny of mankind with a view toward bringing peace, prosperity, and a higher degree of understanding between people regardless of race, color, or creed throughout the world and elsewhere." A worthy ambition no matter how you look at it.

INK ON PAPER WITH BENDAY | 12.6 X 19.5 CM. | 1971

SERGIO ARAGONÉS

BORN 1937

Aragonés is a genuinely international cartoonist. Most of his cartoons are wordless so that they can be understood by everyone, regardless of their language. His passion for pantomime cartooning started early. Born in Spain, he grew up in France until his family moved to Mexico when he was five or six. He enjoyed seeing cartoons from all over the world, but unless he read the language, he could understand only the pantomime cartoons by European cartoonists. He resolved then to do cartoons without words. In college in Mexico, Aragonés studied to be an architect and acted in plays, and subsequently, he studied mime, worked as a stunt person, animator, and photographer. He came to the U.S. in 1962, arriving in New York City with $20 in his pocket. He survived by working nights in a Greenwich Village coffee house, reciting flamenco poetry; during the day, he drew cartoons, which he tried to sell every Wednesday, the day the gag cartoonists in the area made the rounds of magazine cartoon editors' offices. The editors thought pantomime cartoons were too strange for their publications and urged Aragonés to seek out *Mad* magazine. He did. And before the end of the year, the first of his cartoons began appearing in *Mad*. Soon, he was decorating the margins of the magazine with tiny pantomime comedy. In addition to his *Mad* cartoons, Aragonés plotted humor stories for DC Comics in the 1970s, and in 1982, he launched his own comic book. Called *Groo*, it features a catastrophically stupid barbarian warrior in some bygone age. Unlike most of Aragonés' characters, Groo talks, the verbiage being supplied by writer Mark Evanier, working from Aragonés' hints and nudges in the pencilled version of the story. Reuben winner (1997) Aragonés travels a good deal and delights in meeting cartoonists in other lands. They comprise a sort of universal fraternity. "All over the world, cartoonists know each other," Aragonés says. "Cartooning is something that is within you, and the same thing goes on inside every cartoonist."

JACK DAVIS

BORN 1926

Called the "quintessential cartoonist's cartoonist" by Marvel maven Stan Lee, Davis may be the most versatile of the *Mad* men: adept at either serious straight adventure illustration or the exaggerative slapstick comedy, black-and-white or color, he is also one of the fastest artists in the game. A Georgia boy, he went into the Navy right after high school and drew cartoons about a ne'er-do-well sailor whose resemblance to George Baker's famed Sad Sack was, Davis says, "no accident." The character reappeared in the campus newspaper when Davis attended the University of Georgia on the G.I. Bill. Finishing college in 1949, Davis went to New York and the Art Students League, attending classes at night and looking for

work during the day. He knocked on the doors of every comic book publisher in the city, winding up, finally, at the E.C. Comics office; they were impressed with samples of his skill and immediately gave him a script to illustrate, beginning

a long association. Davis drew for E.C.'s war, crime, and horror titles — and for the first issue of *Mad*, which started as a comic book in 1952, and for the first issues of the magazine version, which debuted in 1955. When *Mad*'s originator

Harvey Kurtzman (q.v.) left E.C. in late 1955, Davis went with him to help develop a slick humor magazine called *Trump*. Published twice in 1957 by *Playboy*, the magazine failed, and from 1957 to 1963, Davis scrambled to make a living. He concocted and tried unsuccessfully to sell several comic strips, mostly on Western themes, but *Beauregard*, his most extensive attempt, starred a comical Confederate soldier. Davis did comic book stories for an array of publishers; and he also ventured into illustrating — movie posters, record jackets, books, magazine covers, and advertising. Eventually, deploying a flair for caricature, he did more than forty covers for *Time* and two dozen for *TV Guide*. In jest, Davis accounts for this kind of success by explaining that he was hired by art directors who had grown up on *Mad*. In 1965, he began making occasional appearances in *Mad* again. "I love drawing," he says, "but I can't read or write."

FELT TIP PEN ON PAPER | 13.8 X 27.6 CM. | 1976

NORMAN MINGO
1896 | 1980

Norman Mingo

Mingo walked into the *Mad* office of William Gaines one day in 1956 in response to a classified ad in the *New York Times*. The ad wanted an artist to paint covers for the magazine. Al Feldstein, the editor at the time, gave Mingo some sketches of Alfred E. Neuman, the "What — Me Worry?" kid, and Mingo painted the first life-like portrait of the magazine's mascot. The painting appeared on the cover of the December issue (No. 30), announcing Neuman's write-in campaign for President of the U.S. The mascot idea, Feldstein later explained, came from the *Playboy* rabbit and *Esquire's* goggle-eyed old roue. The actual origin of Neuman's gap-toothed lop-sided jug-eared visage, however, is uncertain; Harvey Kurtzman (q.v.) had played with the image early in 1955 (*Mad* No. 21, dated March) and the halftone source of the face first appeared on the cover of *The Mad Reader*, a 1954 reprint paperback. But Feldstein wanted a "definitive portrait" that would look as if it were of a real person. Mingo's version was so definitive that it has never been altered. Mingo's career began while he was in high school in Chicago: he did model cards for Hart, Schaffner and Marx. He served in the Navy during World War I and returned to study art at the Chicago Art Institute and, later, at the Art Students League in New York. In 1923, Mingo organized his own art agency, with offices in five midwestern cities producing material for the likes of Studebaker and Packard in hundreds of full-page and double-page spreads in *Saturday Evening Post* and other slick magazines. The Depression dissolved the agency, and Mingo went to New York as a freelance illustrator, doing advertising and calendar girl art. In 1953, he opened a studio for silk screening: "It turned out grand work but lost money and wiped me out," Mingo explained. It was then that he answered the fateful classified ad. At the same time, he took a position at an ad agency, and when the combined workload proved too much, he left *Mad*. But he returned in 1963, becoming the most prolific of *Mad's* cover artists until the mid-1970s.

INK ON PAPER | 10.8 X 18.8 CM. | 1976

HARVEY KURTZMAN

1924 | 1993

The creator of *Mad,* Kurtzman may be the most influential American cartoonist since Walt Disney: Disney's vision of America as a small town full of good neighbors and obedient children was sharply contradicted by Kurtzman's satiric portrait of an urban society swarming with grasping politicians and greedy promoters and sexist bosses. Both versions persist but not simultaneously. The nation's youth outgrow Disney as soon as they are old enough to begin reading *Mad,* which infects them with a certain cynicism about the icons of American culture as well as the functioning of its institutions. (Most of the underground cartoonists of the late 1960s were inspired by *Mad.)* Kurtzman attended Manhattan's High School of Music and Art, where he met Will Elder (q.v.); he also went to Cooper Union at night, working a variety of day jobs and winding up at a comic art "shop" that produced comic book stories for several publishers. In the Army during World War II, he made visual training aids. Returning to civilian life in 1945, he freelanced until 1950, when he began drawing for William Gaines' Entertaining Comics (E.C.), which had just launched a "new trend" of horror and science fiction titles. When Kurtzman suggested that E.C. start an adventure story title, Gaines complied, making Kurtzman the editor. But Kurtzman did more than edit *Two-fisted Tales* and, later, its companion, *Frontline Combat*: he wrote the stories, researched them thoroughly, and made detailed, panel-by-panel layouts (that he insisted the artists follow exactly), introducing an understated but highly dramatic manner of storytelling. Concentrating on war stories because of the ongoing Korean conflict, Kurtzman eschewed the usual comic book glorification of battlefield experience, resolutely deglamorizing it instead. In 1952, capitalizing on Kurtzman's penchant for humor, Gaines launched *Mad* (Kurtzman's shortened version of the working title, *E.C.'s Mad Mag).* After a few issues of rampant parodies, Kurtzman perfected the *Mad* formula: by extending a premise of everyday life to its logical and usually ludicrous conclusion, he made parody a powerful vehicle for satire, ridiculing popular culture mercilessly. With the July 1955 issue, *Mad* appeared in magazine format. But Kurtzman, seeking an even more sophisticated vehicle, left E.C. later that year to join Hugh Hefner at *Playboy* in creating a slick humor magazine, *Trump,* which failed after two 1957 issues. Kurtzman followed with *Humbug* and *Help,* but neither lasted. Then in 1962, he and Elder began producing for *Playboy* a fully painted satiric color comic strip called *Little Annie Fanny.* He also taught cartoon storytelling at the School of Visual Arts, but his greatest teaching achievement was establishing *Mad.*

FELT TIP PEN ON PAPER | 17.6 X 25.5 CM. | 1977

BOB CLARKE
BORN 1926

SELF PORTRAIT OF BOB *Clarke*
AFTER 38 YEARS WITH
MAD MAGAZINE!

Believe it or not, the closest Clarke's mother came to art was attending school with Norman Rockwell, but his father was a painter. He painted boats. Not pictures of boats, just boats. He also did more creative artwork in his spare time, and so did all his children. Young Bob's big break came while he was still in high school: he won a contest to join the staff of Robert Ripley's (q.v.) famed *Believe It Or Not* syndicated feature. Clarke did spot art ("rutabaga in the shape of a

poodle"), some research, and the lettering of the Spanish version of the feature. After high school, Clarke enlisted in the Army and wound up in Germany in the closing weeks of World War II; he volunteered for duty on *Stars and Stripes* and was art director when discharged from service in 1946.

Back in the states, he joined an advertising agency, becoming an art director before leaving to freelance in 1955. Doing storyboards, filmstrips, and package design, he heard that *Mad* was looking for more cartoonists (because Harvey Kurtzman, q.v., had just departed). He submitted

samples and was soon numbered regularly among "the usual gang of idiots" who produced the nation's premiere satirical humor magazine. Employing a clean, flowing brushline, Clarke frequently did parodies of advertising and even a feature called "Believe It Or Nuts!" that spoofed guess-who. For covers of various *Mad* imprints, he also painted the magazine's lunatic-looking mascot, Alfred E. Neuman. "Alfred's facial charm," Clarke observed, "is that one eye is higher than the other. I have the impulse to 'correct' that each time I draw him." When not cartooning for *Mad*, Clarke does straight and humorous illustration for numerous magazines.

In the image: 4/90 / DEAR MR. COHEN — / SORRY. NO / SELF-PORTRAIT. / TOO DEPRESSING. / SINCERELY — / PAUL / COKER, JR.

PAUL COKER, JR.

BORN 1929

Coker's distinctively styled drawings accentuated regularly with a sort of lyric linear lurch have been appearing in greeting cards and magazines since the mid-1950s. Choosing cartooning as a profession because, he said, "I'm too little to be a professional athlete," Coker's first published cartoon appeared in the cartoon contest feature of *Open Road for Boys* when the cartoonist was about twelve. Born in Lawrence, Kansas, Coker's first national visibility was in Kansas City-based Hallmark Cards, starting in 1954. By the end of the decade, his antic artwork was appearing in numerous magazines and in many books. He also worked in animation on the Rankin-Bass Productions' *Frosty the Snowman* and a dozen or so others. Coker invaded newspaper pages, too. He did editorial cartoons for the *New York Inquirer* in 1957; and he produced two comic strips — *Lancelot* (March 16, 1970-April 30, 1972) and *Horace and Buggy* (in 1971 for six months) with Duck Edwing (q.v.). And he did a word-play panel in 1985. Coker began contributing to *Mad* in 1962 and has appeared regularly in its lunatic pages ever since, his most notable feature being the series called "Horrifying Cliches."

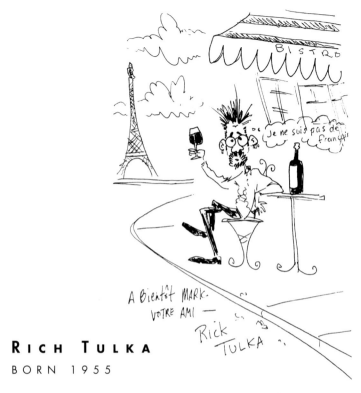

RICH TULKA
BORN 1955

Considering himself a caricaturist and humorous illustrator rather than a cartoonist, Tulka has appeared regularly in *Mad* magazine since 1988. He made his first sale in 1976 to *Cue* magazine at just about the time he finished studying at Pratt Institute (give or take a year). Since then, his work has appeared in such varied publications as *People Weekly, Reader's Digest, Concord Records, Money Magazine, The New York Daily News*, and *RollingStone*. He has also illustrated several books, including a coloring book for children based upon Michael Jackson's video, "Moonwalker." Those whose work he has admired include Toulouse-Lautrec, Al Hirschfeld, Honore Daumier, David Levine, and Mort Drucker. "Their grasp of capturing a likeness still amazes me," he wrote. Since 1995, Tulka has lived in Paris, where his list of clients include *Le Monde, L'Etudiant, Lire, Jeune & Jolie, Telerama, Cadre Courrier*, and *Regard d'Aujourd'hui* among others.

JOHN CALDWELL
BORN 1946

Caldwell says he owes his career in cartooning to the faith and persistence of a high school classmate named Ralph who wanted to be class president. Caldwell did Ralph's campaign posters. And he did them for all three years that Ralph ran unsuccessfully for class president. "I think it speaks well of my work that Ralph kept coming back to me for more posters every year," Caldwell said. Caldwell's cartoons with their spindly headed humanoids have appeared frequently in *National Lampoon*, a publication he believes helped create a hipper audience for the more subtle (not to say weird) cartoons in the last quarter of the century, and in *Mad* (about which Caldwell did not say he believed anything). He also produced a syndicated newspaper panel cartoon called *Caldwell*, which ran 1985-1989. Caldwell lives in Schenectady, New York, where he maintains an office to draw in. The office, he says, is "appropriately" located "over a travel agency in a cheesy part of town near the diners and theaters."

DAVE BERG
BORN 1920

Berg's first work for *Mad* appeared in the issue dated August 1957. Before that, Berg worked pretty exclusively in comic books, writing and drawing both serious and humorous stories. Born in Brooklyn, he studied art at both Pratt and Cooper Union. A comic book art agent discovered him in art class and directed him to Will Eisner (q.v.), whose comic art "shop" was then producing material for Quality Comics. Berg's first work for Eisner was an Uncle Sam story that he wrote and drew with another staffer, Tex Blaisdell. Berg worked on a number of Quality characters, but his longest stint was doing *Death Patrol*, a feature created by Jack Cole in which a band of criminals from Allied countries join forces to fight the Nazi horde in World War II. The Death Patrol was a unique conception: not only does a member of the group die in every issue, but the stories blend humor and violence in antic page layouts, a concoction Berg proved adept at sustaining. Just before entering military service with the Air Force in World War II, Berg moved to Fawcett, where he wrote and drew Captain Marvel stories and numerous humorous filler tales. Of these, the Sir Butch series was notable: in it, a feisty Brooklyn kid falls down a manhole, and, in the manner of Lewis Carroll's Alice, finds himself in a fantasy realm where he battles dragons and sorcerers. Berg returned to comic books after the War, creating stories for war comics (*Combat Kelly*, for example) during the Korean War. But by the mid-1950s, the industry had convulsed itself into collapse in a self-censoring attempt to meet criticisms that comic books were too violent and sexy for America's youth. Berg found his way to *Mad*, where he discovered a home. His irreverent glimpses of American life appeared regularly under the heading "The Lighter Side of..." He produced dozens of paperback titles under the *Mad* imprint, moved to Southern California, lectured in college for five years, and six times judged Miss America competitions at the state level.

MORT DRUCKER
BORN 1929

A master caricaturist, Drucker says he begins by looking for the general shape of the head ("round, long and thin, or square"), then looks for the unique facets of a face as well as "how the features float within the head's outline and their proportion to one another." Born in Brooklyn, Drucker's first professional work out of high school was on the staff of National Periodical Publications (DC Comics), where he did war stories, westerns, humor, and romance. About 1950, he began freelancing, and in the middle of the decade, he found his way to *Mad*. At *Mad* for nearly forty years, he specialized in movie and television satires where his caricature specialty adds immensely to the effectiveness of each venture. At the same time, Drucker pursued

assignments in commercial art, doing advertising, animation for television, movie posters, and covers and illustrations for mag-

azines. In the 1970s, he began doing covers for *Time*, working in color for the first time. In 1984 he teamed with Jerry Dumas, drawing the

syndicated strip *Benchley*, about a minor functionary at the White House, a situation that permitted Dumas to make satirical political remarks and Drucker to caricature the entire menagerie in Washington. The strip was discontinued after a couple years, by which time, Drucker was illustrating children's books in addition to his other work. About an artist's life, Reuben winner (1987) Drucker says: "Most artists live a secluded and sheltered life when working at home, and my wife Barbara has been my immediate audience and liaison with the outside, real world. Were it not for her attention and competence in managing the everyday bills, I would be working in the street by candle-light without a phone, not knowing the day of the month or year for that matter, and I shudder to think what I'd be wearing."

INK ON PAPER (DETAIL) | 20.5 X 27.2 CM. | 1987

CHARLES SCHULZ

BORN 1922

Because of the stylistic simplicity that distinguishes the artwork in *Peanuts,* the doghouse in the strip is always seen in profile — never in three-quarters view — so no one knows whether Snoopy or (in this case) Schulz reclines on a peaked roof or a flat one. A peaked roof would require a delicate sense of balance for the recliner, but Schulz is used to it. He's been doing a balancing act ever since the strip started in seven papers on October 2, 1950. At first, he achieved his unique comedy by balancing the juvenile appearance of his characters against the adult cant they often uttered, the humor stemming from the contrast between the speakers and what they said. Eventually, once Charlie Brown's beagle Snoopy assumed a nearly human personality (he was tired of being a dog) and began imagining himself in World War I aerial battles with the Red Baron (in 1965) or writing novels, Schulz would juggle fantasy and reality to get laughs, alternating between the world atop the doghouse and the classroom or baseball diamond where the kids lived. Arguably the world's most popular comic strip, *Peanuts* helped to set the modern fashion for the way a newspaper comic strip should be drawn. Two-time Reuben-winner (1955 and 1964) Schulz, like his contemporary Mort Walker (q.v.), had been a magazine cartoonist and drew in a simpler manner than most newspaper cartoonists of the day. By the time *Peanuts* began soaring in circulation in the late 1950s, Schulz had refined his style even more, producing drawings that were deceptively simple. Other cartoonists who sought similar success aped the simplicity of Schulz's style. And sometimes they hadn't his skill, and their imitations were crude; but by then, newspaper editors, confronted by the success of some of Schulz's more skillful imitators, had been convinced that drawing ability didn't matter, and they bought the imitations, no matter how clumsy. Given the immense popularity and influence of the strip and its characters and the pervasiveness of the licensed *Peanuts* paraphernalia, the second half of the first American comics century would well be dubbed the Age of Schulz.

INK AND WATERCOLOR ON PAPER | 13.4 X 15.3 CM. | 1988

BUCK BROWN
BORN 1936

Brown was working for the Chicago Transit Authority as a bus driver when he sold a cartoon to *Playboy,* and before too many more years, he could leave the driving to others and concentrate on cartooning as one of the magazine's regulars. He freelanced to other men's magazines, too, but in *Playboy* his work usually appears as a full-page color painting of boldly-outlined figures. In later years, he has produced a series of cartoons featuring an unabashedly sex-starved little old lady (with whom, here, Brown himself is cavorting). Born in Morrison, Tennessee, Brown moved to Chicago after a stint in the Air Force. He drove that bus 1958-1963 and attended Wilson Junior College and then the University of Illinois, receiving a B.F.A. in 1966. Two years later, Brown, an African-American (or, as Don Thompson put it *in The Comics Buyer's Guide,* "Brown is black"), was appointed to a two-year term on the President's Task Force on Youth Motivation. And in 1970, he was named one of Chicago's ten most outstanding young men by the local chapter of the JayCees.

VICTORIA ROBERTS

BORN CA. 1955

VICTORIA
BY
VICTORIA
1R97
For the
Wonderful
Mark ♥
Cohen

Roberts' strangely nosed cartoon people appear regularly in *The New Yorker,* etched into tenuous being with the cartoonist's delicate filigree line. *The New Yorker* is right where Roberts wants to be: ever since 1968, when she first recognized the work of a *New Yorker* cartoonist, Abel Quezada, who had done a poster for the Olympics in Mexico that year, she aspired to being published in *The New Yorker.* She was born in New York but grew up in Mexico where she attended a French school; she remembers fondly the Sempe illustrations in *The Little Prince* and *Le Petit Nicholas.* In 1971, her family moved to Aus-

tralia, and Roberts took two years of art school to finish her high school education. While down under, Roberts had material published in the *Sydney Morning Herald*, and in *The Nation Review*, she did a weekly featured called *My Sunday.* "It was about a typical Sunday in the life of Gertrude Stein," she explained. At the age of nineteen,

she started submitting cartoons to *The New Yorker* occasionally; and after she returned to the U.S. in 1987, she submitted a batch every week. Finally after a couple of years, she got an encouraging note from cartoon editor Lee Lorenz, and soon after that, she sold her first cartoon to the magazine. Now a contract cartoonist with *The New Yorker*, she also does illustrations for *The New York Times.* "The best cartoonists," she says, "have their own world. Look at the wonderful cartoons of Buck Brown [q.v.]. His Granny character is in her own very believable world. My oldest character is Nona Appleby, who usually appears nude," she continued, and when asked about the couple in the living room, she said the lady "is sometimes Alice, and sometimes Sylvia," and the man "is usually Howard."

DUCK EDWING

BORN 1934

Edwing became a cartoonist, he said, because "I've always had lead in my pencil." He had his first cartoon published in Harvey Kurtzman's (q.v.) *Help* in the mid- 1960s and hasn't strayed far since. His bulbnosed squat characters appear regularly in *Mad* and in the books spawned by *Mad* (in seventeen of the latter titles). He coproduced *Horace and Buggy* with Paul Coker, Jr. (q.v.) for six months in 1971, and his cartoons have appeared in *Playboy, Look, True, Saturday Evening Post*, and elsewhere. Asked what he did when he was not cartooning if cartooning was not the principal source of his income, Edwing wrote: "I'm a cat burglar: I look great in basic black."

CREIG FLESSEL
BORN 1912

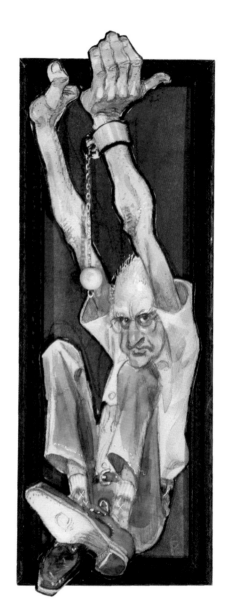

An extraordinarily versatile artist, Flessel has worked in humorous as well as serious illustration in virtually every venue known to cartooning. And his self-portrait here is a prize example of both his comedic sense and his inventiveness. Born in Huntington, New York, he attended two years of classes at Grand Central Art School after high school. Then he began drawing his way everywhere. He illustrated stories in pulp magazines and produced cover illustrations and content for such early comic books as *More Fun* in the 1930s. Joining Johnstone and Cushing, he did advertising cartoons, magazine covers for *Pictorial Review*, and *Boy's Life*. He did watercolors and illustrated books; he created slide shows and did gag cartoons. He also worked on newspaper comic strips — *Dixie Dugan*, *Li'l Abner*, *Friday Foster*, *David Crane* — and, most recently, the *Playboy* comic strip, *Baron Von Furstinbed*. Looking back on his career in 1996, Flessel waxed nostalgic for a moment, noting that at one time "a *microchip* was from a tiny buffalo, *scan* was for a far horizon, *cartooning* was about the foibles and fantasies of man — and it still is." One of his most recent books is *Draw 50 People* in the Lee Ames series — "a best seller at my house," Flessel said.

INK AND WATERCOLOR ON PAPER WITH PLASTIC, WOOD AND METAL CHAIN | 10.2 X 29.2 CM. | 1988

DALE MESSICK

BORN 1906

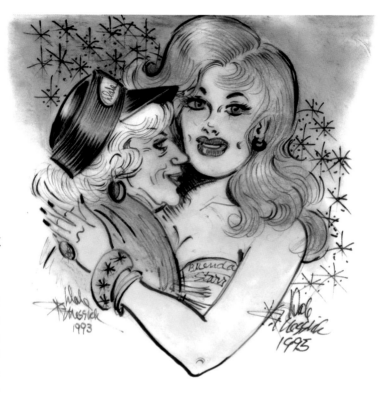

Messick may be the First Lady of the Funnies — not because she was the first female cartoonist (she wasn't) but because her strip became famous, a virtual household word, and because her flame-haired heroine, the eponymous Brenda Starr, presented a startlingly liberated role model to young American women. A working newspaper reporter, Brenda had first emerged from Messick's imagination as a lady bandit — perhaps just a little too liberated for the American forties. Messick, who had shortened her first name, Dalia, to disguise her gender in a male-dominated profession, had tried to break into the comics section four

times before. In the late 1920s, she submitted her first unsuccessful effort, *Weegee*, about a young woman who comes to the big city to make her fortune. Then Messick did *Mimi the Mermaid*, whose finny title character was a considerable departure from the usual funnies fare despite her stunning beauty; then in the mid-thirties, *Peg and Pudy the Strugglettes*, which soon transformed itself into *Streamline*

Babies — both about two young women trying to get ahead in the big city. Finally came *Brenda Starr;* glamour arrived in adventure strips on Sunday, June 30, 1940 (the daily version began in October 1945). With fastmoving (even dizzying) stories, vintage *Brenda* also traded in fluffy nighties and lounging pajamas, low-cut (for that day) gowns, and plots governed only by the whim of Messick's breathless

imagination, which often ignored logic and reason in favor of such purely feminine diversions (in the traditional male chauvinist sense) as a fresh hairdo or a new pair of shoes. "Authenticity is something I always try to avoid," Messick said. But she put stars in Brenda's eyes and always achieved heartthrob, giving her heroine a "mystery man" beau in Basil St. John, who wore an eye patch and raised black orchids from which he extracted a serum that he hoped would cure his fatal disease. Messick retired in 1980, leaving Brenda to others while she produced for her neighborhood paper a cartoon panel called *Granny Glamour*. She still had the touch. And in 1998, NCS presented her with the Milton Caniff Lifetime Achievement Award, which had previously been awarded to only three cartoonists — all men.

GREG EVANS

BORN 1947

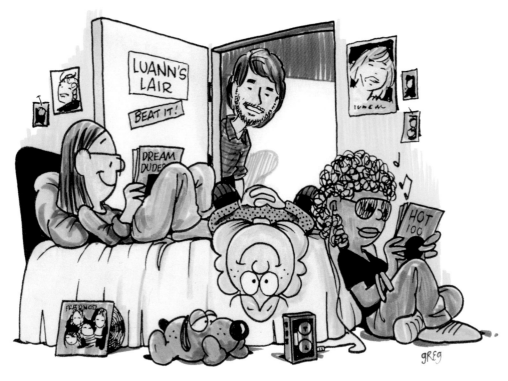

Evans submitted his first cartoon for sale to *Playboy* at the age of eleven. Ever since then, despite various detours, he's steered towards being a full-time cartoonist, navigating through some previously uncharted waters on the way. Growing up in Burbank, he attended California State University at Northridge, majoring in art education, and after graduating in 1970, he taught art. In 1972, Evans married and went with his teacher wife to Australia as part of a teacher-recruitment program; there, he taught for two more years, and he concocted a comic strip called *Just Us,* which, because "there are only about two and a half newspapers in Australia," was not too successful. In 1974, he quit teaching and landed in Colorado Springs, where he operated a TV camera in a local station, eventually becoming a promotion manager. In 1979, he revived *Just Us* and peddled it to a local paper. No sale but a good idea from the editor, who suggested building a strip around one of the characters, a cranky teacher named Fogarty, and selling the strip to school newspapers. Evans took the advice and for the next seven years, sold *Fogarty* and a second strip, *Stu Dance,* to about eight hundred schools around the country by mail.

He also became a performer. At the TV station, he got involved with its radio-controlled robot, and in 1980, he bought his own robot, quit television, moved to Southern California, and began performing with the robot in malls, trade shows, and fairs. All this time, Evans had been freelancing magazine cartoons and sending comic strip ideas to syndicates with no success. Watching his four-year-old daughter one day as she primped and practiced being feminine, he decided to try a strip about "a very contemporary girl," and, realizing that adolescence provided more fertile ground for reaping humor, he invented *Luann*. Beginning March 17, 1985, the strip often goes beyond teenage dating themes; Evans confronts his title character with typical teenage problems (Luann's first menstrual period, for instance), treating the concerns both sensibly and sensitively.

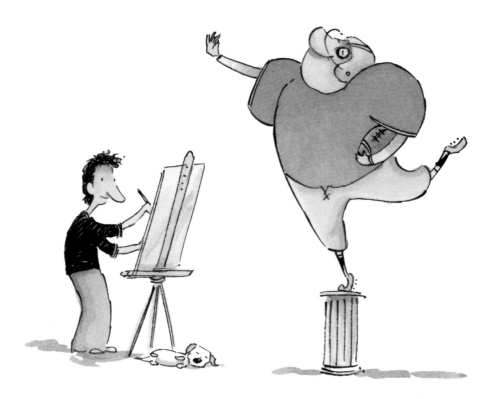

PATRICK McDONNELL

BORN 1956

After graduating from high school in New Jersey, McDonnell enrolled in Manhattan School of Visual Arts and while there sold his first work — to the *Village Voice*. He hoped someday to do a comic strip. "I love comic strips," he once wrote, "— words and pictures, pen and ink, black and white. I love the music in the line, the rhythm of a gag, the variation on a theme." He ap-proached a couple of syndicates after graduating from SVA, but "came away thinking neither of us were ready." So he peddled his wares at magazines, doing spot illustrations for *Forbes, Time, Life*, and *Sports Illustrated*. He illustrated Russell Baker's "Sunday Observer" column for *The New York Times Magazine*, every week for ten years (until Baker stopped doing the column). For *Parents Magazine* in 1983, he developed a monthly cartoon, *Bad Baby*, about a young couple and the joys and terrors of rearing an infant. And he did cartoons for *Parade* and *Reader's Digest* and designed characters for animation. McDonnell and his wife, Karen O'Connell, and Georgia Riley DeHavenon authored the definitive biography of George Herriman (q.v.), *Krazy Kat: The Comic Art of George Herriman* (1986). Then in 1993, McDonnell decided to try for a comic strip again — this time, using a little dog who had been a bystander in many of his spot illustrations. The result, *Mutts*, began September 5, 1994. Infected somewhat with the elfin spirit of Krazy Kat, the warm-hearted strip presents daily comedic epiphanies in the lives of Earl, the pooch, and his buddy Mooch, the cat, and their owners. The animals talk to each other, but only when they are alone in the strip; when they're with people, they act like regulation pets. "I'm trying to keep the animals as animals," McDonnell said. "*Mutts* for me is also about my love for this medium," he continued, "the honor to be even a small part of its rich history. The thrill of trying to breathe life into scratchy pen and ink marks is what I love to do. It's nice to have the chance to do it."

INK AND WATERCOLOR ON PAPER | 11.4 X 10.2 CM. | 1990

WILL ELDER
BORN 1922

A joker of maniac proportions, Elder found his comics metier with his friend, classmate, mentor and studio partner, Harvey Kurtzman (q.v.). Born in the Bronx, Elder first met Kurtzman when both of them attended the High School of Music and Arts; Elder later went on to the Academy of Design. In 1946, Elder and Kurtzman and Charles Stern set up an art agency studio out of which all three freelanced. By 1951, both Elder and Kurtzman were producing material for the "new trend" line of comic books from E.C. (Entertaining Comics). In the crime, science fiction, horror and adventure stories he worked on, Elder was frequently teamed with artist John Severin, whose work Elder inked, but when Kurtzman launched *Mad* in 1952, Elder came into his own as a solo humorous cartoonist, filling the

THE PUBLIC WANTS STAR QUALITY.

Will Elder. '90

panels of the stories he drew with dozens of zany characters irrelevant to the story, each a sight gag. The resultant visual hilarity set the standard for *Mad:* thereafter, all the staff artists crammed their drawings with *chochkes*, as Kurtzman called them — "eyeball kicks." When Kurtzman left *Mad* to start *Trump* in 1956, Elder went with him; and he stayed with him for the run of both *Humbug* (1958-

1959) and *Help!* (1960-1962). Then in 1962, Elder collaborated with Kurtzman in producing for *Playboy* the most sumptuously executed comic strip of all time: *Little Annie Fanny* was a fully painted color enterprise, in which a grown-up, voluptuous version of Little Orphan Annie wanders contemporary society, Candide-like, to satirize hip society and sexual mores. Like most Kurtzman productions, it was meticulously plotted with detailed pencil layouts by Kurtzman. Elder then composed each individual panel ("painting"), initially getting help with the painting from other artists (such as Jack Davis, q.v.) but, ultimately, doing all the final art himself (with generous assistance from Annie herself, as we see here).

INK AND WATERCOLOR ON PAPER | 11.4 X 20.5 CM. | 1990

TRINA ROBBINS

BORN 1938

Long associated with underground comix and feminist issues, Brooklyn-born Robbins has steadfastly championed women in comics — both as fictional protagonists and as artists and writers — in her cartooning and in the books she has authored. Her first published cartoon appeared in the *East Village Other* in 1966. In 1970,

she was among the contributors in the first all-woman comic book, *It Ain't Me, Babe*, and by 1972, she was in California and active in the Wimmen's Comix Collective, which produced an all-woman annual anthology for twenty years. Robbins co edited *StripAIDS USA* in 1988, and in 1990, edited and self-published *Choices*, a pro-

choice book to benefit the National Organization for Women. She has

also occasionally cartooned in the mainstream press and for aboveground comic book publishers. With coauthor cat yronwode, Robbins produced *Women and the Comics* (1985), a history of women cartoonists that she re-worked herself with additional material as *A Century of Women Cartoonists* (1993); and she wrote *The Great Superheroines* (1997).

FLOYD GOTTFREDSON

1907 | 1986

Like Carl Barks (q.v.), Gottfredson made a career of cartooning a Walt Disney character but never signed his name to his work. He remained an unknown for almost the entire time of his forty-five year tenure on the *Mickey Mouse* newspaper comic strip. He was born and grew up Mormon in Utah, and he took correspondence courses in cartooning from the Landon School and the Federal School. By the late 1920s, he was being published in trade journals and the *Salt Lake City Telegram*. Then in 1928 after win-

ning a cartoon contest, he packed up his wife and family and moved to Los Angeles. Unable to find a berth at any of the seven newspapers in town, he worked as a movie projectionist until December 1929, when he began working at Disney. Hired as an in-betweener and backup artist on the daily *Mickey Mouse* strip that was about to be launched (on January 1,

1930), Gottfredson was working solo on the strip by April. For the next two-and-a-half years, he wrote and drew the feature single-handedly. Beginning late in 1932, the strip was deemed important enough to be plotted by a group of Disney storymen, who discussed storylines with Gottfredson, who then penciled the strip, leaving the inking to other staffers (chiefly Ted

Thwaites, 1932-1940). Gottfredson abandoned the joke-a-day formula fairly soon after starting on the strip, and he started telling stories that continued from day to day — adventure stories. Inspired by the likes of Roy Crane (on *Wash Tubbs*) and Sidney Smith (on *The Gumps*), he displayed a knack for gently parodying the devices of movie serials of all sorts — cowboys, detectives, horror — and until the mid-1950s, he produced a suspenseful but fun-filled adventure epic with the diminutive Mickey as hero. In the fifties, the syndicate directed him to give up continuing stories in favor of daily jokes, which Gottfredson did until he retired October 1, 1975. The identity of the Mouse artist was revealed in 1968, and he enjoyed a modest celebrity at comic conventions for a few years until ill health slowed him down.

INK AND WATERCOLOR ON PAPER (DETAIL) | 7 X 12.3 CM. | CA. 1979

BIL KEANE
BORN 1922

At meetings of the National Cartoonists Society and other groups, Keane has acquired a considerable reputation as a stand-up comedian, specializing in one-line zingers, like these about himself: "I was born at a very early age in Philadelphia and grew up there physically if not mentally. Best idea I ever had: marrying Thel in Australia in 1948. I penciled in five children, and Thel did the reproductions." Keane peddled gag cartoons to "all the magazines that folded" while working on the *Philadelphia Bulletin* (1946-1959), but as the great general interest magazines that constituted the largest market for cartoons began disappearing in the fifties, Keane turned to newspaper cartooning. Seizing on the emerging phenom-

enon of television for inspiration, he created *Channel Chuckles*, a daily panel cartoon, which debuted in 1954, just as newspapers began to accept television and publish special TV sections, into which his new cartoon slipped handily (until it ceased in 1977). Keane's son Glen (an animator at Disney) resumes the story: "My father always wanted to have his own cartoon strip but didn't know where to start. I decided to get busy and give him some ideas, and *The Family Circus* was born." Another panel cartoon, this one appears always with a circular border (and might have been called *The Family Circle* had there not been a magazine with that name). "The next few years," Glen reports, "were tough ones for us Keane kids: we

had to do something funny or cute on a daily basis." His father's version of events is somewhat different: "I was a staff artist on the *Philadelphia Bulletin* when I got tired of drawing staffs and moved to Arizona, where I'm still studying to be a saguaro cactus. Created *Family Circus* in 1960 [starting February 1] and have been going around in circles ever since." Several animated specials have been aired on TV, and in 1982, Keane won both the Reuben and NCS's Elzie Segar Award, given to cartoonists who make "a unique and outstanding contribution to the profession."

PAUL MAVRIDES

BORN CA. 1953

FAT FREDDY KRUEGER

PAUL MAVRIDES ©1989 R.O.P.

In 1991, underground cartoonist Mavrides became the lightning rod in a landmark dispute with a California taxing body that ruled that comic book art was subject to sales tax, which should be collected by the cartoonist at point of sale; Mavrides argued that his work was the equivalent of an author's manuscript offered to a publisher and was therefore exempt. Mavrides was the wrong guy to pick on. An archetypal cartoonist of protest who almost never loses his head, Mavrides had his first brush with authorities while a preschooler: "My babysitter took me to a civil rights demonstration and ended up getting arrested, and I was busted right along with her," he recalled. As a teenager too young to be drafted, Mavrides helped shut down the draft board in his hometown, Akron, Ohio, with a Vietnam war protest mounted by his high school classmates. This adventure included a civics lesson he didn't forget: "As responsible citizens," he recalled, "we were out demonstrating against the war and were secretly filmed by G-men. You catch on quick. Exercising your Constitutional rights made you an enemy of the state." After Mavrides graduated from high school in 1970, he rambled around the country from Boston to Tucson, doing odd jobs, including artwork and writing, and wound up in San Francisco in the late 1970s, where he had some of his work published by Rip Off Press. He met Gilbert Shelton, one of the partners and the creator of the Fabulous Furry Freak Brothers (seen here, admiring Mavrides' hairdo), a popular counter-culture comic book team specializing in pot stories. Soon Mavrides was assisting Shelton on the books, eventually, co-producing them. He also did assorted commercial art jobs, produced provocative paintings on black velvet for gallery shows, and may have been one of the founders of the Church of SubGenius, whose basic doctrine is "Don't Believe In Dogma." Needless to say, Mavrides fought the tax ruling. At last report, he won. Had he lost, cartoonists in California would have to collect taxes from whoever bought their work.

INK AND WATERCOLOR ON PAPER | 9.9 X 8.8 CM. | 1989

KELLY FREAS
BORN 1922

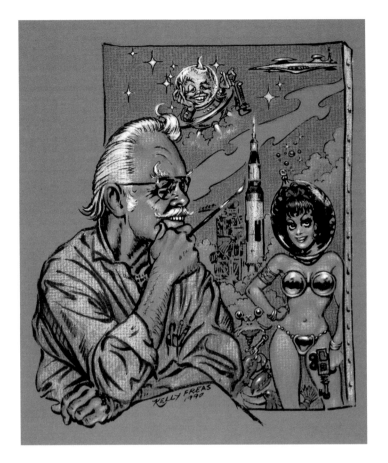

One of the most prolific illustrators ever to work in the science fiction field, Freas sold his first cover painting to *Weird Tales* in 1950. Since then, he has won ten Hugo Awards for Best Science Fiction Artist and has ranked high on a list of fan favorites. Born in upstate New York but raised in Canada, Freas attended Catholic University in Georgetown, first as an engineering student then as a premed student; but his heart belonged to sf. After four years in the Army Air Corps Engineers as an aerial photographer, he graduated from the Art Institute of Pittsburgh. While in school, he resumed a career in advertising, doing freelance illustration on the side. For a year, he was art director of the *Pittsburgh Bulletin Index*, then he joined one of the top advertising agencies in the city. By November 1952, he was selling illustrations regularly to New York sf publishers, and he gave up his advertising career to move to New York and become a full-time illustrator. He was soon sharing cover responsibilities at *Astounding Science Fiction*, a leading sf magazine. Commissioned by Laser Books to produce the covers for its science fiction line, Freas did fifty-seven of them before the series was dropped; he may be the only artist to do all the covers for a paperback line. NASA astronauts commissioned his design for their shoulder patch for the launch of Skylab I, and he designed a series of six posters for the space program. But the reason Freas is in this collection is that he succeeded Norman Mingo (q.v.) in painting the portrait of Alfred E. Neuman for the covers of *Mad* magazine, as well as inside and back covers 1955-1962. Freas had often displayed a sense of humor in his sf work, and the *Mad* assignment gave him greater range for this facility. In his book *Frank Kelly Freas: The Art of Science Fiction,* Freas wrote: "An illustrator, whether science fiction or otherwise, is essentially a storyteller who can't type."

AL SCADUTO

BORN 1928

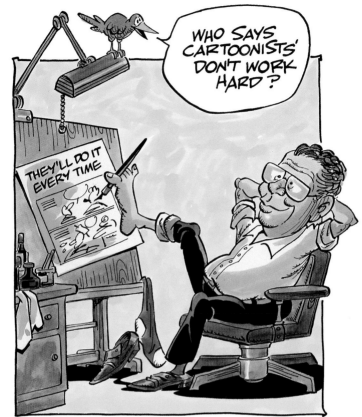

WITH ALL BEST WISHES to MARK J. COHEN
AL SCADUTO.

Scaduto has done the nearly impossible: he modernized the look of a vintage cartoon feature while at the same time retaining the feature's distinctive visual atmosphere. *They'll Do It Every Time*, a newspaper cartoon that confronts its readers with their all-too-human tendency to behave inconsistently, is sixty-some years old, and Scaduto has been associated with it for fifty of those years. The cartoon was launched in the early 1930s by Jimmy Hatlo, who was assisted since 1939 by Bob Dunn. Hatlo's portrayal of the hypocrisy and absurdity of daily life drew a chorus

of fan mail, with the fans pouring in suggestions for gags. Office situations soon resulted in the creation of two of the feature's most memorable characters, the boss J.B. Bigdome and his put-upon subordinate, Henry Tremblechin. Dunn gradually assumed most of the art chores on the feature and on a Sunday spin-off strip about

Tremblechin's mischievous daughter, *Little Iodine,* and in 1948, Dunn recruited an assistant for himself, hiring Scaduto, then in the syndicate bullpen, where he'd been since graduating from the High School of Industrial Arts in Manhattan in 1946. Scaduto took over the comic book version of Little Iodine and did the Sunday

strip. When Hatlo died in 1963, Dunn inherited *They'll Do It.* He roughed out the cartoon and left the final art to Scaduto, and when Dunn retired in 1989, Scaduto took over. Eliminating the cross-hatching that cluttered the panel previously, Scaduto made his drawings crisp and clean even when crammed with detail. Bigdome and Tremblechin have disappeared; Lugnut, the perpetual husband and lout, and his wife Annoya are now among the most frequently appearing characters. Scaduto has also illustrated children's books, advertising, and greeting cards. Passionate about opera since childhood, he is equally devoted to his art: "I hope to keep on cartooning and doing the funnies until my ink bottle is empty."

INK AND WATERCOLOR ON PAPER | 11.4 X 15.3 CM. | 1990

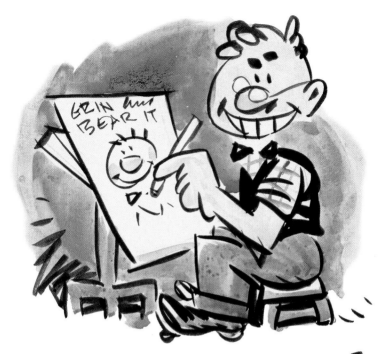

*Best Wishes
Lichty*

GEORGE LICHTY
1 9 0 5 | 1 9 8 3

Possessed of a breezy manner of drawing with a languid brushline, Lichty is reported to have claimed once that he could do a week's worth of his newspaper panel cartoon in less than two days. Probably true. If he spent any more time on a drawing, he would surely destroy one of the most distinctive styles in cartooning. Lichtenstein (his real name) sold his first cartoon to the weekly humor magazine,

Judge, at the age of sixteen, and that determined him on his career. He attended the Chicago Art Institute briefly after high school graduation, but he soon left to go to the University of Michigan. (Rumor has it that he'd incurred disfavor at the Art Institute by putting gag captions under the Rembrandts and El Grecos; or maybe it was for giving

famous portraits moustaches. But you can't depend on rumor.) At Michigan, he edited the campus humor magazine, the *Gargoyle,* and won an Essex sports car as a prize in a cartoon contest (run, presumably, by the magazine, *College Humor*). After college, he joined the staff of the *Chicago Times* in 1929, doing spot illustrations and sports

cartoons. In 1930, he launched a short-lived comic strip about a soda fountain employee, *Sammy Squirt;* and then in 1932, he created the panel cartoon that he would do until retiring in 1974, *Grin and Bear It.* Shading his splashy drawings with soft grease-crayon grays, Lichty produced a long-running commentary on American life as chorused by paunchy middle-aged husbands and dumpy overweight wives inevitably named Snodgrass who worked for Figby corporations, slender young things and their beaux, diminutive squinty-eyed children, and that indefatigable champion of self-interest, Senator Snort, whose every appearance was accompanied by campaign posters proclaiming such slogans as "Vote Snort" or "Snort Will Hold the Fort" or "Snort Leaves No Promise Unspoken."

BRUSH AND INK WITH WATERCOLOR ON PAPER (DETAIL) | 11.5 X 15.3 CM. | CA. 1945

GEORGE BOOTH
BORN 1926

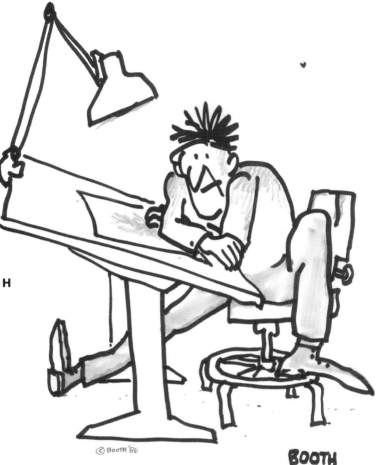

© BOOTH '86

BOOTH

Booth grew up on a farm in Missouri and couldn't seem to escape the Marine Corps. Appearances to the contrary notwithstanding, he was a Marine, one of those spit-and-polish soldiers. After high school graduation in 1944, he went to basic training at Camp Lejune, and then he was sent to Hawaii where he was assigned to a linotype machine: a colonel had written a book, and Booth, who'd apprenticed on the linotype in high school, was volunteered to set the book in type.

Once when he thought no one was looking, he drew a picture of the colonel. The colonel saw it, enjoyed it, and sent Booth packing — for a trip to Washington, D.C., where he joined the staff of *The Leatherneck*, the Corps magazine, and drew cartoons for the rest of his en-

listment. When discharged, he attended the Chicago Academy of Art, but when the Korean conflict heated up, the Marines recalled him. Just as he was boarding a ship to Korea, orders came through transferring him to *The Leatherneck* staff again. This time when he was

discharged, he went to the Corcoran School of Art in D.C.; after that, he moved to New York, where he worked for a communications firm for eight years. He started freelancing gag cartoons in the early 1960s, and in 1969, he sold his first cartoon to *The New Yorker*. He subsequently was enrolled as one of the magazine's contract artists (whose contract specifies that they give *The New Yorker* first choice on all cartoons they produce). Like most *New Yorker* cartoonists, Booth developed not only a distinctive rendering style but a cartoon milieu uniquely his own. Booth's cartoons are populated by cranky antique suburbanites and infested with equally antic pets, spastic dogs and catatonic cats, who either loll about, oblivious of whatever else is going on, or have fits in the middle of the living room.

CHAUNCEY "CHON" DAY
BORN 1907

Day's distinctive airy, open style has been on display in American magazines since World War II, when he developed it. Eschewing the spotting of solid blacks and almost all sorts of shading (except, occasionally, a gray wash), he relies mostly upon a thin sometimes slightly tremulous line and a masterful command of stark simplicity in cartoon anatomy and design for depicting the actors and settings in his one-panel comedic dramas. Day had been published in magazines since about 1929, but it was after the War that his mature style emerged. Brother Sebastian, shown here with the brush in his hand, was invented in the 1960s to please cartoon editor Gurney Williams, who wanted a continuing character for cartoons at his new post with *Look* magazine.

ALDEN ERIKSON
BORN 1928

Since selling a cartoon to *Playboy* in 1957, Erikson has been represented in the magazine regularly, and he has also appeared in most other major magazines. His first sale, however, was to *Saturday Evening Post;* the cartoon appeared on page 86 of the issue for April 16, 1955. "Every cartoonist I have especially liked has influenced me," Erikson said. "The first cartoon strip I can remember liking was *Smokey Stover* by Bill Homan

DAY: INK ON PAPER (DETAIL) | 13.3 X 9.4 CM. | 1988 ERIKSON: FELT TIP PEN AND WASH ON PAPER | 18.9 X 24.6 CM. | 1986

[q.v.]. Pure slapstick. He also did a single panel called *Nuts and Bolts*, and he freelanced magazine cartoons. In the 1950s, I especially liked Gardner Rea's color cartoons in *Playboy* — great captions and great unpretentious but elegant art work." Erikson has also cartooned for advertising purposes in the early 1980s, and in 1972, *Playboy* published a collection of his cartoons, *Playboy's Alden Erikson*.

JOHN O'BRIEN
BORN 1953

O'Brien has written and/or illustrated over fifty children's books, including *The Twelve Days of Christmas, Brother Billy Bronto's Bygone Blues Band, Fast Freddie Frog, What His Father Did*, and *Funny You Should Ask* (to name a few). He has illustrated the covers for such magazines as *Highlights for Children, The New Yorker*, and *Global Finance*, and his antique-finish cartoons have appeared in both magazines (*Omni, Electronic Engineering Times*) and newspapers (*Washington Post, New York Times, Village Voice*). He is a contract cartoonist for *The New Yorker*, lives in New Jersey, plays banjo, and indulges his interests in running, crossword puzzles, bagpipes and piano as often as he can.

HOWARD SHOEMAKER

BORN 1931

A designer as well as a cartoonist, Shoemaker has freelanced in advertising for such clients as *Playboy, Road and Track,* and *Porsche* among others, doing layout and illustration and exhibition design, packaging and posters.

He worked in animation at the Dennis Kennedy Studios in Omaha, Nebraska, and for American Greeting Cards. He sold his first cartoons in 1959 — one to *Playboy,* another to *Realist* — and has freelanced ever since. He has produced gag and editorial cartoons for these publications and for various of the underground press in the 1960s. Shoemaker says he became a cartoonist because "I didn't have guts enough to be a bank robber." He is discouraged about the future of cartooning, chiefly because of the popularity of such creations as Beavis and Butthead, the Simpsons, and South Park — "that awful animated series, starring foul-mouth little bastards who should have their mouths washed out with lye soap" — which have "cast a wet blanket over those in this profession who can draw. This, and the @#$&*#$+@# political correctness have, in my opinion, watered down and stifled really biting satire, intelligent humorous observation of daily life's happenings and of the political pig sty, and free expression. When corporate lawyers have to take first look at accepted cartoons, something is rotten." Confronting society around him, Shoemaker still sees the cartoonist's role is to "keep 'em laughing; God knows it's tuff enuff."

INK WITH WASH ON PAPER | 35.9 X 46.7 CM. | 1989

ELDON DEDINI

BORN 1921

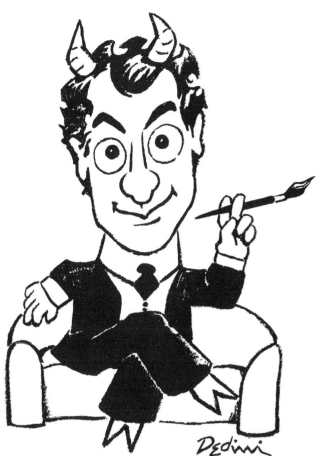

The devilish Dedini seemed for a time to specialize in frolicsome forest scenes inhabited by lascivious satyrs and plump, wanton wood nymphs, whose naked flesh glowed with Rubenesque hues. Cartoons along these lines appeared first in *The New Yorker* (in black-and-white with a wash) and then in *Playboy* (in steamy luminous watercolor). A contract cartoonist at both magazines, Dedini learned about the painterly application of color with the Southern California Watercolor Group while he was doing storyboards at Disney, 1944-1946. He was also influenced by the radiant color of E. Sims Campbell, who specialized in harem cartoons at *Esquire*. But his severe simpli-fication and commanding bold line he learned, he said, from studying Peter Arno's cartoons and Whitney Darrow, Jr.'s (q.v.). As a youth, Dedini did editorial cartoons for local papers without fee in order to gain experience; thanks to a caring teacher, this enterprise also earned him course credit at Salinas Junior College in California. *Esquire* bought his first published cartoon in 1940, and in 1942, he entered Chouinard Art Institute on a scholarship; but he went to classes only three or four days a week so he would have time to freelance. By 1944, when he left Chouinard to work at Disney, he was selling to most major magazines. Then in 1946, David Smart, publisher of *Esquire,* phoned him and offered to double his salary if he would work exclusively for the magazine, generating ideas for the other cartoonists as well as being featured himself. When the arrangement ended in 1950, Dedini started selling to *The New Yorker*. About 1960, he heard from another cartoonist who had just sold a cartoon to *Playboy* and had been advised by editor Hugh Hefner to apply color "in the Dedini style." Said Dedini: "I figured that if they were going to teach people to work in my style, I'd better get in on some of it." And so he did; most issues of the magazine feature a full-page color Dedini cartoon.

BRUSH AND INK ON PAPER | 16.5 X 22.7 CM. | 1986

DON OREHEK

BORN 1929

Orehek's panel cartoons with their distinctive breezy linework and vitally energetic figures have appeared in major magazines since he sold his first in 1950 while studying at the School of Visual Arts in New York. Born in Brooklyn, after high school he went into the Navy where he created a comic strip called *Cyphers;* upon discharge, he joined the staff of Crestwood Publications, helping to produce their line of newsprint magazines featuring gag cartoons, 1952-1956. Going freelance in 1956, Orehek sold regularly to all major magazines from *The Saturday Review* and *Cosmopolitan* to *Playboy* and *Penthouse,* but he is perhaps best known for his cartoons for men's magazines about relations between the sexes, featuring risque gags and pretty young women with wild eyes. He has written and drawn for the humor magazine *Cracked* since it began in the 1950s.

PETER NEWELL

1862 | 1924

Combining autograph and self-caricature, Newell's decorative picture of himself may be the most distinctive in this collection — and it hints at the kind of cartooning for which he is noted. Born Sheaf Hersey in Illinois, he left the family farm in Bushnell at about seventeen years of age and went to New York, entering the Art Students League. Within a few years, his drawings were appearing in children's magazines and the weekly humor magazines like *Judge* and *Life*. His first sale, however, was to *Harper's Bazaar.* Newell sent in a drawing, inquiring whether the editor thought it indicated any talent for the medium; the editor said he could see no evi-

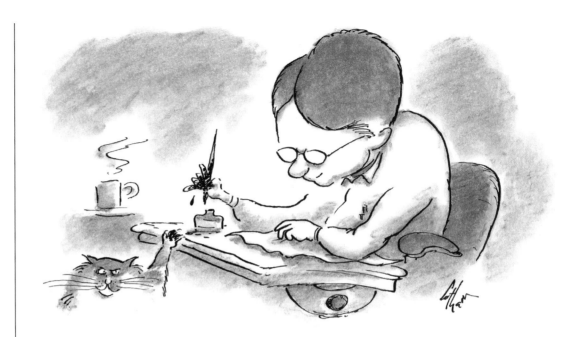

dence of talent, but he enclosed a check in payment for the drawing, which he accepted for publication. For *Judge,* Newell drew pictures that involved some sort of visual trick — upside-down cartoons, for instance, which present differing views (and therefore opinions) of the subject whether right-side up or the reverse (see Al Jaffee herein for a sample). Called *Topsys and Turveys,* these cartoons were collected in book form. And Newell performed other visual trickery in books for children, which amused both youngsters and their parents. He also produced an inventive fantasy comic strip called *Polly Sleepyhead,* which ran briefly in about 1905.

FRANK COTHHAM
BORN 1948

Born in Jacksonville, Florida, Cotham grew up in Memphis, Tennessee. Until 1986, he was a staff artist in the production department of a local television station. Freelancing his cartoons, he sold to such magazines as *Penthouse* and the *Saturday Evening Post, Omni* and *Woman's World, National Lampoon* and *Datamation,* to name a few. He sold his first cartoon to *The New Yorker* in 1993 and his sad-eyed characters have appeared regularly in its pages ever since.

INK AND WASH ON PAPER | 22.2 X 12.8 CM. | 1998

HENRY MARTIN
BORN 1926

Martin cut his cartooning bicuspids on the *Princeton Tiger,* the campus humor magazine at his alma mater. After graduating, he pursued a career in commercial art, illustrating book jackets and co-authoring "Boondoggle" and "Supermarket," two games for Selchow and Righter. Setting up shop near the Princeton campus, he began freelancing cartoons in about 1956, and his distinctive signature and fatuous characters have appeared in most major magazines since, including *Punch* in England. In 1964, he sold his first cartoon to

The New Yorker, where he subsequently became a contract contributor, drawing in a clean, open style with a slightly sketchy line. He also cartooned for the *Philadelphia Inquirer* and produced a syndicated panel cartoon, *Good News, Bad News,* 1978-1992. "'Good News, Bad News' was the title of a book of my cartoons," Martin

explained. "The president of the syndicate read reviews of the book, liked the cartoons, and decided he wanted to syndicate it." Martin's weekly routine is similar to that of most freelancing gag cartoonists. He aims to produce five cartoons every day, starting at eight o'clock each morning. "I work on nothing but ideas until I've got five of them,"

he said. "If I see it's going to be impossible, I quit." He tries to make up the difference the next day, but most days, he hits his quota and then draws five finished cartoons. He works Monday and Tuesday, Thursday and Friday. On Wednesdays, the traditional "look day" in New York when magazine cartoon editors receive submissions in person by cartoonists in the area, Martin takes his cartoons to *The New Yorker,* which has first pick of his output (as it does with all its contract cartoonists). "Every week I do twenty drawings," he said, "which I take up to *The New Yorker;* they pick what they want, and the balance I take to the syndicate."

INK ON PAPER (DETAIL) | 15.4 X 19.2 CM. | 1989

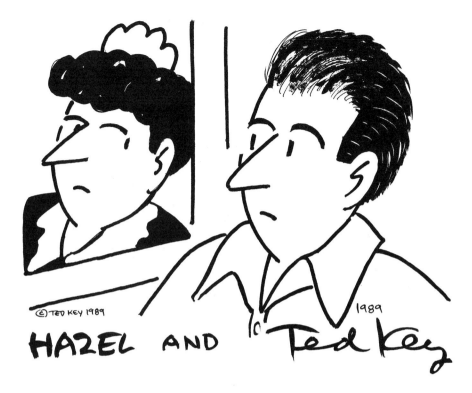

© TED KEY 1989

HAZEL AND Ted Key

1989

TED KEY
BORN 1912

If Key sees himself in Hazel, it's doubtless because she is the most well-known of his numerous successful creative endeavors. Key started drawing cartoons about the strong-willed autocratic maid in 1943, and she appeared in *Collier's, This Week,* and *Saturday Evening Post;* by the fall of the year, though, the *Post* had Hazel under an exclusive contract, and she was in each issue until the magazine folded in 1969. Key even managed to produce his weekly *Hazel* panel while in the Army during World War II. The series was so popular it spawned a television show (1961-1966) with Shirley Booth as the martinet maid. In 1969, Key launched *Hazel* again, this time in a daily syndicated panel. Meanwhile, he was writing radio plays, screenplays for Disney *(Million Dollar Duck, Gus, The Cat from Outer Space),* and children's books (among them, the classic *Phyllis)* as well as illustrating other author's books. Key graduated in 1933 with a degree in art from the University of California at Berkeley (where he was associate editor of the campus humor magazine, *The Pelican).* Having sold a cartoon to *Life* while in college, he went to New York, where he made sales in his first week to *Judge, The New Yorker,* and *Collier's.* Drawing with a bold line and studied simplicity, he made facial expression and characterization a specialty, and by some accounts, he was the most published gag cartoonist in the country during the last years of the Depression.

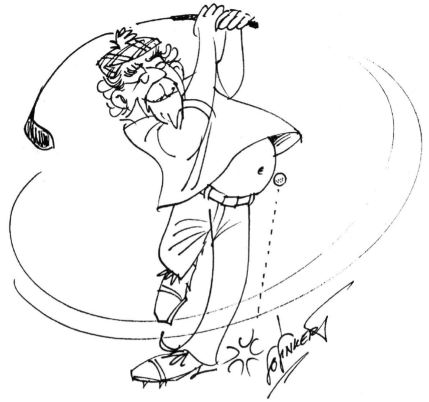

LO LINKERT
BORN 1923

Linkert loves golf so much that he created a humanized golf ball called Dimples, and at least six of his two dozen books of cartoons are about the sport. He says he's produced over 26,000 cartoons since selling his first one at the age of twenty-three. He learned about the power of cartooning in a somewhat unusual (even spectacular) fashion.

Born in Germany, Linkert joined the paratroopers to escape a tedious job as a tool maker. "Traveled all over Europe with them," he wrote; "people threw flowers at us with the pots still on them. Hated traveling ever since." Taken prisoner by the Canadian army, he started drawing caricatures of the officers and men who were his captors. "The camp commander liked his caricature so much that he sent me home on the third day! This was my eye-opener." After the hostilities, Linkert worked as a sports cartoonist for several German publications, then, in 1956, he emigrated to Canada with his wife Inge and two sons. "Had a rough start coming from Germany with little knowledge of the English language," he said. "Looking back, we don't know how we did it. Teamwork, dedication, and a hell of a thick skull. Must be the right combination." In addition to selling cartoons to every major magazine, Linkert produced 1,500 greeting cards and four calendars. Said he: "My last cartoon will appear under my coffin lid."

TOM CHENEY
BORN CA. 1955

A full-time freelancer since about 1977, Cheney graduated from the State University of New York at Potsdam with a degree in psychology, but he spent only three months working in the field as a psychiatric counselor. Said he: "I just didn't have what it takes to keep a straight face while some poor soul told me he tried to commit suicide by eating two hundred Rolaids." So he took a job pumping gas at a local service station and drew cartoons and submitted them in his off-hours, living at home. "I'll always be grateful to my parents for giving me that time to get started," he said. After about eighteen dry months, *The New Yorker* bought one of his ideas (farming it out to another cartoonist to execute); it was the morale boost that Cheney needed. He was now committed. In April 1978, *Saturday Evening Post* published one of his cartoons, and he was on his way. Since then, he has appeared in most domestic and many foreign magazines — from *National Lampoon* to *Omni*, *Saturday Review* to *Penthouse*, *Good Housekeeping* to *Mad* — in addition to being a regular at *The New Yorker*. A freelancer's lot is not always a happy one. Payment comes slowly from some magazines; not at all from others. Once when confronted by a particularly recalcitrant magazine that not only failed to pay him but kept his originals, Cheney called the police department in the magazine's city and reported a larceny. "To my amazement," Cheney recalls, "a detective paid a visit to the magazine with a couple of other police officers. ... The check and my work arrived within a week." No one knows why he drew himself out in a snow storm, and we were afraid to display our lack of sophistication by asking him.

JOHN DEMPSEY
BORN 1929

Dempsey's cartoons have been published in almost every major American magazine, but he has been most closely associated with *Playboy,* for which he has produced a full-page color cartoon in almost every issue for decades. Here his plumply dissolute men and women with their droopy-lidded eyes invest every gag with an aura of jaded enjoyment of some decadent pleasure. For *Playboy,* Dempsey specializes in cartoons set in a nudist colony, drawing (he says) "beautiful hands and noses," an achievement in anatomical rendering for which he feels he has not received sufficient recognition. His first published cartoon appeared in the late 1930s in *Hoofs and Horns*, the official publication of the Rodeo Cowboys' Association. The future of magazine cartooning, Dempsey feels, will be good "as long as Hugh Hefner [publisher of *Playboy*] remains healthy."

WHITNEY DARROW, JR.
BORN 1909

As a young man, Darrow had ambitions to be a writer, but while attending Princeton University, he submitted drawings to the campus humor magazine, the *Princeton Tiger*, and was soon published regularly. Graduating with a degree in art and archaeology just as the Depression began shrouding the country in

DEMPSEY: INK AND WASH ON PAPER | 16.4 X 19.9 CM. | 1987 DARROW: INK ON PAPER | 6.8 X 9.8 CM. | 1988

unemployment, he resorted to his cartooning experience as a possible livelihood, and when his work was immediately accepted by such humor magazines as *Life, Judge,* and *College Humor,* his fate was sealed. With famed *New Yorker* cartoonist Peter Arno as his idol, Darrow set his sights on selling to that magazine. In 1933, he began submitting cartoons there, and with his second submission, he sold seven of ten cartoons and was, forthwith, a contract artist with the magazine. Drawing his comfortably plump persons with a bold line and pencil, charcoal and wash, Darrow has also illustrated books and advertising.

SAM GROSS
BORN 1933

Graduated from the City College of New York with a specialty in advertising, Gross began his cartooning career in the 1960s while in the Army stationed in Germany, where he drew funny pictures for military publications. Subsequently, he freelanced his work, and Gross cartoons started appearing in virtually every major magazine in the country, including such varied venues as *The New Yorker, Esquire,* and *Good Housekeeping.* In the 1970s, he was a senior contributing artist to *National Lampoon*; and in the 1990s, he became cartoon editor of *Smoke* magazine. Drawn in a simple big-nose outline style dressed with wash, Gross's cartoons have been collected in such intriguingly entitled volumes as *How Gross* and *I Am Blind and My Dog Is Dead.*

INK AND WASH ON PAPER | 14.6 X 9.9 CM. | 1987

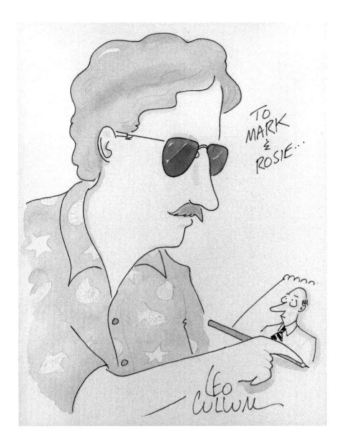

To Mark & Rosie...

LEO CULLUM

BORN 1942

Cullum's gag cartoons have appeared in most major magazines, but as a contract artist with *The New Yorker*, he lets that magazine have its pick of every batch. He grew up in New Jersey and went into the Marine Corps after graduation from Holy Cross College in 1963. Trained as a pilot, he flew F-4s in Vietnam, and when he was discharged in 1968, he became an airline pilot for TWA. He took up painting during one of the frequent lay-off periods endemic to the air-line business at that time, and then one day, noticing a magazine cartoon that he thought was neither funny nor well-drawn, he thought he could do better and decided to become a cartoonist. "Cartooning seemed like an effortless pastime," he remembered once, "but I soon realized that there was more to it than meets the eye, and for me, it entailed hours at the drawing board in a quiet room. Enjoyable hours, but not necessarily easy ones." For a few years in the early 1970s, Cullum made the rounds of magazine cartoon editors' offices in New York every Wednesday, called "look day" because editors received cartoonists' submission in person on this day every week. He moved to Southern California in 1973 and thereafter submitted cartoons by mail. He sold a few, and then in 1976, *The New Yorker* bought one, and slowly thereafter, he began tailoring his work with *The New Yorker* in mind, specializing in gray flannel suits and business-men with wide-eyed but vacant stares. He continued flying for TWA until 1990 and worked on cartoon ideas between flights. "One of the advantages of the job is that I spend a lot of time in hotel rooms with my complete drawing kit at hand. I have no idea what the maids think when they find the room littered with crumpled paper and the ashtrays brimming with watercolor." He does a little advertising work and, with a partner, launched an aviation-oriented line of greeting cards.

FELT TIP PEN WITH WASH ON PAPER | 26.5 X 32.4 CM. | 1997

VIRGIL FRANKLIN PARTCH

1916 | 1984

Partch signed his cartoons VIP (a distortion of his initials with which he began signing his work while in high school) and may have single-handedly jolted the genre of the single panel cartoon out of its verbal complacency in the 1930s and into its most imaginative era, roughly the 1940s and 1950s. He began working at Disney Studios in the early thirties, but by the dawn of the next decade, some of his cohorts there had convinced him to try freelancing cartoons to magazines. He sold his first to *Collier's* (which published it February 14, 1942) and gave up animation. His work was distinguished by its highly visual content: the joke usually depended upon a bizarre picture which made the caption comic. At a restaurant, a woman is shown with a fork-full of spaghetti on her head as she asks her male companion across the table, "How do you like me as a blonde?" In a hotel lobby, a score of identical men are milling around and one accosts another, saying, "Your face is familiar, but I don't recall your name." His reliance upon his pictures to do more than simply set the scene demonstrated vividly the narrative value of the visual element of a cartoon. As celebrated as his wacky sense of humor was his zany rendering style that displayed a certain nonchalance about ordinary anatomy. A frequent objection was made to his unabashed disregard for the number of fingers that are customarily issued with each human hand (as in his own caricature here). To this carping criticism, Partch responded patiently: "I draw a stock hand when it is doing something, such as pointing, but when the hand is hanging by some guy's side, those old fingers go in by the dozens. And why not? At Disney, I spent four years drawing three fingers and a thumb. I'm just making up for that anatomical crime." When the magazine market began drying up in the late 1950s, Partch turned to newspaper syndication with *Big George,* a panel cartoon (1960-1989).

INK ON PAPER | 10 X 14.7 CM. | 1976

ROWLAND B. WILSON
BORN 1930

Wilson thinks of cartooning as "picture writing," and the fun of the work, he says, is in designing the picture. His full-page color advertising cartoons for New England Life Insurance in the early 1970s and his full-page cartoons in *Playboy* with their startlingly different perspectives and dramatic framing and lighting are resounding demonstrations of the fun he must have had. Born in Texas, Wilson graduated in 1952 from the University of Texas with a degree in art and then went to New York and Columbia University to work on a master's degree. He completed the course work but not his final project, probably because he was by then freelancing cartoons to major magazines, having sold his first to *Saturday Evening Post* in 1952, almost as soon as he'd arrived in the city. After a 1954-1956 stint in the Army, he joined an advertising agency and freelanced cartoons, his full-page compositions appearing in *Esquire*. Frustrated by the production-line methods of agency work, he left in 1964 and went freelance. *Esquire* stopped using full-page cartoons, and Wilson started selling to *Playboy* about 1966, and he also developed a comic strip for syndication, *Noon,* about an unemployed cowboy in a dying Texas town. When the strip failed, Wilson turned to his first love, animation. He went to England and the animation studio of Richard Williams (1973-1975), where he worked with two of the industry's great animators, Disney alums Art Babbitt and Grim Natwick. "Art ran a class every day for a month on subjects like timing," Wilson remembered, "problems of a man on a tightrope — how to handle the slack wire — falling water and the like. It was a great experience working with them." Upon his return to New York, he joined a firm specializing in advertising animation. His film, *The TransSiberian Express*, won a first prize at the Third International Animation Festival in 1975.

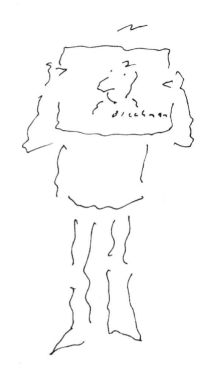

R. O. BLECHMAN
BORN 1930

Deriving his principal income from advertising, Blechman does his cartooning "for the fun of it." His advertising cartoons are seen everywhere, and he won two CLIOs (the "Oscar" of the television and radio commercial field) in the animation category. He is credited with the revival in the late 1960s of advertiser interest in animated commercials due to the success of the "talking stomach" ad he designed for Alka-Seltzer. His magazine cartoons with their tiny, tenuous figures drawn with a spidery line are published chiefly in *The New Yorker*, but it is his "picture stories" — narratives in words and pictures published in

book form — that, to him, have the most "validity." Among his book titles are *Juggler of Our Lady, Onionsoup and Other Fables,* and *The Life of Saint Nicholas*. He attended the Manhattan High School of Music and Art, the Columbia University School of Painting and Sculpture, and Oberlin College in Ohio. He worked for a time at Terrytoons, set up his own design firm and freelanced in

advertising. Because cartoonists work with words as well as pictures, Blechman feels there ought to be more of them in advertising. The trick in creating effective advertising, he once said, is "having a healthy disrespect for what you're doing; you can't be in awe of a job you're doing." If you are, he elaborated, then the job commands you, and you can't manipulate it and work with it. "You

tighten up just as a dancer does if she's aware of the dance steps themselves instead of the music. In art, if you're self-conscious about your work, then it will come out stilted and unnatural: it won't have the flow that all art must have. All art must look spontaneous." In 1961, he started teaching a course in the School of Visual Arts in New York City, often telling his students that "all of us — good, bad, and indifferent — are still working at becoming better artists. It's a never-ending process — art is something that's always evolving."

INK ON PAPER | 4.8 X 8.8 CM. | 1990

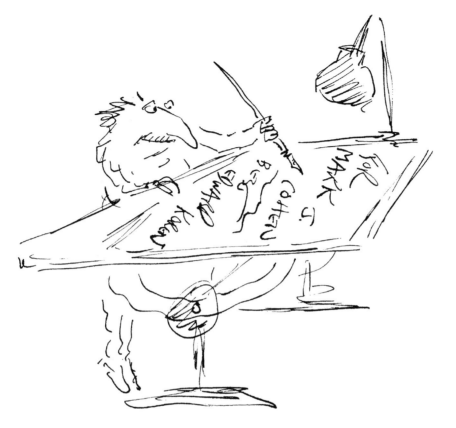

EDWARD KOREN

BORN 1935

One of the few cartoonists around with a thorough academic preparation in "serious art," Koren studied art in Paris and eventually earned a master's degree at Pratt Institute in New York in 1964. He then went to Brown University where he was a pro-fessor of art until 1977. His cartoons are populated by wooly crocodilian humanoids, and their over-all appearance has been likened to the floor of a barbershop just before closing time. Social historian Richard Calhoun once noted that "Koren has obviously seen something in his fellow man that most of us only sense and has incorporated that perception into his work." Koren sold his first cartoon to *The New Yorker* in 1962 and has been a contract artist with the magazine for most of the years since. At last report, he lived in Brookfield, Vermont, where he was captain of the volunteer fire department.

JACK ZIEGLER

BORN 1943

When Ziegler was thirty years old, he decided to become a cartoonist. Until then, he'd kicked around at several jobs — page at CBS, buying telephone lines for net-work transmissions. Jobs like that. "I knew I wasn't doing what I wanted to be doing," he said, "so I decided to try my hand at car-tooning." His hand, it turns out, is pretty good: he sold his first cartoon to *The New Yorker* within a year and has been a regular on its pages ever since. His simply lined but expressive drawings also

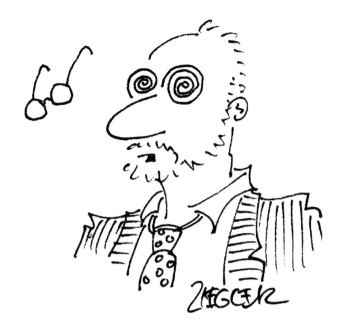

ARNIE LEVIN
BORN 1938

appear often in *Playboy*, the other of the two highest-paying magazine markets for gag cartoonists. But Ziegler has doubts about the future for magazine cartooning: "The market is disappearing," he said. "The art directors have taken over. They think cartoons detract from the prettiness of the page.

They like a lot of flashy pictures that don't mean anything." Five collections of his cartoons have been published, including *Worst Case Scenarios* and a book about celebrities. He lived quietly in New Milford, Connecticut, for a long time, but he moved to Las Vegas, where his wife is a singer.

In the Mojave Desert while in the Marines, Levin reports that he discovered the art of cottage cheese sculpture while on KP duty. Discharged in 1958, he eagerly took the secret of his discovery back home to Miami, Florida, and, after a short stay, to New York, where he continued his studies (briefly) at the Art Students League, forsaking them to run an espresso house ("poetry and that stuff") during the Beatnik era. Eventually, he became animation director for Electra Studio, designing, directing,

and producing films until the early 1970s, "when the industry crashed." He was then "discovered" by Lee Lorenz, art director of *The New Yorker*, and in 1974 Levin began doing cartoons and covers for the magazine. Winner of several awards at the London Film Festival for his animated films for the Children's Television Workshop, he continued his interest by taking up computer animation and video; and he taught courses at the School of Visual Arts and Pratt Institute.

ZIEGLER: FELT TIP PEN ON PAPER | 6.9 X 6.6 CM. | 1996 LEVIN: INK ON PAPER | 8.5 X 11 CM. | 1988

GAHAN WILSON
BORN 1930

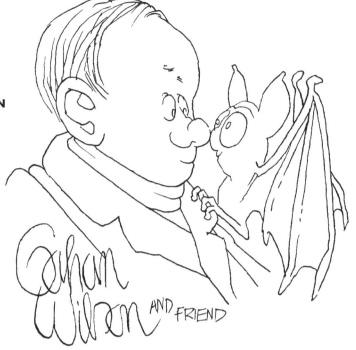

Gahan Wilson AND FRIEND

The kinds of friends Wilson keeps — at least, if the accompanying portrait is accurate (and there's no earthly reason to doubt it) — suggests strenuously the kinds of cartoons he produces. Strange ones. Bizarre depictions of scaly monsters, lurking predators of all species, and bug-eyed necrophiliacs of a vaguely human persuasion. Master of macabre comedy, Wilson claims to have descended from P.T. Barnum and William Jennings Bryan, a fact he offers in explanation of his sense of humor — but which, of course,

has nothing to do with it. And neither does his claim to have been born dead. His weirdly wrinkled albeit flat-looking drawings have appeared as cartoons in such major magazines as *Playboy, The New Yorker, Paris Match, The National Lampoon, Punch,* and (naturally) *Gourmet.* Wilson graduated from the Chicago Art Institute in 1952 and went to Greenwich Village in New York and began to make the rounds to magazine cartoon editors. The editors all laughed uproariously

at Wilson's grotesqueries, but none of the major magazines bought anything: Wilson was simply too far out. "It was a very square phase," Wilson explained. "The fifties sucked. That's why the sixties happened — because the fifties were so awful. The sixties were — 'God, let's get out of this!'" Then one day the cartoon editor at *Collier's* left, and the art director was temporarily charged with buying cartoons. Because he was not an expert cartoon editor,

Wilson said, he didn't realize Wilson's cartoons were too strange; he thought they were funny, and he bought several during the few weeks he reigned. When Wilson's cartoons showed up in the magazine, other cartoon editors apparently thought, "Well, if they're in *Collier's,* they must be okay." And Wilson began to sell everywhere. His inauguration at *Playboy* was equally unconventional. One day while visiting his parents in Chicago, he called unannounced on editor Hugh Hefner, hoping to sell him something for *Trump,* the Harvey Kurtzman (q.v.) creation. Hef, whom Wilson didn't know, reached across his desk, extending his hand to Wilson, and said, "I've been waiting for you." Yet another beginning. In addition to cartooning, Wilson has written children's books, mystery novels, and short stories of the horror ilk.

ABIAN A. WALLGREN

1891? | 1948

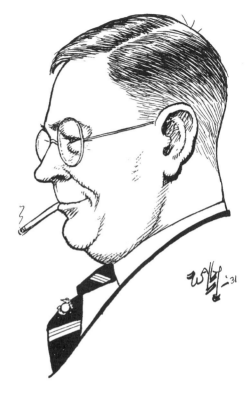

Wallgren was to World War I what Bill Mauldin (q.v.) was to World War II: a soldier cartoonist whose irreverent depictions of life in uniform relieved the tedium and the tensions of warfare. Cartoons signed "Wally" appeared on page seven in every weekly issue of *The Stars and Stripes,* the serviceman's newspaper, beginning with the inaugural issue of February 8, 1918. About Wally's work, John T. Winterich (a fellow staff member and, subsequently, a journalist and author) said: "His wholly human, wholly soldier types moved up and down the army, a ludicrous and dowdy battalion, suffering the identical discomforts and predicaments that the rest of us suffered and lending us the God-given and Wallgren-transmitted ability to laugh at our own ordeal by mud and homesickness." Oddly, none of the histories of cartooning make any great mention of the legendary Wally — odd because he was so celebrated during the hostilities in

Europe. He grew up in Philadelphia and, after high school, "shuttled back and forth" doing sports cartoons at virtually every newspaper in town and creating at least two comic strips, *Inbad the Sailor* (c. 1910-1914) and *Ruff and Ready* (n.d.). When the American Expeditionary Force was mustered in 1917, he joined the Marines, who, cognizant of his artistic talents, made him a sign painter. Judging by Winterich's often tongue-in-cheek account, Wally did not take to military life, spent a good deal

of time in the guard house for minor infractions of military discipline but seemed content: he used his enforced leisure time to make picture postcard drawings of Fifth Regiment personnel, which he sold, achieving a greater income than his commanding officer. Transferred to *The Stars and Stripes*, his behavior did not much improve: according (again) to Winterich, he was absent from the office more often than present. After the War, he went back to Philadelphia but maintained an

association with *Stars and Stripes* staffers. The editor, a rough-hewn hobo newspaperman named Harold Ross, returned to civilian life in May 1919 to edit *Home Sector*, a postwar imitation of *The Stars and Stripes* for veterans, and he assembled his old crew (including Wally and Winterich) as contributors. *Home Sector* was absorbed by the newly launched *American Legion Weekly* in March 1920, and Ross was invited to assume the editorial reins, bringing Wallgren and Winterich with him. When Ross left in 1924 to found *The New Yorker*, Winterich inherited the editorship. And Wally. Until his death, Wallgren was the more-or-less official cartoonist of the magazine. He also did some cartoons for the old *Life* humor magazine in the 1920s, and later he produced two short-lived comic strips, *The Muddleups* (1937) about married life, and *Hoosegow Herman* (1938-1939) about a soldier in the peacetime army, but his most memorable creation was for the *American Legion* magazine — "the salutin' demon," a mousy soldier who instinctively salutes everything that walks whether superior in rank or not.

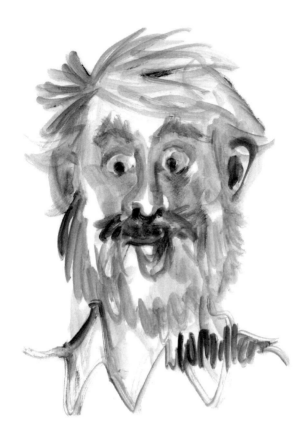

WARREN MILLER
BORN 1936

Growing up in Chicago where his father had a commercial art studio, Miller seemed destined for a career in art. His first rejection slip for a cartoon came from *Saturday Evening Post* when he was seven years old, but he did little cartooning after that. He attended the American Academy of Art for a year, then took a B.A. with a major in art at Beloit College in Wisconsin. Working in the post office one winter, a fellow worker who was sorting mail with him early one cold morning suggested that Miller should try to sell his funny drawings to magazines. Resuming the career he'd abandoned at the age of seven, Miller started submitting cartoons to magazines by mail. His first sales were in 1961 to *Esquire*, which bought three ideas but not the artwork. The next year, he was selling his cartoons regularly to *Playboy* and *The New Yorker*. (He visited the *Playboy* offices when the magazine was still located on Ohio Street in an old Chicago brownstone — just to see Janet Pilgrim, one of the magazine's staff who had posed as a Playmate one month.) As a contract cartoonist with *The New Yorker*, Miller gives that magazine first choice, taking his week's batch of cartoons in to the office every Tuesday and then joining other *New Yorker* cartoonists for lunch. His cartoons have appeared in *Esquire, Punch,* and *Playboy*, as well as *The New Yorker*. He also does advertising cartoons and children's books. Two collections of his tidily drawn, softly gray-toned cartoons have been produced — *All Thumbs* and *Prince and Mrs. Charming*.

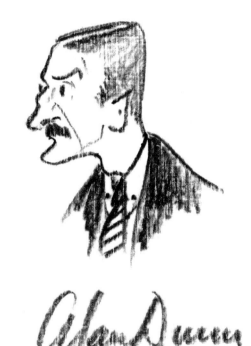

Self portrait, without the use of a mirror —

Alan Dunn

ALAN DUNN

1900 | 1974

Married to another *New Yorker* cartoonist, Mary Petty, Dunn was perhaps the most published of that magazine's contributors. His first cartoon appeared in its pages when the magazine was just a little over a year old (in the issue for August 7, 1926) and the 1,915th in the issue for May 6, 1974, the month of his death. Not quite one cartoon for every weekly issue, but close. Drawing with a vibrant penline and shading with a grease pencil on pebble-finish paper, Dunn produced lively pictures with a realistic, gritty, big city quality. He had studied art at Columbia University (1918-1919), at the National Academy of Design (1919-1923), and at the American Academy in Rome (1923-1924). He saw himself as a social com- mentator "whose pen is no sword but a titillating feather that reminds us constantly that we do not act as we speak or think." People, he thought, were a combination of genuine virtue and pure cussedness. Harold Ross, *The New Yorker's* founding editor, called Dunn "the hermit around town" with some justification: the Dunns were reclusive, living and working in a small apartment on East 88th Street (on the ground floor because Dunn was phobic about fire).

GREASE PENCIL ON PAPER | 8.3 X 13.2 CM. | 1934

GARRETT PRICE

1896 | 1979

Trained as an artist, Price did his first professional work in 1916, illustrating news stories for the *Chicago Tribune* while attending the Chicago Art Institute. Moving to New York, he continued his career as an illustrator but for the numerous newly emerging slick national-circulation magazines, not for newspapers. He also began producing cartoons, drawn more realistically than most albeit in a simple outline style. His work appeared in *Harper's Bazaar, Scribner's, Stage, Collier's, College Humor,* and the old humor magazine, *Life.* He varied his treatment at artistic whim, sometimes using wash or heavy brush stroking, sometimes just his simple slender line; sometimes contrasting solid blacks to stark white areas, sometimes with no embellishment at all. He became a regular contributor to *The New Yorker* shortly after the magazine was founded in February 1925 and to *Esquire* when it started in 1933. In the same year, Price launched a syndicated newspaper comic strip called *White Boy.* Set in the nineteenth century American West, it presented the adventures of a blond teenager among Native American tribes. The strip ran only on Sundays, and Price varied his layouts and breakdowns and colors with panache, creating one of the most unusual-looking strips in history. Too unusual, it seems: to pump up its circulation, the syndicate urged major changes on Price, and so he abandoned Native Americans and the nineteenth century, plunging his young hero into contemporary dangers in Skull Valley, which was the name of the strip when it ceased in 1936. Price, who had attended the University of Wyoming and lived in Oklahoma and South Dakota, said he was "hampered by my authentic knowledge of the old West." Following his strip career, he continued producing cartoons and illustrations for magazines.

NATHAN "NATE" COLLIER
1883 | 1961

BARBARA DALE
BORN 1951

Dale '96
SELF-PORTRAIT

Born in Orangeville, Illinois, Collier studied art at the Acme School of Drawing and at the Lockwood Art School. He contributed regularly to the old weekly humor magazines, *Life* and *Judge*, as well as to their younger general interest brethren, *Saturday Evening Post*, *Collier's* and other such publications, well into the 1950s. He illustrated Will Rogers' book, *The Illiterate Digest* and co-authored and illustrated *Breaks*. Collier's drawing style was uncluttered and therefore modern-looking, which made him appear avant garde in the magazines of the earlier decades in this century.

Specializing in off-the-wall humor of the taste-expanding variety (not unlike the self-portrait here), Dale started her own greeting card business in 1979. At first, Dale Cards were sold only in her home town in Huggies diaper boxes, but in 1981, she negotiated with Recycled Paper Greetings to market the cards nationally and internationally. Her cards, she says, "helped create the 'alternative' greeting card market in America." By the mid-1980s, "alternative cards became mainstream," she said, "and Dale Cards and licensed products (like mugs, pads, post-it notes and balloons) covered mall stores like the morning dew." In 1990-1991, she co-authored *The Stanley Family*, a syndicated cartoon panel. And she's published at least two humor books in addition to sustaining her greeting card company.

COLLIER: INK ON PAPER | 11.2 X 17.3 CM. | 1909 DALE: INK ON PAPER | 10.4 X 12.3 CM. | 1996

BERNARD KLIBAN
1 9 3 5 | 1 9 9 0

Beginning with a book about cats, Kliban pioneered in the 1970s a fashion in cartooning that Gary Larson would parlay into fame and fortune in the 1980s with his newspaper panel, *The Far Side*. Kliban's cartoons appeared in many major magazine markets, but his career received its greatest impetus from the 1975 book *Cat*, which includes mostly pictures of cats doing odd things (buying a tail at a tale sale, for instance, or going underwater swimming with snorkle and fins). But with the next volumes *(Never Eat Anything Bigger Than Your Head and Other Drawings,* 1976, and *Whack Your Porcupine,* 1977), Kliban began captioning some of the drawings to create bizarrely comical situations.

"Monroe is visited by the oral hygiene fairy" is illustrated with a drawing showing Monroe sleeping on a bare mattress on the floor and, hovering over him, a naked woman brandishing a toothbrush and wearing a tube of toothpaste around her neck on a string. Neither speaks. Another caption, "First contact with the bean tribe," shows a typical African safari group (native bearers, white hunters, blonde female interest) encountering three human-sized beans. No one speaks. The back cover of *Cat* shows a cat on a chair addressing tiny six-inch tall humans: "Cat," it says, "one hell of a nice animal, frequently mistaken for a meatloaf." Inside, Kliban helpfully provides a sketch captioned "How to tell a cat from a meatloaf;" evidently, a meatloaf doesn't have ears or a tail. Given the circumstances, this self-caricature is probably closer to a portrait.

ARNOLD ROTH

BORN 1929

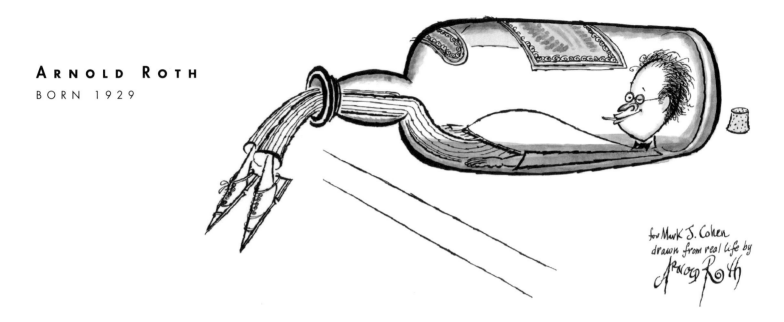

for Mark J. Cohen
drawn from real life by
Arnold Roth

Roth's comic illustrations have appeared in most major magazines (and on the covers of many), including *Playboy, Saturday Evening Post, TV Guide, Holiday,* and *Punch.* He attended the Philadelphia College of Art in the city of his birth and began freelancing cartoons in 1951. He was one of Harvey Kurtzman's (q.v.) editors on *Humbug* humor magazine, 1957-1958, producing several features in every issue in his tightly-drawn mannered style. Roth also created a shortlived syndicated feature, a Sunday-only strip called *Poor Arnold's Almanac,* which ran 1959-1961 and again in 1988, adding a daily version. He has written and illustrated five books and received (according to him) "more awards than deserved — for instance, the Reuben in 1984." But, he reported, he has not received the Legion of Honor. ("Am told they never mailed it in the first place. Am I disappointed? Is it any wonder that I drink?") As his drawing style matured, it became more and more stylized, his lines fat or thin, curlicued or straight, the human figures elongated or squashed to suit either satirical or compositional purposes as need be, establishing Roth as one of the most inventive humorous illustrators since Ronald Searle (q.v.), whose linework and imagery Roth's is sometimes reminiscent of.

INK AND WATERCOLOR ON PAPER | 22.5 X 11.6 CM. | 1986

Searle achieved international celebrity as a British cartoonist in the 1950s, whereupon he fled to an obscure mountain-top village in southern France. He first gained notice in the early 1950s with a series of cartoons about the ghoulish schoolgirls at a fictional girls' school in England, St. Trinian's. The series resulted in several books, which Searle would eventually be almost desperate to disown. In 1956, he joined the Round Table at *Punch,* and his work also began to appear in the U.S. in *Holiday* and *TV Guide* and elsewhere. Over the years, he has progressed from cartoonist to caricaturist to satirist to a kind of moral portrait artist, producing several book collections of highly satirical comic drawings, usually in color. His rendering style in black-and-white with its distinctive rickety line influenced many cartoonists, chiefly editorial cartoonists (beginning with Pat Oliphant, the Australian who took America by *sturm and drang* in the 1960s). One aspect of Searle's life is a stunning testimony to the power of art for the artist. He spent virtually the whole of World War II in a Japanese prisoner of war camp, where, starved and afflicted with malaria, beri-beri and a host of other ailments, he kept himself alive by drawing, maintaining a visual record of his experiences. A fellow prisoner observed: "Imagine something that weighs six stone or so [about eighty-four pounds], is on the point of death and has no qualities of the human condition that aren't revolting, calmly lying there with a pencil and a scrap of paper, *drawing,* and you have some idea of the difference of temperament that this man had from the ordinary human being." Searle was awarded the Reuben in 1960.

SAM NORKIN
BORN 1920

Norkin may have seen more rehearsals than anyone living. A theatrical caricaturist, he does his work by attending dress rehearsals. And since these run-throughs often lack sets and costumes (despite the name), he talks to costume designers and looks at sketches of the sets and discusses make-up with the actors. He draws the whole performance, and then later, he concentrates on individual caricatures of the players and the composition of the scene he selects that will be most telling about the production. A master of caricature,

Norkin sees his task as distilling a likeness of the subject. "This doesn't depend upon any one feature," he noted; "what do you do when there is no prominent feature?" The trick is to realize the general shapes and features in relation to one another. He grew up during the art deco period and was influenced by Miguel Covarrubias, the great caricaturist who also influenced Al Hirschfeld, the only other practicing theatrical caricaturist in New York at the end of the century. But Norkin uses a brush; these other masters used pen. Norkin's art training began in earnest at the Metropolitan Art School and continued at the Brooklyn Museum

Art School and in similar courses at other institutions. But, he says, "The artist is always teaching himself." One of Norkin's first jobs after school was in the art department of the *New York Herald-Tribune*, doing mechanical work. Occasionally, he got to do drawings — starting with a sketch of a play. After that, it was simply a matter

of following his interest in the theater. Beginning in 1940, he has produced a drawing of a theatrical production almost every week — first for the *Herald-Tribune* for fifteen years; then for the *New York Daily News* for twenty-five. He calculates that he's sketched over 4,000 productions.

WARD KIMBALL

BORN 1914

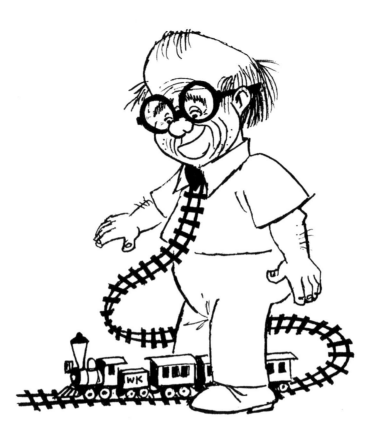

Kimball dotes on Dixieland music and trains. In the thirties, he satisfied his musical urges by collecting a number of like-minded would-be musicians from the staff of the Disney Studio where he worked and formed them into the semblance of a band, and the group played for the Studio's little parties. At first, it was called the Hugga-Jeedy Eight ("because that was the sound my old Model T Ford made while idling," Kimball explained), then the San Gabriel Valley Blue Blowers, and finally, towards the end of the forties, the Firehouse Five Plus Two. The group made several record albums. His passion for trains he satisfied by building a railroad in his backyard. Kimball joined Disney in early April 1934 and worked in the bull pen, which was filled with sweating employees in the summer. "We had to strip to the waist because there was no air conditioning and very little ventilation. We used to sing Volga boatman songs, as if we were galley slaves. It was all new to me, this curious business of making things move." Eventually, Kimball was transferred to the animation department, and he worked on such classic features as *Pinocchio, Dumbo* (on which, he was assisted by Walt Kelly, q.v., with the celebrated crow sequence), *Fantasia,* and *The Reluctant Dragon.* He directed the Academy Award winning animated film *Toot, Whistle, Plunk, and Boom,* and when the animation department was organized in the forties for supervision by a board of senior animators, Kimball was one of that number. The number was nine, and Disney joked about them, calling them his "Nine Old Men" after the nine justices of the Supreme Court (who had been so-labeled by Franklin D. Roosevelt, whose legislative schemes they unhorsed in the thirties). In writing about Disney, two other members of the Nine, Ollie Johnston and Frank Thomas, said Kimball was "the true iconoclast of the group" whose "approach was too unique to pass on."

AL FRUEH

1880 | 1968

Frueh (pronounced "free") made his reputation as a theatrical caricaturist, but he also produced a quantity of magazine cartoons. Reportedly, he became interested in caricature while a young man attending a business school in his home town, Lima, Ohio: he amused himself by converting the Pitman shorthand symbols into caricatures. By the time he was twenty-four, Frueh was working in the art department of the *St. Louis Post-Dispatch,* and it was there that fame first brushed against him. His caricature of a music hall singer named Fritzi Schneff in 1907 so angered the star that she canceled a performance, and Frueh's reputation was made. Moving to New York in 1910 after a trip abroad, Frueh began a theatrical caricaturing career with the *World* that lasted (with occasional interruptions for travel) until 1925. His caricatures are distinguished by a stark simplicity of line and an abstraction of shapes that he wrenched into a likeness of his subject. He relied as much upon the physiques of his subjects as upon their physiognomy: his caricature of George M. Cohan, for instance, is all body language; the face is blank. Frueh also did cartoons for the old weekly humor magazine, *Life,* and, when *The New Yorker* debuted in 1925, he began contributing to it, producing the cover drawing for the second issue. Many of his cartoons were full-page multi-panel extravaganzas, often tracing in pantomime the gradual accumulation of a minor disaster for the chief actor in the manner of British cartoonist H. M. Bateman.

RALPH STEADMAN
BORN 1936

Teamed with madman gonzo reporter Hunter S. Thompson in the early 1970s on a couple of *Fear and Loathing* books, Steadman developed an intensely personal wildeyed drawing style. "We were like journalistic terrorists," Steadman recalled, "and it was during that time that I developed this approach to drawing which became far more visceral. It was a kind of anger, really — partly induced by Hunter but also the screaming lifestyle of America." Almost overnight, Steadman's chunky angular style with its raggedy line turned manic: his lines slimmed down to a spiderweb thinness, and he distorted his renderings into nightmare visions, spraying the results with a fine mist of ink into which he inserted occasional blotches like

drops of his life's blood. Steadman's earliest work was mechanical drawing for engineers, which he did his sixteenth year after leaving school near Liverpool, England, where he was born. He worked for an advertising agency briefly then entered the Royal Air Force for two years; he took a correspondence course in drawing while in the service and freelanced cartoons. Discharged in 1956, he started producing editorial cartoons for the Kemsley papers and freelanced, selling his first to *Punch* in about 1959 and to the more radical *Private Eye* in 1961, beginning an association that lasted nearly ten years.

All the while, he attended art classes in the evenings. In 1970, returning briefly from a visit to America, Steadman did political cartoons for the *London Times* during an election, but his work proved "too seditious." It was the last time he did work other than freelance. He has written and drawn scores of books (including several for children) and illustrated magazine articles and books; and he wrote an operetta. Says the iconoclast: "You feel as if you can change things when you're young, and then somehow you sour with life. The world is conspiratorial. I find that absolutely everyone seems to be out to get you. And those who join the bureaucratic regime seem to be saved from it because they just become the oil in the works." But art rescues him: "I still find that the line is still the most expressive art form of all: to think that a white sheet of paper can contain so many variations of a line going somewhere."

INK ON PAPER | 25.6 X 42.5 CM. | 1989

DAVID LEVINE
BORN 1926

With his copious cross-hatching and the other shading nuances of his penwork, Levine betrays the influence on his drawing style of nineteenth century English and French graphic satirists. But when his caricatures began appearing in *The New York Review of Books* in 1964, they seemed startlingly modern, their biting cynicism coupled to an antique appearance that somehow lent the stature of historicity to the work, making it all the more insightful and therefore true. Within a remarkably

short time, he had clearly emerged as the most influential caricaturist since Al Hirschfeld, the maestro of theatrical caricature. His work appeared everywhere — either drawn by Levine or one of his many successful imitators. Brooklyn-born, Levine went to the Tyler School of Fine Arts at Temple University on the G.I. Bill and then the Hans Hoffman Eighth Street School of Painting in Manhattan. After his schooling there, he tried to enter the cartooning profession

by way of comic books, but the companies he applied to didn't need pencilers, and his inking, Levine said, "wasn't slick enough." Moreover, they objected to his using a pen. Finally, Levine was driven to painting as a livelihood. "I found I was able to sell paintings," he remembered. "I used to have a show of maybe fifty very small paintings and sell them out, boom! I used to say that painting was my way to make a living and to support my hobby, which was cartooning."

His big break was appearing in *Esquire,* doing spot drawings in his distinctive style for the department columns in the front of the magazine. When the magazine's art director Sam Antiput was asked to design *The New York Review of Books,* he suggested the editors try Levine. They did. About his incisive caricatures, he said: "I'm not interested in cutting people up in a way that is abusive. I've always preserved the sense that this is my species."

ROBERT CRUMB

BORN 1943

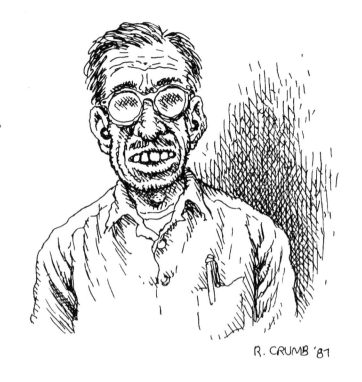

R. CRUMB '87

Crumb may be the drawingest fool the cartooning profession has ever seen. At a very early age, he and his older brother Charles spent every spare hour producing home-made comics in notebooks. Crumb finished high school in 1961 but did not join the work force; third-born in a self-proclaimed dysfunctional family, he stayed at home in Philadelphia, drawing constantly in sketchbooks, a practice he continued the rest of his life. Visiting Cleveland in the fall of 1962, he was hired by American Greeting Cards. In the summer of 1964, he started wandering: he went to New York, did some work for Harvey Kurtzman (q.v.) on *Help,* got mar-

ried, spent a year in Europe, then back to Cleveland briefly, then again to New York, where, in the East Village, he experimented with drugs. Every place he went, he drew everything he saw and much of what he imagined, filling page after page of his sketchbooks. In Chicago, he experienced what he later called "fuzzy" acid. It affected the way he thought and drew, and he gave up drawing from life and started producing great quantities of his goofy galoot style cartoons, people with big feet and tiny

heads, copiously cross-hatched. By spring 1967, Crumb was in San Francisco with the Flower Children, still filling his sketchbook. That fall, he produced the contents for *Zap Comix* No. 1, published in February 1968. He sold them on the streets of hippy-dom, the Haight-Ashbury District; although not the first underground comix, they established the irreverent genre as a viable outlet for an anti-establishment cartoonist, and Crumb emerged as the hero of the counter-culture (even though he

was too iconoclastic to be a member of it). In the next few years, Crumb set the pace for other underground cartoonists, inventing such characters as Fritz the Cat, Mr. Natural, Flakey Foont, Shuman the Human, the Snoid, Anglefood McSpade, Eggs Ackley and the Vulture Demonesses. His most enduring character, however, was himself: Crumb made autobiography in comics fashionable. He rejected his overnight fame and most of the blandishments of the mainstream culture, living simply in rural California for a time and then moving to Southern France, far away from the temptations of the capitalistic middle-class culture he so rigorously ridiculed in his comix.

INK ON PAPER (DETAIL) | 16 X 22 CM. | 1987

art
spiegelman
1987

ART SPIEGELMAN
BORN 1948

In the turbulent late 1960s, Spiegelman was among a number of iconoclastic young cartoonists who shaped what were later dubbed "underground comix," which were notable for their shock tactics, glorifying drugs and sex as a way of satirizing the conventional albeit apparently shopworn values of middle class Americans. Spiegelman's interest, however, went beyond the satiric message to the nature and function of the comics form itself. He produced a number of very cerebral formal experiments that were later published in book form as *Breakdowns* (1977). With his wife Francoise Mouly, he founded in 1980 the experimental magazine *Raw*, which published some of the more adventurous efforts of American and European cartoonists. In 1986, he published *Maus: A Survivor's Tale*, the first part of what would become a highly acclaimed "comic book" (or "graphic novel") about his parents' experiences surviving the Holocaust. Through the ingenious device of depicting the Jews as mice and Nazis as cats, Spiegelman aimed to convey an overriding sense of the oppressive nature of anti-Semitism. The second part of the work was published in 1991 as *Maus II: Here My Troubles Begin;* and the next year, the work as a whole was awarded a Pulitzer Prize, drawing attention to the serious literary purposes that cartooning could be made to serve. Subsequently, Spiegelman has worked mostly as an illustrator, garnering considerable notice with some brilliantly controversial covers for *The New Yorker*.

INK ON PAPER | 9.5 X 14.2 CM. | 1987

JACK KIRBY
1917 | 1994

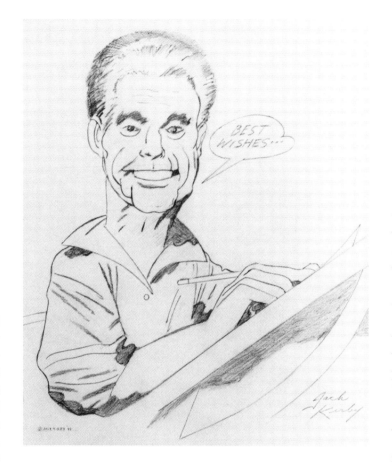

More than any other figure in comic book history except Superman, Kirby invigorated the medium in its infancy. And then, as the industry seemed about to expire twenty years later, he re-invigorated it. Kirby's first cartooning was in animation as an in-betweener, after which, he produced a complete array of newspaper cartoons for a bush league syndicate and then worked in a comic book art "shop" before meeting Joe Simon in 1939. The two began working together — Kirby penciling, Simon inking. Thereafter, Kirby seldom inked his work: "If I ink it," he said once, "I would be drawing that picture all over again for no reason at all."

(Hence, the pencil portrait above.) Soon the partnership was operating as a stand-alone enterprise with Simon as the business manager and salesman and Kirby as the production department. Together, they concocted, produced, and sold some of the most celebrated comic book features — *Captain America, Boy Commandos, Newsboy Legion, Boys' Ranch, Fighting American,* and *Sandman* (to name a few). With *Captain America* in late 1940, Kirby set the pace for superhero comic books: to the action sequences, he applied the concept of continuity of movement that he'd absorbed as an in-betweener, and his figures moved with exaggerated realism — acting and reacting, often moving outside the panel borders — and the page layout varied to accom-

modate this ferocious activity. His technique widely imitated, Kirby went on (after a stint in the army during World War II) with Simon to invent romance comics. The duo separated in the 1950s, and Kirby created the *Challengers of the Unknown* at DC Comics and then went to work at Marvel Comics with Stan Lee. With Lee supplying plot ideas and scripting the action, Kirby produced in 1960 the *Fantastic Four* (another of his hero group inventions), the *Hulk,* and *Thor.* These characters and the Lee-Steve Ditko creations *Spider-Man* and *Dr. Strange* attracted an older readership, and with that, the comic book industry, flagging under the self-censorship regimen that had been introduced in 1954, revived, brought to life a second time by the enormous creative energy of Jack Kirby, who, by the end of his career, was dubbed "King of Comics."

Dan DeCarlo

BORN 1919

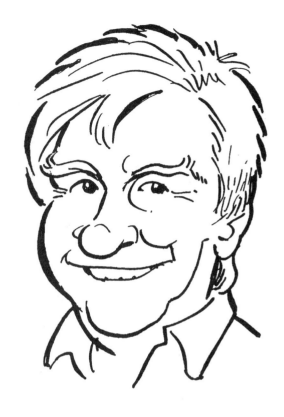

The word "perky" may have been invented to describe the pretty girls DeCarlo specializes in. Not just perky: sexy also. And not just perky and sexy: funny, too. DeCarlo succeeded in developing a style of rendering cute women sexy in slapstick comedy, no small achievement. The DeCarlo Girl has reigned at Archie Comics for half-a-century, ever since the cartoonist began freelancing Betty and Veronica stories in 1952. But DeCarlo developed this distinctive comic book iconography for pretty girls at Marvel (then called Timely) Comics. Born in New Rochelle, New York, after high school DeCarlo worked days in a factory while attending Art Students League at night, aiming at a career in advertising, but World War II changed his mind. In the 8th Air Force, he was officially a "draftsman," but he also cartooned — mascots and insignia and a company comic strip and posters warning about venereal disease. After his discharge in 1946, he tried freelancing magazine cartoons without much success, finally landing a job as assistant to Merrylen Townsend on her panel feature, *Judy*. Then in 1948, he answered an newspaper ad for a comic book artist placed by Stan Lee of Timely Comics. His first assignment was to draw Jeanie, dark-haired heroine of a humorous comic book of that name, but he found fame drawing a series of blondes — Millie the Model, My Friend Irma, My Girl Pearl, and Sherry the Showgirl, to name the most memorable female leads in comic books bearing their names. By the early 1950s, DeCarlo's cute girl comediennes were setting the fashion in comic books. While working on Timely titles as a staff cartoonist, DeCarlo was freelancing on Archie titles, and when Timely cut back its staff in about 1957, he went full-time with Archie and freelanced pretty girl panel cartoons to Humorama magazines (*Joker, Breezy*, etc.). He and Stan Lee collaborated on a syndicated comic strip, *Willie Lumpkin*, in 1960, but the strip went nowhere, and DeCarlo settled in at Archie, for which he produced style-setting pictures for over a generation.

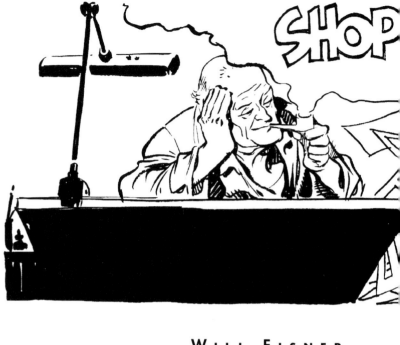

Eisner (on the left) towers over the comic book medium like a colossus, one foot firmly planted in its formative past, the other striding resolutely into the future. He is indisputably one of the most influential figures in the history of comic books; the others being Jack Kirby (q.v.) and Harvey Kurtzman (q.v.). Some would say Eisner is THE most influential. Kurtzman, for instance, says of Eisner that he, "more than anyone else, developed the multipage booklet story form that became the grammar of the medium." Eisner did his first comic book work in early 1936 for *Wow!* That fall, he and its editor, Jerry Iger, formed one of the first comic art "shops," a factory-like system of creating original material for comics as economically as possible

by employing writers and artists as specialists in an assembly-line of production. Sitting at the front of a room staffed with artists and writers, Eisner was the art director of the shop: he roughed out the pages of story, breaking the action down into panels, designing the layouts of the pages and then passing them to the specialists in prescribed sequence for finishing. In the spring of 1940, Eisner left Iger and formed a new shop to produce material for Quality Comics, including a Sunday supplement that was syndicated to newspapers. For the supplement, he created his most memorable character, the masked crime fighter called The Spirit. For the comic books, he also created Sheena, Hawks of the Sea, Dollman, and the Blackhawks. But it was in the Spirit stories that Eisner reached for (and often achieved) the literary status he felt

WILL EISNER
BORN 1917

comics could aspire to, combining human interest tales with shadowy cinematic art and spectacular moodsetting splash pages. Drafted during World War II, Eisner was assigned to produce safety and maintenance training publications for use by field soldiers; what he learned about the instructional function of comics there, he would put to use after being discharged, setting up his own educational comics company, one of the first in

the field. In the early 1970s, he sold this business and started teaching at the School of Visual Arts; by the end of the decade, he was cartooning in yet another new format, dubbed "graphic novel" because of its book-length narrative. In this mode, Eisner tackled mature themes of life and death and family and loyalty, setting the pace once again for the artform he had done so much to bring into being.

JOE KUBERT
BORN 1926

Kubert, who drew himself on the right above in this joint self-portrait with Will Eisner, started in comic book production while still a teenager in high school — sweeping up in the comic art "shop" run by Harry "A" Chesler, who established the first such enterprise in imitation of the production methods of advertising agencies in the summer of 1936. By the time he was sixteen, Kubert was drawing for

Smash, Police, and *Speed* comics and inking the work of such masters as Jack Kirby (q.v.), Lou Fine, and Mort Meskin, experience that constituted much of his artistic education. In 1944, he began drawing Hawkman for *Flash Comics* at DC, then went on to do Dr. Fate, the Flash, and the Vigilante among others. After a stint in the Army in the early 1950s, Kubert freelanced for a number of comic book publishers and, with cartoonist

Norman Mauer, developed a process that resulted in the illusion of three-dimensional art in comic books. He returned to DC Comics in the 1960s, producing realistic war comics with such heroes as Sgt. Rock and the Enemy Ace. When DC acquired the rights to Tarzan, Kubert got the assignment and etched a lithe ape man into being with his distinctive languid line. He also drew hundreds of covers. In the fall of 1976, he acquired a twenty-three-room mansion on six acres of land in

Dover, New Jersey, and opened the Joe Kubert School of Cartoon and Graphic Art, "where talented people can learn every phase of cartooning, art and graphics as applied to comics, advertising, syndication, animation, and the like." Advising his students, Kubert emphasizes the narrative nature of the medium rather than the pictorial, urging them to focus on telling the story, not drawing perfect illustrations.

Charles Clarence "C.C." Beck

1910 | 1989

C.C. BECK

"To be or not to be" was a crucial question in Beck's career, even though his career had very little else to do with the Bard (appearances to the contrary notwithstanding). The best selling comic book super-hero of all time was the joint creation of Beck and a writer named Bill Parker, both staff members at Fawcett Publications when the company decided to add comic books to its line of magazines in late 1939. By then, Superman had been proving the popularity of costumed super-powered beings for well over a year, and Parker and Beck produced another of the

breed in Captain Marvel, who was summoned into existence when-ever teenager Billy Batson shouted "Shazam," producing a lightning bolt that struck the kid and magically transformed him into "the world's mightiest mortal." "The Big Red Cheese," as he was called by his arch enemy ("the

world's maddest scientist"), Dr. Thaddeus Bodog Sivana, was soon starring in a series of comic books that were selling better than anything the Superman folks ever produced before or since. So na-turally, the Superman folks at DC Comics sued Fawcett for infringing on their copyright. The suit was

successfully prolonged for over a decade, but in the end, Fawcett retired its line of comic books in 1953. For this entire time, Beck was either drawing the Captain and the "Marvel family" of similarly super-powered folks or closely supervising those who did, all done under the cloud of the pending lawsuit. Beck retired to Florida, where he pursued a career in commercial art until DC bought the rights to Captain Marvel in the early 1970s and turned to Beck to revive the character. But Beck quit after ten issues of *Shazam:* scorning the visual fashions of the day that dictated elaborate flayed musculature for superheroes, he advocated simplicity in rendering for the sake of clarity in storytelling, and he shouted it from whatever platform he was provided with. Holy moley, as Captain Marvel was wont to say.

INK ON PAPER | 10.8 X 16.6 CM. | 1989

ALEX TOTH
BORN 1928

Toth is not just a master of black-and-white illustration: he's also the indisputable champion of telling simplicity in drawing. As his style matured, it simplified. And with every simplification, his work became more and more refined until it achieved the absolute distillation of visual storytelling. In short, there is an exquisite purity in the mature Toth artwork, a purity of spirit and expression that serenades the soul of the beholder. Understanding exactly what he is doing, Toth quotes the maestro violinist Isaac Stern: "Make it so simple you can't cheat!" Said Toth on another occasion: "For the first half of my career I was concerned with discovering as many things as possible to put into my stories — rendering, texture, detail. For the second half of my career, I have worked as hard as I could to *leave out* all those things." Born in New York City, Toth sold his first comic book stories to *Heroic Comics* while attending the High School of Industrial Arts. In 1947, he was hired by DC Comics, and, under the influence of Milton Caniff (q.v.) and, in particular, Noel Sickles, he drew superhero comics and westerns. He did work for a variety of publishers in the sixties, establishing a visual style for romance comics; he also ghosted the *Casey Ruggles* comic strip for a time, served in the Army, and then settled in at Western-Dell publishing, producing a series of television-based titles such as *77 Sunset Strip, Zorro,* and *The FBI Story,* all the while, honing his style. Moving to Southern California, he began doing work for animation studios, chiefly character design, as well as an occasional comic book story. Of the latter, his 1975 creation of an Errol Flynn-like swashbuckler named Jesse Bravo in a too-short series deftly dubbed "Bravo for Adventure" is the ultimate Toth. By then, Toth's line was spare and expressive, his solid blacks dramatic and vital, and his storytelling masterful, and the character and the 1930s milieu and the stories seemed to express what Toth believed adventure tales should be. Regrettably, there is too little of Bravo and the silvery laughter of adventuring for the fun of it.

CARL BARKS

BORN 1901

CARL BARKS · 1977

"I was just a duck man," Barks said, "— strictly a duck man." Ah, but what a duck man! He was describing his position at Disney Studios, where he had gone in 1935, starting as an in-betweener (drawing the pictures that developed the action between key poses supplied by animators). Transferred soon to the story department, he concentrated on Donald Duck for the next seven years. At the end of that period, he adapted an abandoned film script about Donald to a comic book; and that comic book was the basis upon which Dell-Western comic book publishers subsequently asked him to do original ten-page stories about the duck for *Walt Disney's*

Comics and Stories. The first of these appeared in No. 31 (April 1943), and for the next quarter century, Barks wrote and drew comic book stories about Donald and his trio of nephews (Huey, Dewey, and Louie), inventing along the way a clutch of memorable supporting characters — Gladstone Gander, Grandma Duck, Gyro Gearloose, the Beagle Boys, and, the grandest

of all inventions, Uncle Scrooge, the miserly but rich and resourceful old relative. Barks' duck was different from his onscreen version: Donald was still somewhat excitable, but Barks made him a sympathetic character, a sort of Everyman with feathers and a beak. And he sent this Everyman off on adventures both pedestrian and exotic. Donald might be a door-to-door salesman

one month, an arctic explorer the next. By paying meticulous attention to his locales, Barks gave even his most exotic tales a realistic resonance. And in his stories, he championed such traditional American values as hard work and loyalty (as well as material aspiration), producing moral fables for the times. All comic book artists labored anonymously in those days, but Barks' readers recognized his work, and he was known as "the good artist." Barks had always wanted to be an artist or cartoonist, but he'd worked in a variety of unskilled laboring jobs before becoming modestly successful as a freelance cartoonist in the late 1920s and then, in 1931, as art editor for a little magazine of risque humor called *The Calgary Eye-Opener*. But it is as the Duck Man that he reigns in readers' hearts.

JEFF SMITH
BORN 1960

On the face of it, the history of Smith and his *Bone* comic book seems like one of those Hollywood movie success stories: young animator launches comic book and becomes rich and famous overnight. But "overnight" is scarcely accurate: Smith carried the Bone characters — softly rounded doughboy creatures with Pogo-like features — around in his head since he was in kindergarten, and he has persistently made career choices aimed at getting those characters into print. After graduating from high school, Smith enrolled in the Columbus (Ohio) College of Art and Design, but he stayed there only a quarter because he quickly saw that the curriculum wouldn't help him as a cartoonist. For the next few years, he held a number of odd jobs, including clerking at a college bookstore. He had discovered Garry Trudeau's *Doonesbury* by then and decided that doing a newspaper comic strip for a college audience would give him the education he sought. He enrolled in the Ohio State University in 1982 expressly to draw a comic strip for the campus paper, *The Lantern*, and he did it daily for four years. He became interested in animation, and in 1986, he cofounded Character Builders in Columbus, producing animated commercials for local companies and then getting projects farmed out from Hollywood — portions of *Ferngully: The Last Rain Forest, Rover Dangerfield,* and *Bebe's Kids.* Then in 1989, he realized that if he didn't do something with the Bones soon, he might never do anything. Seeing a flood of black-and-white comic books in the market, he decided to plunge in. Drawn in a clean, crisp manner with a fluid line and high-contrast solid blacks, the first issue of *Bone* came out in July 1991, but by then the market was glutted with black-and-white comic books, and sales were disappointing. It wasn't until late 1992 that his work received the notice that stimulated sales. Suddenly (it seemed), his creation was riding the crest of a wave of enthusiastic readership. Smith was soon able to sell his share of the animation studio to concentrate on *Bone,* evolving issue-by-issue in exquisitely timed episodes his archetypal epic of love and heroism.

INK ON PAPER (DETAIL) | 19 X 16.2 CM. | 1993

AFTERWORD

A caricature of me! I thought Mark Cohen was kidding when he asked me for one — but he wasn't.

In a way, I draw myself every day as Elly Patterson in *For Better or For Worse* — but that's the INNER self. Middle aged. Rubbery. Out of focus. What I didn't want to do was look in the mirror and draw what I saw, not what I felt.

So, I copped out and produced a faceless me looking into a mirror ... with the reflection of Elly Patterson looking back. Hmmm.

It was interesting, later, to see the way in which other cartoonists responded to the challenge — and they did, without reservation. Mark's collection of cartoon self-portraits isn't a who's who, but a who's what ... since each illustration is more than a likeness, it's a signature, a statement and a sentiment as well.

It's evident that I'm not the only one who draws caricatures of myself in my work every day. I'm not the only one who researches and exposes the inner me through the faces I draw — to some extent, we all do! With or without the mirror, we are reflected in our work.

No wonder I like cartoonists so much. We're the only people I truly understand. Thanks, Mark, for asking.

Lynn Johnston

Index